PICASSO
Landscapes 1890-1912

From the Academy to the Avant-garde

First North American Edition

ISBN 0-8212-2239-2
Library of Congress Catalog Card Number 95-76696

Bulfinch Press is an imprint and trademark of
Little, Brown and Company (Inc.)
Published simultaneously in Canada by
Little, Brown & Company (Canada) Limited

PRINTED IN SPAIN

PICASSO
Landscapes 1890-1912

From the Academy to the Avant-garde

Under the direction of
MARIA TERESA OCAÑA

A Bulfinch Press Book
Little, Brown and Company
Boston • New York • Toronto • London

Note on catalogue references

Height comes before width. Only one source of identification
is given for the works, with the following criteria: the
Christian Zervos catalogue reference where this exists; if not,
the Museu Picasso of Barcelona catalogue reference (MPB)
and, if this does not apply, the Daix-Boudaille or Daix-Rosselet
catalogues, the Palau i Fabre books or the Musée Picasso de
Paris (MPP). See the reference bibliography.

This book is published on the occasion of the exhibition taking place
at the Picasso Museum of Barcelona, November 1994 - February 1995.

Honorary President: Her Majesty the Queen of Spain

MUSEU PICASSO OF BARCELONA

Direction
Maria Teresa Ocaña

Communications
Claustre Rafart

Documentation
Lluís Bagunyà

Registrar
Malén Gual

Administration
Antonio Garachana

Photographic Archives
Margarita Ferrer

Secretary
Anna Fàbregas
Carme Herrero

LUNWERG EDITORES

General Manager
Juan Carlos Luna

Art Director
Andrés Gamboa

Technical Director
Santiago Carregal

Layout
Bettina Benet

Editorial Coordination
María José Moyano

Translation
Caroline Clancy

ACKNOWLEDGEMENTS

The Picasso Museum of Barcelona wishes to express its gratitude to all the museums, galleries and collectors who have agreed to lend their works. To all of them, both those mentioned in the following list and those who have preferred to remain anonymous, we owe our thanks for having made this exhibition possible through their co-operation.

Civico Museo d'Arte Contemporanea: Collezione Jucker, Milan
Fondation Silva-Casa, Geneva
Fondation Thyssen-Bornemisza, Lugano
Galerie Jean Krugier. Marina Picasso Collection, Geneva
Galerie Max G. Bollag, Zurich
Glasgow Museums: Art Gallery and Museum, Kelvingrove
Kawamura Memorial Museum of Art, Sakura
Kunstmuseum, Berne
Moderna Museet, Stockholm
Musée des Beaux-Arts, Rheims
Musée Picasso, Paris
Museo de Bellas Artes de Bilbao
The Pushkin Fine Arts Museum, Moscow
The Hermitage Museum, St Petersburg
The Museum of Modern Art, New York
Národny Galerie, Prague
Philadelphia Museum of Art. The Louise and Walter Arensberg Collection, Filadelfia
Virginia Museum of Fine Arts. The T. Catesby Jones Collection, Richmond
The Visitors of the Ashmolean Museum, Oxford

Sr. Georges Encil, Bahamas
Sra. Christine Ruiz Picasso

The Museum wishes to express its special gratitude to those people linked with the life and work of Picasso whose cooperation in the process of organization has made this exhibition more complete:

Catherine Blay-Hutin, for her friendly help and her enthusiasm towards the Museum over the years; Claude and Sidney Ruiz Picasso, for their backing of the project, which has contributed to its happening; Christine Ruiz Picasso, who from the beginning showed her support; Brigitte Léal, Curator of the Musée Picasso, Paris, with which this Museu feels a special affinity; Bill Rubin, whose assistance has been decisive in arranging for the loan of exhibits.

We are grateful for the special collaboration of Salvador Martínez of ART.

The Museu Picasso of Barcelona would also like to thank the entities and persons mentioned below for their various contributions.

Centre Picasso, Horta de Sant Joan
Centro Cultural Arte Contemporáneo A. C. de México D.F.
Centro de Documentación de la Fundación Pablo Ruiz Picasso de Málaga
Condeminas, S.A.
Llotja de Barcelona

Ramon Maria Angarill
Josep Maria Carandell
Mr. & Mrs. Horacio Castillo
Eugenio Chicano
Mercè Doñate
Paloma Esteban
Joaquim Ferràs
Dolors Fontdevila
Agustina Fort
Joseph Guttmann
Rafael Inglada
Lam Khong
Guy Loudmer
Cristina Mendoza
Josep Palau i Fabre
Lluís Permanyer
Joaquim Pradell

Summary

FROM THE ACADEMY TO THE AVANT-GARDE

M. Teresa Ocaña

A simple glance at Picasso's work is enough to realize that, as well as cultivating portraiture and the painting of nature in a continuous fashion, the genre of landscape appears intermittently throughout his career. It appears, disappears and reappears in a natural manner in his development.

Nevertheless, it is a fundamental type of work, frequently seen at the beginning of his training and formative years, and becomes the theme which leads him into the avant-garde through his experiments with cubism.

The frequency of his landscape attempts during his formative years can be attributed to the importance given to landscape in the 19th century, particularly in Málaga, where in the second half of the century this genre had enjoyed a definite splendour with the arrival from Valencia of the painter Antonio Muñoz Degrain. Picasso, as a youth, declared himself Muñoz's disciple on the presentation of the oil painting *Science and Charity* in the General Fine Arts Exhibition of 1897, although in his landscapes there is no glimpse of the impact of this important landscape painter. It is important to note also such significant figures in the Málaga panorama of that time as Emilio Ocón, for whom José Ruiz Blasco, Pablo's father, also professed a profound admiration, and whose landscapes left their mark on the first seascapes of the young Picasso.

This artistic atmosphere, an unrestricted exponent of official painting, enjoyed a prestige in the most outstanding circles of the country. It was, in fact, what would satisfy the ambition of his father, José, who aspired to have his son introduced into this nucleus of artists dictating the patterns of artistic trends in the country.

Picasso's first attempts at landscape, with the exception of some undertaken in Málaga, were concentrated in Corunna, coinciding with the beginning of his training, in which this genre had an important position. These are the product of early trial and error.

The arrival at Barcelona opened new horizons. The richness of the artistic panorama of Barcelona, at that moment when the city was avid for any innovative movement which would therefore be in the vanguard, must have shaken up the ideas of this adolescent young man, in whose subconscious it probably generated the beginning of his rejection of the Academy and the turning of his eyes towards the more creative and in-

novative currents developing around him. He would have noted and been affected by the fact that the more restless students of La Llotja had left the institution because of the stuffiness of its teaching, and that some of them, outside it, had formed a group called the "Colla del Safrà" (the saffron group), which, when Picasso was living in Barcelona, began to exhibit luminous landscapes with yellowish tonalities which had nothing to do with what was taught in La Llotja. It is likely that in viewing the work of these young artists who, from outside the ambit of official painting, stood for the culmination of the rich development that the landscape genre had reached in Catalonia during the second half of the 19th century, the young Picasso looked for new perspectives for his future.

The landscapes in the summers of 1896 and 1897 in Málaga, and those done during his first stay in Horta, are notable in the incipient manifestation of opposition to the official circles and, to a degree, against the directions which his father had planned for his future.

After this point, naturally, the young Picasso's view turned to positions by which he could seek the possibility of making a new art, more innovative. Gradually, he turned his back on the Academy to bring himself into the more advanced cenacles: "if I had a son who wanted to be a painter I would not keep him a moment in Spain, and don't think that I'd send him to Paris (where with any luck I'd be), but to Munik (sic). I am not for following any particular school as these bring nothing more than conformity and lack of variety for those that take this path", he wrote in November 1897 from Madrid. His stage in Barcelona was decisive for this change in his artistic ideas although, perhaps, in place of change, it would be more correct to speak of a logical reaffirmation of his personality in opposing the directions of his parents.

Following this road we note the landscapes done between 1899 and 1900, years in which he identified himself more fully with the attitudes of the Catalan avant-garde, taking part in their ideas and their values. Sabartés noted the impact which Barcelona had on the young Picasso with these words: "There is Paris. There is Europe, and Picasso has not yet crossed the Pyrenees. We breathe an atmosphere full of northern modernism, the only thing that matters is what is imported: what is going on in Paris". But this open European atmosphere was only seen through the experiences of others who had preceded him on the long road to Paris, which is the origination of Picasso's first journey to Paris in 1900, the preamble to the later explorations which marked his incorporation into the European avant-garde, of which he is one of the founders.

The lively chromaticism of the post-impressionist landscapes done between Paris and Barcelona within the years 1900 and 1901, and the move to essentially urban views in blue monochromes, configure the preamble which would lead to new explorations. In them the search for volumes begun in the summer of 1906 in Gósol and the achievement of the geometrication of shapes originates some landscapes in which the primordial end is the simplification of form and the command of line as the essential force of the composition, where the optical effects of colour also play a notable role. The landscapes of La Rue-des-Bois, the first set of authentically cubist landscapes, mark the

beginning of cubism, with a compositional structure in which the influence of Cézanne is clear.

The stay in Horta was the key moment in which the effervescence achieved in Rue-des-Bois reached its maximum brilliance. It was spurred on by the sober austerity of the Horta countryside, which synchronized perfectly with the break-down of landscape into facets whose transparency, combined with the reduction of colour to ochres and greens, as well as the arrangement of planes, accentuated the monumental and solid character of the work.

The hermetic quality of the paintings from 1910 in Cadaqués and the winter of 1911, in which the reduction of the subject to a severe structure of lines and planes prevailed, produces a contact with abstraction, a temptation from which he voluntarily turns away in favour of a greater legibility and clarification in his works from the summer of 1991 in Céret.

Picasso, now immersed in the avant-garde and a pioneer, together with Braque, in one of the most decisive movements of this century, stimulates us to look back and discover, through landscape the rapidity with which the young artist rushed through the successive stages of his training to arrive at the consolidation of his career.

THE MONTES OF MÁLAGA

M. Teresa Ocaña

Some years ago I was shown a work which represented a landscape done by Pablo Ruiz Picasso in his youth, catalogued by Christian Zervos (Z. 6, 100) (fig. 1). A few years later, by chance, I had the opportunity of seeing another almost identical landscape which up till then had not been catalogued, but which did have full documentation and authentication from the artist himself to D.H. Kanhweiler and P. Daix (fig. 2). It was the beginning of a study which I will now describe in detail. But, first of all, I would like to record that these two landscapes, almost unknown until now, attracted my attention for being very closely tied to works which belong to the collections of the Picasso Museum of Barcelona, and that both stand out as the culmination of an exercise which Picasso conducted between 1896 and 1897 in Málaga. The context of the works which surround these two oils made me think at once that they were landscapes from Málaga, a point which has been confirmed to me by the Documentation Centre of the Picasso Foundation of Málaga, who sent me ample graphic material in which the orography of the landscape represented coincides with the range of the Montes of Málaga, which are around the city. It is this

that has led me to give the title *Montes of Málaga* to these two oils.

In all the artistic training of Pablo Ruiz Picasso, it was during the summer of 1896 that his incursions into the exercise of landscape painting were greatest. After the little panels that he had done during the previous winter and spring in Barcelona, the young Picasso, that summer in Málaga, tackled canvases on a larger scale.

Two works from these months in Málaga brought together the successes of the artist for his relatives in the area, who were anxious no doubt to verify their nephew's progress. One, *Portrait of Aunt Pepa*[1], is without doubt one of the most important works of his formative years; the other is *Mountain Landscape* (cat. no. 35), the most ambitious landscape painted up till then, in which the dark and sombre tonalities of his previous works are replaced here by a new luminosity, already experimented with in some landscapes done in Barcelona the previous spring.

This landscape, which aspired to surpass the tentative previous works, was not, of course, an isolated exercise, but had been arrived at as a final state through researches which he made at the time, since, besides another smaller canvas

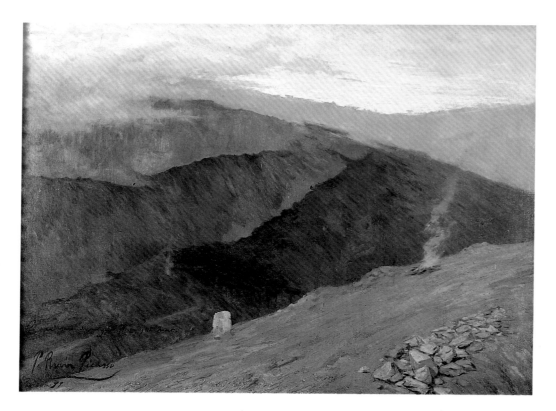

which is a preparatory work, there are a series of smaller landscapes.

However, I want to direct attention not to the great importance which landscape had during this Málaga summer, which is the subject of a chapter in this catalogue, but just on the two versions of *Montes of Málaga* (cat. nos. 41, 42), probably done in the following year, in the summer of 1897, in Málaga.

These two very similar landscapes, excellent in their composition and execution, show already the young artist's command of his medium. Both canvases display a view of the Montes of Málaga, a subject which he had worked profusely in the summer of 1896, as can be seen in this part of the exhibition. However, the mastery of these two compositions, very little known until now, makes them in my judgment the master works of this period, and even the culminating point of his formation as a landscape artist.

The panorama of the Montes in the painting which seems to be the second version (fig. 1, cat. no. 41), is taken from a point further back and higher than the first (fig. 2, cat. no. 42), albeit its composition is very similar. The fact that the first is of smaller dimensions and that two women are shown collecting bundles of wood, who do not appear in the other; that the thick smoke which spreads from the bonfire, seen very clearly in the second version, appears on a more distant plane; and that the angle from which it is taken allows him to insinuate a little hamlet in the valley and two small houses further off; leads us to believe that the artist made the version with the two countrywomen first and that subsequently he painted the second canvas, in which the angle of vision was a little higher, from the top of the hill on which he was placed. In this second version, in which the marks of identity of the landscape, the little bunch of houses and the hamlet, disappear, and in which the embers of the bonfire replace the two countrywomen, the fleetingness of the moment is accentuated and the atmosphere of illusion goes beyond the simple depiction of a countryside. The melancholy of the

1. *Montes of Málaga.* Málaga, 1897. Oil on canvas. 82.5×60.5 cm. Georges Encil Collection, Bahamas. Zervos 6, 100.

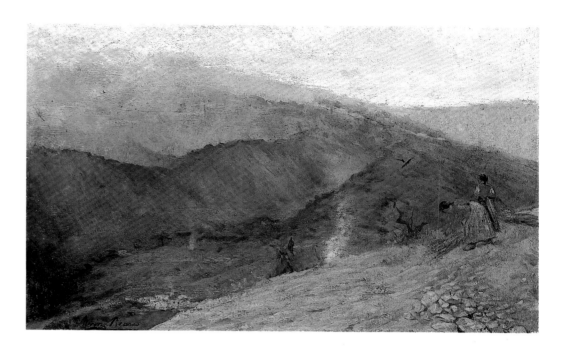

2. *Montes of Málaga*. Málaga, 1897.
Oil on canvas. 34×54 cm. Private collection.
Not catalogued by Zervos.

dusk, brought out by a muted play of lights, is increased by the smoke which comes from the embers of a bonfire, disappearing in the penumbra of the sunset. All this makes this painting a significant step forward in the artist's work, so that *Montes of Málaga* takes on a significance of grandeur and innovation in this first period of development.

The thick brushwork and impasto in *Mountain Landscape* (cat. no. 35) from the previous summer is resolved in these two canvases into smoother and lighter brushwork, with which the tonalities of the mountains in the background mark and determine the characteristic orography of this region. The foreground, defined by a diagonal which marks the division between reality and illusion, is more evident in the second version. The rocks which appear in the lower right corner already show his mastery of technique and skill, the group of stones are shown individually with a smooth and agile brush, giving the foreground of the scene a realism which contrasts with the ethereal clouds which fall on the mountains in the background. The meticulous description of the ground on which the artist has his easel is diluted

through the "zoom" which broadens the perspective. The embers of the bonfire, emitting the smoke which is lost in the shadows of the dusk, resolve a subtle and appropriate conjunction in which the immediate reality gives way to the wooded and inaccessible mountains where the mystery of the advancing night hovers over them, giving a grandeur to these canvases which shows the young Picasso as an excellent landscape artist.

The quality and singularity of these two landscapes, in relation to his previous work, showed that Picasso, who had been living in Barcelona since the autumn of 1895, had been influenced by the Catalan landscape artists active in the last quarter of the 19th century. In this sense it is especially important that in the General Fine Arts Exhibition of 1894 and, more particularly, that of 1896—in which Picasso himself participated—there was a public presentation of work by the young artists who belonged to what was called the "colla de Safrà" (the saffron group), which the more advanced critics found surprisingly good. As is well known, the "colla de Safrà" was formed in 1894 and its members were Isidro Nonell, Juaquim Mir, Ricard

Canals, Adrià Gual, Ramon Pichot and Juli Vallmitjana. These artists decided to paint the suburbs of the city—outside the official teaching of the Llotja Academy of Fine Arts in Barcelona—with an absolutely modern concept of landscape. The name "colla de Safrà" was due to the intense yellow tonality of their paintings.

In our second version (fig. 1), the dedications which appear on the lower left corner are "to my dear friend Hermenegildo Montes", signed and dated "P. Ruiz Picasso. Barcelona 97", lead us to think that Picasso painted this in 1897. The landscape represents the Montes of Málaga, where the young artist went in the summer of 1897[2]. We note that the dedication and "Barcelona" are done with a finer line than the signature "P. Ruiz Picasso" and "97". This makes us think that the picture was painted in Málaga in the summer of 1897, but dedicated and sent from Barcelona later, as a present to Hermenegildo Montes[3] who had represented him in the national exhibitions, first with *Science and Charity* and then again with *Customs of Aragon* in 1899, or perhaps it was painted in Barcelona in 1897, starting from the first version. What is clear is that this canvas was the culmination of all his landscape work during the stay at Llanes the previous summer and that the little landscapes (cat. nos. 43-50) were a preparatory exercise.

On the other hand, in view of the fact that he sent it to Montes, who had represented him in the Madrid exhibitions, inclines us to believe that this second version was considered by him, and probably by his father also, as a work well executed and adequate to be a gift to a friend.

6. *Village house.* Málaga, 1895-1895. MPB 110.221.

In addition, a radiological examination of this canvas (fig. 3) discloses a previous painting in which three figures are seen; a young woman with a child in her arms, standing in front of an old man who is seated. These same figures appear in two small compositions *Peasants in the country* (fig. 4, cat. no. 57) and *Fisherman and children* (fig. 5, cat. no. 58), both probably done in the summer of 1896 in Málaga. This composition, underlying *Montes of Málaga*, must, because of its size, constitute the beginning of an attempt to make an important composition which would justify what we have seen as the whole preparatory road surrounding this theme, and with which the young artist was trying to forge an achievement which would constitute a serious link of consolidation in his career; and which he subsequently rejected in painting over it the *Montes of Málaga*.

The positions of the two people seen in the radiography of this canvas refer us directly to *Peasants in the country* (fig. 4), in which an old peasant with a hoe is seated, chatting to a young woman leaning on a staff. The landscape acts a background to this composition, with the Montes of Málaga as a final frame, and the two figures placed in a part of the valley surround-

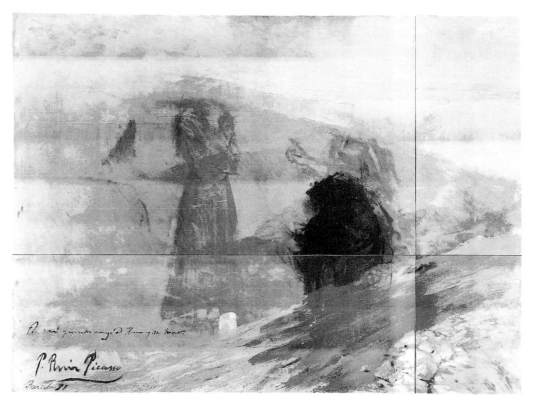

ing the farm at Llanes which belonged to Picasso's godparents. The vegetation shown on the smooth slope on the right hand side refers us to *Landscape* (cat. no. 38) and also to *Mountain Landscape* (cat. no. 35). This same composition with another background scene appears in *Fisherman and children* (fig. 5) in which the young woman, on this occasion seated, turns towards an old man, probably a fisherman, seated on a boat; by the girl there are two small boys. We recall that in the radiography the young woman held a small child in her arms. Probably the two boys are the same two as appear playing in the oil *Village House* (fig. 6, cat. no. 59).

Up till now this composition had been considered to have been done in the summer of 1896 in Málaga, however the house is almost identical to *Houses on the Outskirts* (cat. no. 10), dated in Corunna, April 1895[4]. On the other hand, the landscape which appears in *Peasants in the country* has, as we have seen, a close tie with the landscapes painted in the summer of 1896. It is probable, then, that the composition underlying *Montes of Málaga* and all the preparatory work which we have described could have had as a final end the preparation of a work of more complex proportions, which then did not satisfy the young artist, and he painted over it the last ver-

sion of *Montes of Málaga* for whose depiction he had exercised so intensively in the summer of 1896, as we can see in this present exhibition. However, the painting *Montes of Málaga* with the two country-women is already good evidence of the solidity of his craftsmanship and a very notable ability in the command of the brush, which must have been considered by Picasso as an important step in the consecration of his career as a landscape artist. Our doubt rests on whether the first version was painted in the summer of 1896 as a result of all the landscape exercise undertaken around these places, or if perhaps it was painted, like the following one, in the summer of 1897. The close relation of compositional and thematic subjects in both canvases inclines us to place its painting in the summer of 1897, when the version with the figures became the culmination of all the previous work and also a anteroom for a more ambitious canvas in which the artist could have had the idea of a painting which—as happened with *Portrait of Aunt Pepa*, the culmination of an exhaustive exercise in portraiture—would constitute a landmark in his incipient career as a landscape artist.

The importance of landscape at that time, and especially the creativity which unfolded around this subject during the summers of 1896 and 1897 in Málaga, when the interpretation, depiction and analysis of landscape sequences took place, and in which some became the genesis of others, had in the summer of 1896 the first important objective, in opposition to the academicism which surrounded him, in *Mountain Landscape* (cat. no. 35) which was achieved in the summer following

with the two versions of *Montes of Málaga*. This was the consolidation of the young artist's craftsmanship, still without openly confronting the norms and restrictions which the Academy imposed upon him, but showing on the other hand a precocious mastery of composition. At the same time he felt a great impulse to dash through the stages of his training and launch himself into new experiences, which would satisfy his intention that behind paintings like this one there would be an innovative plastic language. His tenacity and creative capacity as Sabartés told us many years later, drew him constantly to new discoveries in which his photographic eye sought new possibilities of experience.

"Stopping before the picture dealer's window, he said to me, looking at a landscape representing a sunset, some cows and some groups of trees which were reflected in the waters of a brook:

"I would love to be able to paint like that.. You can't imagine how it would please me!..."

"Such pleasure was denied him. Not for him was the gentle calm of a landscape at twilight, his destiny was something other. The energy which moved his creative machine possessed him in such a way that scarcely had he conceived the form through which to give the idea of an idea of his, the whirlwind of his aesthetic concerns caught him and involved him, shook him and agitated him, introspective in the fantastic dance of his imagination"[5].

NOTES

1. MPB 110.010

2. Various studies make the stay in Málaga during that summer certain, however the Documentation Centre of the Picasso Foundation in Málaga does not give it as definite.

3. Jesús Gutiérrez Burón: *Picasso y las exposiciones nacionales: tradición y ruptura.*

4. This could perhaps be the treatment of a subject begun in the summer of 1895 in Málaga and continued in the following year.

5. Jaime Sabartés: *Picasso, retratos y recuerdos*, p. 29.

FIGURE INTO LANDSCAPE INTO *TABLEAU-OBJET*
PLACING PICASSO'S CUBIST LANDSCAPES

Christopher Green

7. *The Horta factory.* Horta de Sant Joan, 1909. Oil on canvas. 53×60 cm. Hermitage Museum, St Petersburg. Zervos 2, 158.

In the summer of 1915, the English Vorticist Edward Wadsworth wrote to Wyndham Lewis, hoping to persuade him to come to Hebden Bridge in Yorkshire for a holiday. "Hebden Bridge," he wrote, "is a most inspiring place—like an early Picasso drawing come true."[1] He mentioned in passing that he was making drawings for woodcuts. Certain of Wadsworth's woodcuts of 1914-1915 do indeed invoke Picasso landscapes, those painted above all at Horta de Sant Joan in the summer of 1909 (figs. 7 and 27, cat. no. 204). Their jagged geometry, however, invokes also the industrial architecture of the mill-towns among which Wadsworth grew up, Cleckheaton and Bradford.[2] Picasso's Horta landscapes may have been made in a remote corner of Tarragona, far away from the urban animation of Barcelona or Paris, but their firm geometry imposes a cerebral order on nature, an order which Wadsworth clearly felt was closely attuned to urban experience in an industrialised world.

For Wadsworth, it seems, Picasso's contribution as a landscape painter at Horta lay in the way he used architecture (the clustered cubes of the little town) as the means to take possession of nature. This

was the way too that Gertrude Stein, famously, interpreted the Horta landscapes. In her Picasso monograph of 1938, she picked out *Maisons sur la colline, L'Usine à Horta de Sant Joan*, and *Le Réservoir, Horta* as the three works with which Picasso announced Cubism. For her, the key to these, the first Cubist paintings (in her view), was the geometry of Horta's architecture pitched against its natural setting; it was not necessarily urban and it was specifically Spanish, something found in that place and in the hard "Spanish" intelligence of Picasso the painter.[3]

That summer of 1909 which Picasso spent at Horta de Ebro, Braque spent in the Ile-de-France, at La Roche-Guyon near Mantes. Before Picasso returned to Paris in mid-September, Braque had departed for a month's military service, which was followed in October by two or three weeks painting with their mutual friend Derain at Carrières-Saint-Denis close to Chatou in the commuter belt of Paris.[4] At Carrières, as at La Roche-Guyon, Braque selected Cézannian motifs which set architecture against nature; in this case the masonry terracing of the park and the buildings of the old town above against trees and grassy slopes

and perhaps water (fig. &). In the paintings he took the angular geometry of buildings as the cue for an over-all faceting of surfaces that over-rides the organic curves of trees and branches. Just as Picasso's arid ochres and browns captured the parched heat of Tarragona's "Terra Alta" in summer, Braque's deeper browns and enveloping greens captured the well-watered cool of the parks and woods along the Seine in early autumn.

It could be said, in Gertrude Stein's terms, that in 1909 Picasso and Braque had both found ways of representing landscape as a cerebral architecture, stimulated by the relationship of buildings to natural form, the one responding to landscape motifs which are strongly Southern (Catalonian and Spanish), the other to landscape motifs which are just as indelibly Northern (French). Furthermore, it could be said that common to both recognisably Cubist approaches to landscape painting was not merely the geometric but a readiness to transform and manipulate the motif in ways that radically threatened its integrity. This is something to which Stein's text does not draw attention (she stresses instead the *likeness* of Picasso's paintings to Horta), but recent research has accentuated its importance. On the one hand, the work of Anne Baldassari on Picasso's Horta landscapes in relation to his photographs of the town has demonstrated how in both *Maisons sur la colline* and *Le Réservoir* (especially the latter), Picasso fused a downward view of the buildings with an upward view of the architectural ensemble, so that any impression of perceptual coherence is denied.[5] On the other, my own work on Braque's *Carrière-Saint-Denis* series in relation to

the park and old town of Carrières has led to the conclusion that the picture in the Fundación Colección Thyssen-Bornemisza is almost certainly a synthesis of different views of the ponds, terraces and architecture it represents.[6] Braque, of course, had painted landscapes from memory before, adding invention to remembered perception,[7] and, as this essay will show, so had Picasso.

1909 was the year when Picasso's and Braque's alliance as painters became especially close, and, as landscape painters, it might seem from this analysis that the key to their closeness was a common willingness to manipulate the features of the motif, to fragment the unity of its space and to subject everything to the rigours of architectural structure. None of these factors, however, have featured prominently in most analyses of the role of landscape in the Cubism of Picasso and Braque, even though landscape has, in fact, taken on a heightened significance in the way the history of early Cubism has been constructed. With one or two exceptions, over the past forty years historians have consistently played down the importance of the manipulative and the geometric in early Cubist painting altogether.[8] Especially influential in this development has been William Rubin, above all his essay of 1977, "Cézannisme and the Beginnings of Cubism."[9] The stress has switched from geometry and construction to "flatness," to what is perceived as Picasso's and Braque's determination to represent figures, objects and the envelope of atmospheric space in flat planar terms consistent with the two-dimensional fact of the canvas support. Cézanne has become the central figure in this analysis, and

8. Braque: *Carrières-Saint-Denis Park.*
1908-1909. Oil on canvas. 40.6×45.3 cm.
Thyssen-Bornemisza Museum, Madrid.

landscape a central theme. As a genre, land-scape shifts the attention of artist and spec-tator from the figure or object as such to the environment as a whole; it encourages therefore an engagement with the entire pictorial field. Attention to the totality of the flat picture-surface has been found to follow from attention to the wide and deep spaces of landscape, especially where late Cézanne is the model. Picasso's Horta land-scapes, like Braque's Carrières-Saint-Denis landscapes, are transparently Cézannian in facture, but this has not, in fact, led to the confirmation of Stein's opinion of the Hor-ta landscapes as the first Cubist pictures. Instead it has diverted attention away from Picasso to Braque, and above all to Braque's work as a landscape painter between 1907

and 1909. Whatever impact Picasso's Hor-ta landscapes might have had on Edward Wadsworth and Gertrude Stein, it was, after all, Braque who proved himself the most committed both to Cézanne and to land-scape before the summer of 1909. Picasso, indisputably, had allowed himself only the briefest excursions into landscape, while he had found African or Oceanic artefacts as compelling as he found Cézanne. Further-more, his Horta landscapes are rather too easily seen as responses to the landscapes Braque painted at L'Estaque in the summer of 1908. For the first time, it can be shown, Picasso gave precedence at Horta to the Cézannian technique of "passage" (that is, the melding of one planar facet into another whatever their relative positions in

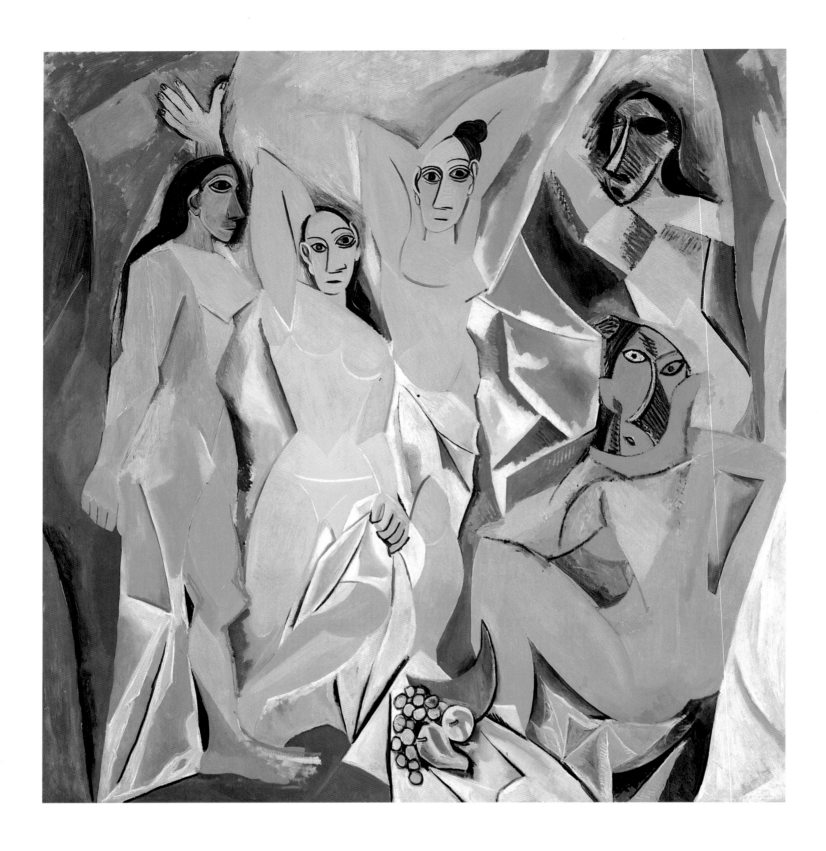

9. *Les Demoiselles d'Avignon*. Paris, 1907.
Oil on canvas. 243.9×233.7 cm.
The Museum of Modern Art, New York.
Acquired through the Lillie P. Bliss legacy. Zervos 2*, 18.

10. *Woman seated*.
Horta de Sant Joan, 1909.
Oil on canvas. 81×65 cm.
Private collection. Zervos 6, 1071.

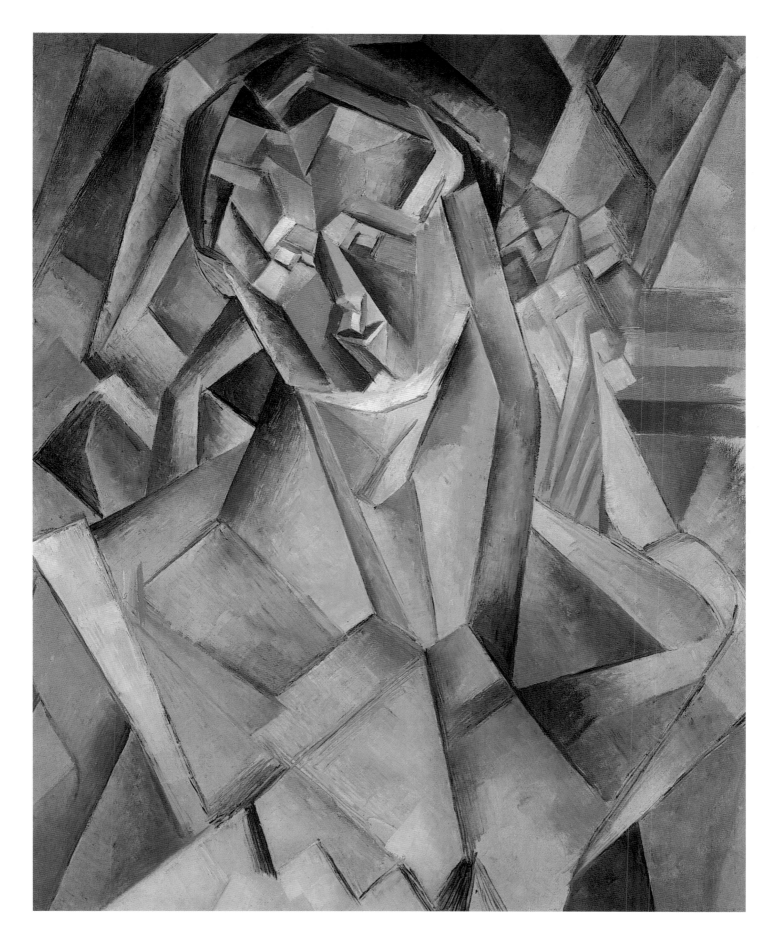

the depth of the landscape motif); and in doing so he learned a lesson from late Cézanne that Braque was already able to teach him.

My intention in this essay is to look again at the role of landscape in Cubist painting (especially before 1911), and, by centring the discussion on Picasso rather than Braque, to re-focus attention on the themes of inventive transformation and pictorial construction. I do not wish to suggest that "flatness," the technique of "passage," and the example of late Cézanne were insignificant factors in the early history of Cubism; they clearly were important, for Picasso as well as Braque, and I shall bring them into my analysis. My feeling is, however, that their recent domination of accounts of Picasso's and Braque's achievement has diverted attention from factors which were of at least equivalent significance, factors whose significance Gertrude Stein certainly understood; I want to redress the balance somewhat. In my view, Cubism was too open to change and too plural in its manifestations for definitions to be useful; and in the case of Picasso and Braque before 1914, Cubist painting was patently concerned as much with invention, transformation and pictorial language as with flatness. Furthermore, its subject-matter counted (again something Gertrude Stein realised); and my intention, finally, is to bring out the way that the places Picasso chose to transform as a Cubist landscape painter themselves carried meanings. The Horta de Sant Joan that Picasso painted in 1909 is to be seen in contradistinction to Wadsworth's Bradford or Braque's Carrières-Saint-Denis; remotest Catalonia, on the borders of Aragon, is a

very long way from centres of industrialisation in the European North or the French countryside of the Seine valley.

One feature of the argument that places Braque's landscapes at the beginning of Cubism is the decision to set Picasso's major painting of 1907, *Les Demoiselles d'Avignon* (fig. 9), to one side in the history of Cubism. Where for Kahnweiler, Barr and Golding, the flattenings and figurative dislocations of *Les Demoiselles* opened the way to Cubism, for Rubin its "African" savagery, its engagement with themes of psycho-sexual exorcism and above all its failure to develop "passage" relationships between faceted surfaces distinguishes it absolutely from early Cubism proper. For Rubin, at the most profound level, *Les Demoiselles* has nothing whatever to do with Cubism.[10] To re-instate the themes of transformation and pictorial construction at the centre of the study of early Cubism is to allow *Les Demoiselles* back into its history: it is to recognise that its all-over surface rhythms of lines and planes, and its shifts of view-point are developmentally linked to those found in *Trois Femmes* of summer-autumn 1908 (fig. 113) and in the Fernande Olivier portraits painted alongside the Horta landscapes of 1909 (fig. 10 & 11); and it is to recognise that there may be other links between them too. At Horta, plainly, landscape was the counterpart of figure-painting the portraits of Fernande compliment the views of the town. It has rarely been remarked that *Les Demoiselles d'Avignon* had a landscape counterpart too, for in 1907, Picasso developed an outdoor composition at exactly the time that he was working on the final stages of *Les Demoiselles*: a figure-painting in a land-

11. *Nude.* Horta de Sant Joan, 1909. Oil on canvas. 92.5×63 cm. Dr. & Mrs. Israel Rosen Collection, Baltimore. Zervos 2*, 175.

12. *Sketch.* 1907. Sketchbook 14, page 5R. Musée Picasso, Paris.

13. *Sketch.* 1907. Sketchbook 13, page 7R.
Musée Picasso, Paris.

14. Photograph of Pedraforca.

scape setting. The figure-painting in question is *Les Moissonneurs* (cat. no. 174), and, tellingly, the connections between it and *Les Demoiselles* were direct.[11]

Pierre Daix has recorded Picasso's testimony that *Les Moissonneurs* was painted alongside *Les Demoiselles* in his Bateau-Lavoir studio.[12] He also records Picasso's statement that one of three closely related tree studies "was linked to work on *Les Moissonneurs*," implying that all three were, including the most highly abstracted, the large gouache in the Musée Picasso, Paris (cat. no. 177).[13] These are, as Daix remarks, explorations of "the spatial rhythm of the landscape," a rhythm which is highly developed in the painting, where trees, sky and hay bales form a setting for the figures obviously comparable with the draped setting for the prostitutes of *Les Demoiselles*. In fact, the abstracted arboreal landscape studies relate intringuingly to a series of studies for the parted curtains in two of the sketchbooks associated with the *Demoiselles*, both of which have been dated to the summer of 1907; the culminating months of Picasso's work on the large painting.[14] All but one of these curtain studies are without figures and explore the rhythms of the drapes alone. One in particular (fig. 12) strikingly echoes the large gouache arboreal abstraction (cat. no. 177), as if a common unifying rhythm is to be found in the confined space of the brothel and in the space articulated by trees outside.

Daix has also recorded Picasso's testimony that *Les Moissonneurs* is based on "memories of Gósol," the village in the Pyrenees where he stayed with Fernande Olivier between June and August 1906. Tellingly, the first of the two sketchbooks

with sketches of parted curtains contains a drawing of Josep Fontdevila, the innkeeper of the Cal Tampanada at Gósol, his scrawny naked body newly scrutinized in terms of Picasso's developing figuration for the *Demoiselles*[15] Moreover, the sketchbook which Picasso filled in between the two with the curtain sketches contains, in sequence, an ink wash mountain landscape evocative of "Pedraforca," the dramatic peak that dominates Gósol (figs. 13 & 14), a Fontdevila head, and a sheet of foot studies which may relate to the bare feet of the central figure in *Les Moissonneurs*.

The fact that Picasso could so directly transpose the rhythms of parted curtains into those of trees and landscape (or vice-versa) underlines the immediacy of the relationship between the insalubrious urban setting of the *Demoiselles*, in a brothel, and the idyllic rural setting of *Les Moissonneurs*, in landscape. Picasso never developed the idea almost hurriedly explored in *Les Moissonneurs* into something comparable in ambition to *Les Demoiselles*, but I believe it can be seen as an attempt to create a foil to *Les Demoiselles*, a landscape-based composition which, in stylistic and thematic terms, represented the very antithesis of the brothel painting.

On 29 May 1906 Apollinaire celebrated Picasso's departure for the South with a long comic poem; it ended with the image of the train departing "comme un pet vers le sol ibérique."[16] Paris is left behind in a cloud of foul air. Apollinaire's metaphor was apt. Gósol, for Picasso and Fernande, was to be the epitome of cleanliness. Fernande remembers above all "le bonheur" in the "simplicité de vie" there. She writes of a world "tout là-haut, dans un air d'une pureté incroyable", living "au milieu des êtres que la civilisation n'a pas touchés".[17] It was a place which, from the beginning of the Catalan "Excursionista" movement in the 1890s, had drawn urban people because of its wild mountain landscape and its remoteness.[18] Palau i Fabre has suggested that Picasso went there, as he had first gone to Horta de Ebro in 1898-99, not only to find a simple life but to restore his health, in this case to free himself from drugs.[19] Gósol stood for the "primitive" in the elemental sense, and at the same time for "purity" and health. Once there was illness in the village, Picasso left; a case of typhoid drove him away with Fernande in mid-August 1906.[20]

Palau i Fabre has further pointed to the existence of two strains in Picasso's Gósol production: one that was idealized in a Mediterranean, classicized sense, and one that was "realist." He comments on the "markedly telluric" character of the "realist" strain, a feeling of being "tied to the Earth's crust and to the soil which the artist treads."[21] It is to be associated with the depictions of Fontdevila and with Picasso's drawings and paintings of other local people, including those in the so-called "Carnet Catalan."[22] The "classical" strain, which relates to the current Mediterraneanism of such Catalan writers as Joan Maragall and Eugeni d'Ors, is especially well represented by those nudes most reminiscent of arcaic Greek "Kuoroi."[23] It emerges too, but imbued with a disturbing undercurrent of sexual energy, in two works which have often been considered preludes to the *Demoiselles*: the gouache *Trois Nus* and the oil *The Harem*.[24]

If the *Demoiselles* took up that convergence of idealising stylisation and disturbing sexuality found in *The Harem* and set it, charged with a new savagery, in an explicitly urban situation, *Les Moissonneurs*, is a reprise of that "realist" strain which went with the picturing of Gósol as a peasant idyll. Its brilliance of colour, which has led Daix to call it "the only truly Fauve work by Picasso,"[25] is an obvious attempt to recapture in Paris the dry heat of summer in the high Pyrenees. An antedote is offered to the libidinous degeneracy and dark, aggressive primitivisation of style of the *Demoiselles*. Where the parted curtains in the *Demoiselles* open into deep shadows, the rhythmic lines of the landscape in *Les Moissonneurs* frame the vivid pink of the mountains and the bright sunlit yellow of the hay piled in the wagon.

Just how "real" the scene Picasso depicted was is difficult to say, though cattle were pastured and hay was indeed made in the high summer at Gósol, even at over 1,420 meters.[26] Like the *Demoiselles, Les Moissonneurs* represents most likely a merger of memory and invention. Picasso's rare sorties into landscape in the winter and spring of late 1907 and early 1908 are still more obviously mergers of memory and invention; he did not work from any actual landscape motif again until August 1908. Increasingly, into the spring and early summer of 1908, Picasso concerned himself with bringing together the primitivised nude and the idealised remembered landscape of Gósol, until the elements of the two could be made literally to fuse, at least now and again.

Daix's phrase "the spatial rhythm of landscape" is apt certainly for the arboreal

studies of 1907 and for the landscape setting of *Les Moissonneurs*. Alongside the *Demoiselles* Picasso painted one tree picture which summed up his studies of such rhythms in purely landscape terms, *L'Arbre* (cat. no. 178). The key to the connection between the draped setting of the *Demoiselles* and the landscape setting of *Les Moissonneurs* was, as we have seen, rhythm, a rocking over-all rhythm set up by the curves of curtain folds and of trees or foliage. Between the Summer of 1907 and the later sping of 1908, while Braque pursued a flat over-all pictorial cohesion by means of Cézanne's "constructive stroke" and "passage," Picasso pursued a dynamic over-all cohesion by means of linear and surface rhythms. The Spaniard took as his central theme in this pursuit, the nude in landscape. Its most ambitious product was *Trois Femmes* (fig. 113), his sequel to the *Demoiselles*. The "savage" women of the brothel scene were taken outdoors into nature, a nature, as we have seen, that for Picasso was clean and pure. Significantly, Picasso's idealised memories of Gósol, and especially of the mountain "Pedraforca" seen between trees, played a role in these developments.

Two parallel groups of studies precede *Trois Femmes*; they were both the work of spring 1908.[27] One is limited to three nudes, and sets them in an indeterminate space which may be outdoors, binding them together with interlacing eliptical curves (fig. 15). The other adds the two figures from *L'Amitié*, and develops another compositional idea for a *Baigneuses* composition never completed; here the nudes are placed among trees, between which a deeper space is suggested, like that be-

tween the trees of *Les Moissonneurs* and the curtains of the *Demoiselles* (cat. no. 181). Where the studies for *Trois Femmes* are primarily linear, the *Baigneuses* studies introduce tonal modelling so that both figures and, at certain points, the spaces between them become solidified; there is a hint of low-relief faceting, but few hints of "passage." It is this solidification of form, with the introduction of both angular faceting and "passage" that marked out *Trois Femmes* itself; tellingly, both the *Baigneuses* subject and the repeated use of diagonal hatching in the *Baigneuses* studies invoke Cézanne. In the spring of 1908 the pursuit of rhythmic cohesion briefly coalesced with a Cézannian pursuit of cohesion in terms of faceted surfaces given definition by the "constructive stroke."

At the centre of the *Baigneuses* studies Picasso placed a nude with tilted, downward looking head and elbow raised high as if in the act of drying her back; she is adapted from the nude second from the left in the *Demoiselles*, who had already been adapted for *Nu à la draperie* at the end of 1907. The raised arm and elbow form a peak between the central arch of trees. It is here, at the focal point of the composition, that figure and landscape most completely fuse. Probably alongside the *Baigneuses* studies in the spring of 1908, Picasso produced an oil and a gouache landscape (with attendant studies), whose subject is "Pedraforca" seen between trees: a recollection of Gósol now nearly a year further distant than it had been when he painted *Les Moissonneurs* (fig. 16 & cat. no. 187).[28] In the *Baigneuses* studies the raised arm of the central nude literally stands in for the mountain; arm and

mountain substitute one another, just as almost a year later the table-top objects of Picasso's major still-life *Pain et Compotier sur une table* would substitute the figures of *The Carnival at the Bistro.* By lifting his nudes out of the brothel of the *Demoiselles* and placing them in nature, Picasso moved towards an idealisation of their sexuality. Their savagery, like that of Derain's primitivized bathers of 1907-1908, was identified with an elemental notion of the "natural" rather than with pathological aggression and degeneracy. That process, with its Nietzschian undertones,[29] is brought out particularly effectively by the role of Gósol (with its connotations of health and purity) in the *Baigneuses* studies, and above all by the metamorphic relationship between the central nude and "Pedraforca."

It may not be a coincidence that the fusion or confusion of figure and landscape created in the *Baigneuses* studies prefaced a brief, wholehearted return to landscape in Picasso's painting. At the end of May or the beginning of June 1908, Wiegels, a German painter who was a neighbour in the Bateau-Lavoir, killed himself after apparently overdosing on drugs. According to Fernande's *Souvenirs intimes*, the shock of the event abruptly stopped Picasso's and her own dabblings in drugs.[30] It was, she also recalled, to get over the effects of Wiegel's suicide that they decided to spend August in the country, this time not on the borders of Catalonia, but in the Île-de-France at the hamlet of La Rue-des-Bois not far from Creil.[31] Here Picasso painted several landscapes dominated by rich greens and browns strongly evocative of the fields and forests of the area (cat. no. 190 & 192), and when he returned to Paris followed

15. *Study for "Three women": the three nudes.* Paris, 1908. Indian ink and pencil. 32.6×25 cm. Musée Picasso, Paris. Zervos 26, 333.

16. *Landscape.* Paris, 1908. Oil on panel. 67×30 cm. Künstmuseum, Zurich. Private collection on loan. Zervos 2*, 72.

them up with one or two landscapes based on a merger of memory and invention much as he had in the case of Gósol (cat. no. 199 & 193). Once again, the restoration of health was a crucial element in the decision to escape Paris. This time, landscape as such figured much more prominently than it had in Picasso's escape to Gósol; the place in its own right made a direct and immediate impression on his work. And the depth of that impression is demonstrated by the fact that one of the landscapes painted from memory, *Le Pont* (cat. no. 199), was not to be produced until nearly a year later and yet synthesizes with particular cogency the views across the Oise to be found not far from La Rue-des-Bois, for instance the view across the river towards the church at Rieux.

For William Rubin, the landscapes of La Rue-des-Bois compared with those Braque painted at L'Estaque the same summer are retrograde; they lack the conflation of near and far made possible by "passage," which he argues entered Picasso's work fully only after he saw Braque's L'Estaque pictures in the autumn, most importantly with the completion of *Trois Femmes*. Rubin, however, concedes that one of the La Rue-des-Bois landscapes, *Paysage* (cat. no. 190), possesses nonetheless "an extraordinary plastic energy."[32] My contention is that this "energy" (present too, for instance, in *Maison et arbres* (cat. no. 192) follows from the fusion of figure-painting and landscape pursued especially in the *Baigneuses* studies of spring 1908. An all-over tension is achieved between the angular and the cursive, while the solidification of every feature (sky included) and their treatment as if in low relief gives the effect of a sur-

face under pressure at every point, a surface close to bursting. The substantiality and vigour of Picasso's figure-painting (throughout the previous twelve-to-eighteen months always concerned with wrapping the figure up in its environment) is transmuted into landscape. Perhaps the clearest demonstration of this is, ironically, a work whose "plastic energy" might be questioned, the landscape idyll *Paysage avec deux figures* (cat. no. 193), one of the works probably painted after his return to Paris, a picture in which the figures are rather too obviously absorbed into the solidified rhythms of a wooded setting. It is here too that the association between Picasso's passing involvement with landscape and his periodic need for a restorative imagery of idealised purity is clearest. Returning to the La Rue-des-Bois landscapes themselves it is, of course, significant in this respect that they invoke the "Douanier" Rousseau more plainly than Cézanne, for the notion of naïvety, which by 1908 was indelibly associated with Rousseau, had carried strong connotations of purity and innocence from the 19th Century.[33]

Braque's use of "passage" in the L'Estaque landscapes of 1908 was indeed peculiar to him at that date, but it is worth interjecting that some of those paintings hold in tension competing angular and cursive rhythms in a way that may owe something to Picasso's figure-and-landscape studies of spring 1908, which were, of course, produced just before Braque's departure for the Midi.[34] In this at least Picasso took the lead.

There can be no doubt, however, that when Picasso fully grasped the potential of

"passage," his work moved (almost literally) onto another plane: its tendency to spatial condensation, plastic fullness and flatness was consolidated, and at the same time the angular rhythms of faceting displaced altogether the cursive rhythms of the *Demoiselles* and *Les Moissonneurs*. The Cézannism of the Horta de Sant Joan landscapes of the next summer is, as I have already stated, indisputable, and so is their significance for Picasso's development as a Cubist in 1910-1911. Yet, when viewed with the precedents of Gósol and La Rue-des-Bois in mind (especially the earlier figure-in-landscape explorations), it becomes possible to pick out other themes in Picasso's Horta painting as important too, in particular the way in which a landscape imagery of elemental purity becomes central once again, and the way in which the portraits of Fernande interact with the landscapes.

I have mentioned already Horta's role in the restoration of Picasso's health in 1898-1899; this is an episode most fully explored in John Richardson's biography.[35] In 1909, he arrived there early in June, and writing to Leo and Gertrude Stein in July dwelt on his love of the region and on the splendour of the journey through the mountains from Tortosa (only possible on muleback), comparing it to the Overland Route of the Far West.[36] Horta was, in a sense, the model for Gósol in Picasso's scheme of things: the essential "primitive" place, utterly remote, clean and "pure." Like Gósol, it too was dominated by a rugged peak, that of Santa Bàrbara, which he painted soon after his arrival (fig. 24). The degree to which he integrated with the town's inhabitants through the family of his

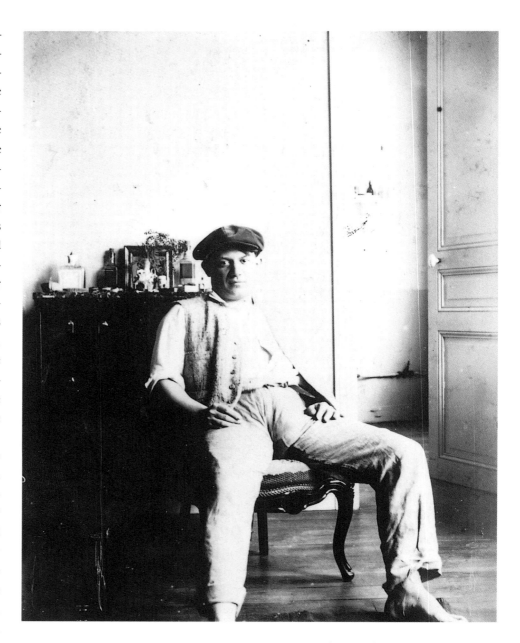

17. Photographic self-portrait of Picasso at Horta de Sant Joan, 1909. Picasso Archives, Paris.

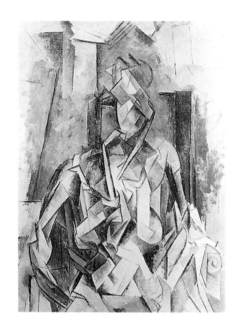

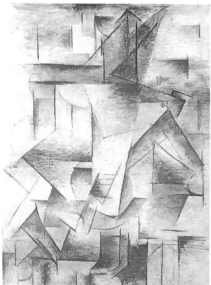

18. *Woman seated in an armchair.* Paris, 1910. Oil on canvas. 100×73 cm. Musée National d'Art Moderne, Centre Georges Pompidou, Paris. Zervos 2*, 200.

19. *The guitarist.* Cadaqués, 1910. Oil on canvas. 100×73 cm. Musée National d'Art Moderne, Centre Georges Pompidou, Paris. Gift of M. & Mme. André Lefèvre. Zervos 2*, 200.

old friend Manuel Pallarès is obvious from the photographs he took of them;[37] the degree to which he relaxed there is suggested by a self-portrait photograph that survives from that summer (fig. 17). He may have manipulated the motifs he painted there, but the fact that he photographed them himself (fig. 28) and made a point of sending the Steins the photographs demonstrates how directly he believed his landscapes had come out of the place. The stripped down pictorial elements of the landscapes, so patently based as they are on the architecture of Horta and on its rocky environs, function on one level as a metaphor of the basic, the elemental in its most fundamental sense. For all the complexity of their relations (especially in pictorial space), their prime characteristic is simplicity.

Again writing from Horta to the Steins, Picasso mentioned starting two landscapes and two figures (24 June 1909); he added that it was "always the same thing."[38] The remark implies that, whether he painted landscape or the figure at Horta, essentially what he painted was, for him, the same; and it is certainly true that the jagged rhythms and crystalline faceting of the Horta landscapes were adapted wholesale to his painting of the figure there, as was his version of "passage" to the relationship between the figure and its setting. In the case of paintings like *Femme assise* (fig. 10), the figure-subject is kept separate from landscape, but in four recorded cases Fernande is placed in landscape settings (fig. 11).[39] Especially in the half-length nudes, angular faceting, staccato rhythms and "passage" encourage a fusion of figure and mountain landscape which can obviously

be read as an amplification of Pedraforca's fusion with the central bather in the *Baigneuses* studies of 1908. Picasso's pictorial language has changed, but not his readiness to switch between figure and landscape subjects as if they could fuse into a single substance and as if, ultimately, one could be transmuted into the other.

In September 1909, just after Picasso's return to Paris he held a little exhibition of his Horta work in his studio.[40] Gertrude and Leo Stein, prepared by Picasso's letters and his photographs of the motifs, bought both *Maisons sur la colline* and *Le Réservoir* (cat. no. 204 & fig. 27). Not only Gertrude Stein, but Picasso himself treated the Horta landscapes as a crucial stage in his development. It is, therefore, at first puzzling to find that once again landscape almost vanished as a genre from Picasso's painting throughout the period of Cubism's first youth and maturity, between the end of 1909 and 1912, returning in only a very few, highly atypical pictures (cat. no. 209, fig. 121). In my view, the key to this lies in the very ease with which Picasso had learned to move between the genres of landscape and figure-painting between 1907 and 1909 (as he had also between still-life and figure-painting), and especially in the way that the metamorphic relationship between the genres made it possible to give one the characteristics of the other, indeed in many senses to collapse the distinctions between them altogether. After 1909, what Picasso learned from landscape and the places in which he worked became an indissoluble part of both his still-life and his figure-painting; landscape as such, it could be said, ceased to matter. The genre of landscape was absorbed into the *tableau-*

objet, and, with this process, the theme of health and purity that had gone with Picasso's painting of landscape was set on one side.

In the winter of 1909-1910 he painted just one landscape, the view from his new apartment on the Boulevard Clichy up the hill to Sacré-Coeur. Significantly, it is relatively unworked (cat. no. 209). It is striking too that the placing of the dome and the complex piling up of architectural forms below closely follows the placing of heads and upper torsos, as well as their treatment, in the figure-paintings of this phase, *Femme dans un fauteuil* of spring 1910, for instance (fig. 18). The next summer Picasso again sought out somewhere as remote as possible from the city: he painted at Cadaqués, then a fishing village which, like Horta, could only be reached on muleback. With him at Cadaqués for some of the time was Braque's companion when he painted the park at Carrière-Saint-Denis the previous autumn, André Derain. There, as Kahnweiler was the first to establish, the opening up of things into their settings made possible by faceting and "passage" became a fact in Picasso's work, with implications of enormous importance for his and Braque's later Cubist painting. I would add that, with this final opening up of the contours of things, both the metamorphic and the architectural were given an amplified role. Daix and Rosselet attribute four figure-paintings, three still-lives and just two landscapes to Picasso's summer in Cadaqués (figs. 121 & 19).[41] The two landscapes are both based on views of the harbour with fishing-boats, but, again as in Horta, it is the architecture of the village, its tightly clustered buildings piled up

around the church as Derain's view recalls for us (fig. 20), that dominated the construction of the Cadaqués paintings. The figure-paintings in particular are obviously infused with its structures, and the ochres of the rocky volcanic landscape around the town penetrate many of the spaces not only in the figure-paintings but in the still-lives too. There is a sense in which *all* the Cadaqués paintings are intensely experienced responses to Cadaqués as a very particular place.

Writing on Cubism, from as early as 1912, has stressed the "conceptual" above the "perceptual."[42] Picasso's engagement with landscape between 1907 and 1910 was infrequent, but it was, I have tried to argue, important; it brings out especially well the way his work oscillated between "conceptual" and "perceptual" poles, the "conceptual" desire to manipulate, to invent and to construct continually in tension with experience and with his "perceptual" memories of the places in which he painted, mostly in the summer. I do not believe that either Picasso's or Braque's Hermetic Cubist work of 1910-1912 ever simply replaced the "perceptual" by the "conceptual," and it is perhaps a measure of this that the space of the Hermetic paintings, even where they are relatively easily read as still-lives or figures (fig. 21), can also be read in the expansive terms of landscape.[43] These shadowy studio and café interiors, with their strong urban atmosphere, can seem after all not so very far from the clean, open-air places to which Picasso periodically still escaped from Paris to restore his energies.

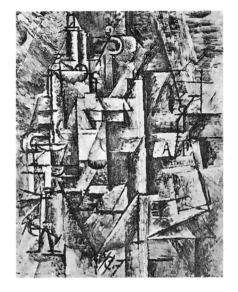

21. *Bottles, newspaper and glasses.* Paris, 1911-1912. Oil on paper glued to canvas. 64.4×49.5 cm. The Solomon R. Guggenheim Museum, New York. Zervos 2*, 299.

20. André Dérain: *Cadaqués.* 1910. Oil on canvas. 60.5×73 cm. Künstmuseum. Basle.

NOTES

1. Letter of 23 July 1915, cited in Barbara Wadsworth, *Edward Wadsworth. A Painter's Life* (Salisbury, 1989) p. 68.

2. Examples are *Cleckheaton* (1914) and *Bradford: View of a Town* (1914). For a discussion of Wadsworth's woodcuts, which takes account of this, see Richard Cork, *Vorticism and Abstract Art in the First Machine Age*, Vol. 2, *Synthesis and Decline* (London, 1976), p. 351ff.

3. Gertrude Stein, *Picasso* (Paris, 1939), p. 71.

4. For their movements that summer and autumn, see Judith Cousins (with the collaboration of Pierre Daix), 'Documentary Chronology', in William Rubin, *Picasso and Braque. Pioneering Cubism* (Museum of Modern Art, New York, 1989), pp. 361-4.

5. Anne Baldassari, *Picasso Photographe, 1901-1916* (Musée Picasso, Paris, 1994), pp. 164-175.

6. I refer to my work for the catalogue raisonné to be published in 1995 by Philip Wilson, *The European Avant-gardes: Art in France and Western Europe, c1904-c1945, from the Thyssen-Bornemisza Collection*. My evidence for this conclusion will be set out in the entry for *Le Parc de Carrières-Saint-Denis*.

7. Most notably in the case of *Le Port en Normandie* of spring 1909.

8. The leading exception is perhaps Leo Steinberg, though his focus has been almost exclusively on Picasso.

9. William Rubin, 'Cézannisme and the Beginnings of Cubism', in Rubin (ed.), *Cézanne. The Late Work* (Museum of Modern Art, New York, 1977).

10. This is one key facet of Rubin's argument in his 1977 essay. Ibid.

11. My work on *Les Moissonneurs* in relation to *Les Demoiselles d'Avignon* has been occasioned by the researching of the catalogue raisonné mentioned in note 6, above. A fuller account of the painting will appear there.

12. Pierre Daix and Joan Rosselet, *Picasso: The Cubist Years 1907-1916*, a catalogue raisonné of the pantings and related works (London, 1979), p. 201, no. 55.

13. Ibid, p. 201, nos. 56, 57 & 58.

14. These sketchbooks are Carnets 12 and 14, following Brigitte Léal's numbering; she dates them to the end of June or the beginning of July and to July 1907 respectively. See *Les Demoiselles d'Avignon*, Vol. 1, Musée Picasso (Paris) 1988, pp. 273-5 & 291-3. C12 1R, 2R, 3R, 4R, 5R, 6R, 7R, 8R, 9R, 10R, 11R; & C14 1R, 2R, 3R, 4R, 5R, 6R.

15. Ibid, p. 275, C12 12R.

16. Letter 10, Apollinaire to Picasso, in Pierre Caizergues & Hélène Seckel (eds.), *Picasso-Apollinaire, Correspondance* (Paris, 1992), p. 45.

17. Fernande Olivier, *Souvenirs intimes* (Paris, 1988), p. 214.

18. See Josep Sindreu, *Gósol* (Gósol, 1988), p. 37.

19. Palau i Fabre, 'The Gold of Gósol', in *Picasso 1905-1906, From the Rose Period to the Ochres of Gósol*, Museu Picasso (Barcelona, 1992), p. 75.

20. See Olivier (1988), op. cit., p. 216.

21. Palau i Fabre (1992), op. cit., p. 81.

22. For the 'Carnet Catalan', see Zervos XXII, 359, 360, 361, 262, 364, 365, 367, 368.

23. Especially the painting *Deux Adolescents*.

24. Zervos I, 340 & 321.

25. Daix & Rosselet (1979), op. cit., p. 201, no. 55.

26. See Sindreu (1988), op. cit., pp. 170-1.

27. They are dated to spring 1908 both in Daix Rosselet (1979), op. cit, p. 213, and in Michèle Richet, *Dessins, Aquarelles, Gouaches, Pastels: Musée Picasso, Catalogue sommaire des collections* (Paris, 1987), pp. 82-5.

28. One of the attendant studies is Carnet 106, no. 71, M. P. 1863/71, in the Musée Picasso, Paris. Daix and Rosselet date the large gouache in Berne and the oil, spring-summer 1908, *before* the departure from Paris for La Rue-des-Bois in August. See Daix & Rosselet (1979), op. cit., pp. 224-5, nos. 182 & 183. Rubin places the gouache in August in La Rue-des-Bois. See Rubin (1989), op. cit., p. 99. Because of the relationship between these imaginary landscapes and the *Baigneuses* studies discussed above, I would date them spring-summer 1908.

29. Leighten associates Picasso's pursuit of rural idylls in the early years of the Century with political Anarchism and with Nietszche. See Patricia Leighten, *Reordering the Universe: Picasso and Anarchism, 1897-1914* (Princeton, N. J., 1989), pp. 42-3. *Les Demoiselles d'Avignon* has, of course, often been associated with the Dionysiac in Nietzsche.

30. Fernande Olivier (1988), op. cit., p. 228.

31. Fernande Olivier, *Picasso et ses amis* (Paris, 1933), p. 148.

32. Rubin (1977), op. cit., p. 182.

33. Again it is Rubin who has especially stressed the relevance of Henri "Le Douanier" Rousseau to the La Rue-des-Bois Landscapes. See Ibid.

34. I would single out especially Braque's *La Forêt, L'Estaque*, July-August 1908, in the Statens Museum for Kunst, Copenhagen.

35. John Richardson (with the collaboration of Marilyn McCully), *A Life of Picasso*, Vol. I: *1881-1906* (London, 1991), chapter 7.

36. The letter, dated unspecifically to July, is quoted in English by Cousins, in Rubin (1989), op. cit., p. 361.

37. See Baldassari (1994), op. cit., pp. 156-163.

38. The letter, dated 24 June 1909, is quoted in English by Cousins, in Rubin (1988), op. cit., p. 361.

39. The others are Daix & Rosselet (1979), op. cit., nos. 294, 301 & 302.

40. For the evidence of this, see Cousins in Rubin (1989), op. cit., p. 363.

41. These are Daix & Rosselet (1979), op. cit., nos. 355-363.

42. The agenda for this was set in Maurice Raynal's article 'Conception et vision', *Gil Blas* (29 August 1912).

43. A perusal of Daix and Rosselet's catalogue suggests that they have positioned the few landscapes of 1911-12 to bring out, by the juxtaposition of reproductions, their highly ambiguous relationship with other genres, both figure and still-life. See Daix & Rosselet (1979), op. cit., especially, *Le Pont Neuf*, 1911 (no. 401) and *Paysage, Céret*, 1911 (no. 419).

The Second Stay at Horta de Ebro

Pierre Daix

If on his first return to Spain after settling in Paris Picasso had set off on an adventure by going to Gósol in northern Catalonia, his trip in the spring of 1909 was totally different as his destination was Horta de Ebro, Pallarès's village. He had wonderful memories of it from his convalescence in 1898. It was the first time for the city-dweller as he was by then that he had stayed in the country, on a farm. A complete change of atmosphere among nature and ancestral life as compared to the academic constraints that he had borne so ill in Madrid: "everything I know, I learnt in Pallarès's village" he would later say over and over again. In Horta he had to learn to speak Catalan day and night, which enabled him to shed the Andalusian image, hardly an advantage in that part of Spain. For the first time ever he experienced the pleasures of youth, escapades that he would never ever forget. He painted everything he saw, just as he felt like painting it; Santa Bàrbara mountain, the old houses in the village, carts in the courtyard, a procession, an ass. Freedom. He had kept a small oil painting of Santa Bàrbara mountain by his friend Pallarès which was still hanging in his living room in Mougins when he died.

He obviously had these memories at the back of his mind in 1909 when he decided to regain strength at his friend Pallarès's house. He had reached a crucial stage in his Cubism, going from rather abrupt to softer geometric abstraction, which he also created by producing the first fragmentation of shape into facets and by reassessing pictorial space in line with Cézanne's teachings. He had come an extraordinarily long way since his first trip to Spain—to Gósol in 1906—and his *Les Demoiselles d'Avignon* and, very probably, he needed to distance himself a little from his "mountain ties" with Braque.

To begin with, let's recall what we know about this stay which lasted approximately three months.

The works and the problems related to the stay

Barcelona, where he arrived in May 1909, is an important period because Picasso does some quite abstract pen drawings there, reinterpreting what he sees from his hotel bedroom (Zervos 6, 1083, 1085, 1087, 1091-1093, see cat. no. 200-203). Three of them are still at the Musée Picasso in Paris,

two of which, Zervos 6, 1092 and 1093, bear witness to his innovation of adding some palm trees to create a contrast between the curves of their leaves and the cubes of the houses (probably a recollection of the effect obtained by Matisse in *Blue nude, a reminder of Biskra*). Later he said: "That was when everything got started [...] That was when I understood just how far I could go." (Daix 1987, p.102). Soon after, he painted a Cézanne-like *Portrait of Pallarès*, simplified by the clarity of light brush strokes.

His departure for Horta was delayed because of Fernande's illness which he let Alice Toklas know about on 31 May. Through Fernande's letters to Gertrude Stein, we know that they finally set off on 5 June. She gave their address on 15 June, saying that they had been there for ten days and, on 24 June, Pablo wrote saying that he had begun two landscapes and two figures. Stylistically, as confirmed by *Braque and Picasso pioneering Cubism* in New York in 1989, they were two landscapes of *Santa Bàrbara mountain* that he had already painted in 1898, though by this time he was able to apply what he had learnt from Cézanne's *Sainte-Victoire mountain* to this theme. As far as the figures are concerned, as he said in a letter to Gertrude "I'm still doing exactly the same", they must be the *Athlete*, destroyed by fire at the Sao Paolo Museum, whose composition is similar to the *Woman with a flower vase*, one of the first portraits of Fernande in Horta.

Even though he managed to "smash" Fernande's face, it was certainly not aggressive or sensual simply because it was there, just as it was for *Santa Bàrbara mountain* or the *Bottle of Anís del Mono*—the most

widely-drunk aperitif in that part of Spain—on which he based a still-life painting exalting the geometry of the glass decoration. That was the painting that would predominate as a new force in the making, exempt from all rules, only obeying the softening of geometrical compositions. The continuity of this force in all the Horta works is even more striking because that summer everything seemed to coincide to upset Picasso's creative solitude.

Firstly, Fernande's illness took a turn for the worst and delayed, as Stein wrote in July, his trip to Madrid and Toledo. The doctor finally authorised Fernande's trip and Picasso was overjoyed. Unfortunately for him, Fernande could not go. She sent a letter of desperation to Gertrude: "He's too selfish to understand [...] that he's mostly to blame for my being like this all winter. He has upset me completely. It's all to do with my nerves, I'm sure [...]."

It is quite descriptive and gives a good idea of the tension existing between them. Pablo, consumed by his painting, leaves Fernande completely alone, cut off from everything, in a village much less remote than Gósol, but also less interesting from a touristic point of view. In particular, the sensual spark between them in 1906 had long gone.

The second source of upset was the Barcelona revolt. Due to disasters caused by the Rif war of 9 July, the government had called up the reserves but only in Catalonia. That quickly turned into a generalised uprising which, at one and the same time, was anti-militarist, anti-clerical and a demonstration of social unrest. To give some idea of the degree of repression, 175 workers were killed, 2,000 people were ar-

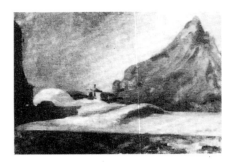

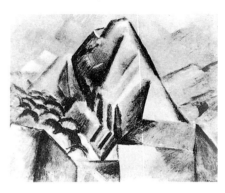

22. Manuel Pallarès: *Mountain at Horta.* Oil on canvas. Present whereabouts unknown.

23. *Santa Bàrbara mountain.* Horta de Sant Joan, 1909. Oil on canvas. 54×65 cm. Present whereabouts unknown. Zervos 2*, 151.

rested and the same number of refugees had fled to France. In a letter to Stein, Picasso wrote: "We have been in Spain in the grip of revolution". The letter probably dates from around 20 July, the *Tragic week* occurred mid-month.

In fact, Pablo kept working without a break. The longer the stay lasted, the more luminous the palette became, a play on greys with metallic-like brilliance, pale ochres, pale greens. He took a lot of photos of themes (see below) before exalting them as masterfully as Cézanne had glorified Gardanne. He set about inverting perspective, and purged the geometry of *Houses on the hill*, *Reservoir* and even more of the *Factory*, in which he once again places imaginary palm trees, as he did in his pen drawings of Barcelona.

The facet treatment he gave to the compositions of Fernande's bust and face followed exactly the same procedure, which extended to merging her nude body with the mountain in the background to make it more exciting, prior to creating the masterpiece *Nude in an armchair*, an admirable piece of work because of its monumentality, the extreme, abstract elegance of the geometrization in which Fernande is no longer an identifiable pretext.

A letter from Fernande to Gertrude in August says that Picasso felt badly about avoiding going to his sister's wedding, but that they were going to spend a fortnight in Barcelona. On 28 August they still had not left. Picasso asked the Steins if they had received the photographs of four of his paintings: "One of these days, I'll send you the others of the countryside and my paintings. I still don't know when I'll be coming back to Paris. I'm still doing some studies

and working quite regularly. Kahnweiler is coming here at the beginning of September. That annoys me. Perhaps I'll go and see Pichot in Cadaqués on my way back to Paris." (Rubin 1990, Chronologie, 351-352)

In fact, he cut short his return and only spent a few days in Barcelona—maybe because of the worsening violence and repression which led to the execution of Francisco Ferrer in mid-October, a militant member of the anarchist movement accused of being morally responsible for the uprising. His haste to return to Paris made him forget about any idea of stopping over in Cadaqués or Céret, which also had the advantage of cutting short his meeting with Kahnweiler.

He clearly cannot wait to show the Steins the successes of his stay. By 13 September, he wrote to them from Paris: "My dear friends, my paintings will not be mounted until the day after tomorrow. You are invited to the reception on Wednesday afternoon." It was a great success. "The essential element, his treatment given to the houses, was totally Spanish and consequently very typical of Picasso [...] When they were hung on the wall, everyone naturally began to protest [...] Gertrude Stein displayed the photographs and, in fact, as she rightly said: 'the paintings could only be accused of being an overly photographic copy of reality'. That moment marked the beginning of Cubism". (Stein 1934, p. 98)

Landscapes and Cubism

Landscapes were, as Gertrude Stein had noticed, the original element of Picasso's

stay in Horta and his major concern at that time, and the facet treatment he had given to the compositions of Fernande's bust and face would finish by being the qualitative leap produced after returning to Paris by the *Shattered head* sculpture of Fernande. In order to evaluate that, it is necessary to go back to the summer of 1908 when Picasso had experimented with imaginary compositions of forests in the background of his numerous paintings of women bathers before his return to La Rue-des-Bois. From there had come highly geometrized and simplified landscapes which went beyond the theme (see *Little house in a garden*), though with no resemblance. Braque in Estaque had performed some similar geometrizations and simplifications in his landscapes which had given rise to talk about *petits cubes* and given birth to the term Cubism although they were different from Picasso's in that they contained even freer recompositions of the theme and graduations of colours, the reprise of Cézannian *passages*, communication between different levels that gave them a certain atmosphere. On seeing them, Picasso had carried out some revisions evidenced by his *Landscape with two figures, Little house and trees* or the forest in the background of the *Dryad*, although the work was in fact done in a studio.

Of course, he had furthered his Cézannism by graduating the colours and rhythms emphasizing those of the theme, *passages*, in the numerous figures of the final versions of *Three women, Woman bather nude on the seashore*, and in still-life paintings. However, he almost certainly wanted to return to landscapes that on this occasion would be his own and not as foreign

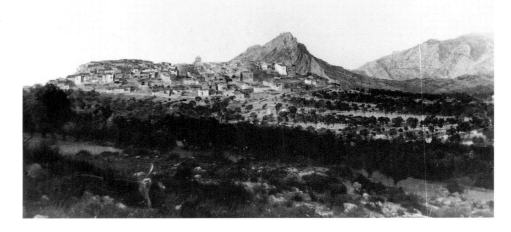

25. Photograph of Horta de Sant Joan, 1909.
8.5×11 cm. Picasso Archives, Paris.

26. Photograph of Horta de Sant Joan, 1909.
23×29 cm. Picasso Archives, Paris.

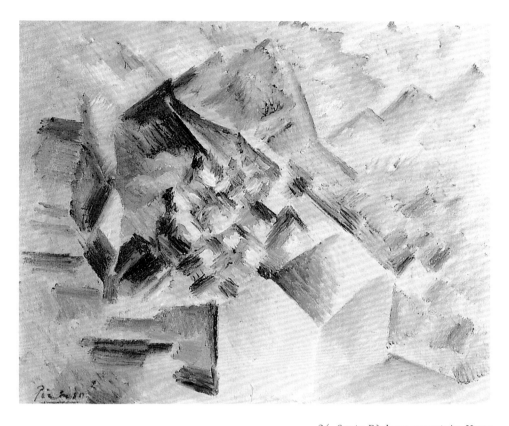

24. *Santa Bàrbara mountain*. Horta de Sant Joan, 1909. Oil on canvas. 39×47.3 cm. Joseph Pullitzer, Jr., St Louis. Not catalogued by Zervos.

as the majestic leafy forest of Halatte, so typical of wetter, northern France which surrounded La Rue-des-Bois. Besides, Horta offered Mediterranean landscapes similar to those treated by Cézanne.

The dual treatment he gave to Santa Barbara mountain is indicative of his ambition. First (fig. 23) he geometrizes, simplifies and glorifies it. Then (fig. 24) he retrieves it, adjusting the geometrized composition of the vegetation and multiplying the *passages* in the vibrant touches which are found again even in the sky. Picasso had taken, as we know from the exhibition *Picasso photographe* (Musée Picasso, Paris 1994) two photographs of Santa Bàrbara mountain (figs. 25 and 26). He changed his viewpoint, which must have allowed him to get a stereoscopic comparison and, when comparing the photographs and the two canvases, it seems very apparent that they were not taken as a verification of the paintings, but as a model, already in two dimensions, and abstracted from the theme. The resemblance did not concern him, though the rigour of their transformations did. His painting departs from the formal relationships that the theme suggests to him, and, as he liked to say, "it does something else to it". It is that something else that the photographs of the places unquestionably allowed him to see better.

Analysis of the archives has in fact shown, contrary to what was generally known, that he took a great many photographs of Horta de Ebro, and made an extensive photographic record of the people and even of himself and Fernande. Of major importance, to begin with, are the photographs of landscapes or portions of landscapes that he painted. Up to now we

had known about the photograph reproduced by Gertrude Stein. Anne Baldassari, curator and author of the catalogue, has re-assembled two photographs of the place where the *Reservoir* canvas was situated and the general view of *Houses on the hill*. The group of shots confirms that Picasso, as he had done in his preparatory drawings in Barcelona, did not take them to demonstrate the realistic equivalence of the theme as Gertrude Stein had so prematurely believed. In fact the opposite was the case, he had taken them to verify what painting was capable of, not just to simplify by arriving at the essence, but to modify it altogether. That was when he really saw how far he could go.

He not only magnified the formal contrasts—the curve of the reservoir against the straight lines of the houses, the angles of the different roofs—but also provoked some astonishing contrasts of perspective, even going as far as different inversions of perspective which were conjugated to produce an impressive touch of monumentality in height, just as Cézanne had done with his Gardanne landscapes. The theme was no longer the source of landscape painted: that was simply a springboard for the magic painting that the painter could extract from it. Geometry was no longer the reduction of forms, but a way to overcome the natural contours to extract the structure which speaks to the imagination. The dialogue with external reality was certainly there, like the memories contained in a photograph, though it was not that dialogue that dictated what the painter had to do; the painter was in charge.

There are no photographs of the *Factory* and the location has not been found.

28. Photograph of the pond at Horta de Sant Joan, 1909. 23×29 cm. Picasso Archives, Paris.

30. Photograph of the Horta de Sant Joan studio with the works *The Horta factory* and *The pond at Horta*, 1909. Picasso Archives, Paris.

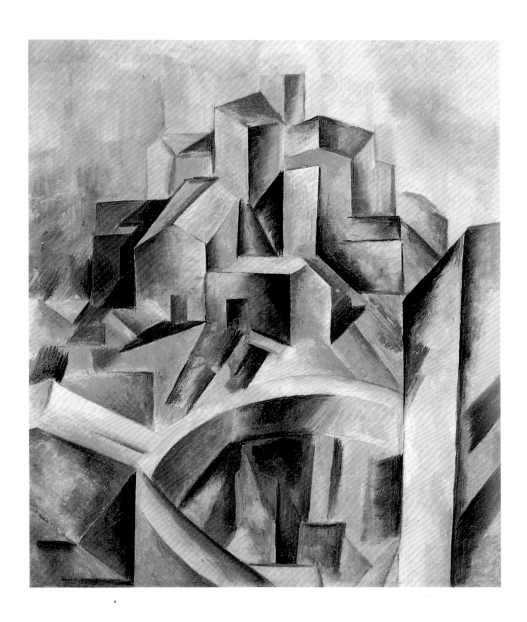

27. *The pond at Horta.* Horta de Sant Joan, 1909.
Oil on canvas. 60×50 cm.
Mr. & Mrs. David Rockefeller Collection, New York.
Zervos 2*, 157.

It is very likely that employing the light of Horta, Picasso produced—as if it were one of Cézanne's imaginary landscapes, like *Factory near Cengle mount* which he could have seen at Vollard's house— an imaginary landscape, perfect in some way, where the geometric contrasts, with the aid of a square chimney dominating the contrasts of angles and inversions of perspective, come up against stylised palm trees— the palm trees that he had already dreamt of in Barcelona. *Factory* is thus the most Cubist landscape of Horta, in the sense that in Picasso's work, as Apollinaire already knew, Cubism is first and foremost a conceptual art.

Some ten shots reveal the comparisons that Picasso made between his own canvases in setting them out against a wall. Only one was previously known about. We are now able to understand the reasons for this *accrochage*. (Baldassari 1994, 132-136, 140, 142, 143, 145): not only the comparison of the paintings among themselves, from which Picasso stands aside, but also, as can be seen in photographs 143 and 145, some meticulously prepared superimposi-

tions of paintings. This resulted in what Anne Baldassari rightly called "completely new visual phenomena [...] A complex and ambiguous structure, transparent planes, dispersion of elements [...] Here we can find some of the principles which will be seen in the development of analytical Cubism up to its ultimate stage." (Baldassari 1994, p.194)

Here, it is possible to perceive the extent to which Picasso's working holiday in Horta was really much more important than was previously thought, in terms of his awareness of the unprecedented possibilities of what today is known as his Cubism, or "how far he could go" as he once said. In this unprecedented exploration, of the possibilities of which Picasso was still unaware, the landscapes acted as a control over the relationship with the visual source. This control was necessary for him because, if he rejected the obstacles and the reductions of realism, abstraction—in the abstract art sense— would run the risk of becoming decorative. It is in that sense that we can say that his Cubism really did begin at Horta de Ebro.

29. Photograph of the pond at Horta de Sant Joan, 1909. 23×29 cm. Picasso Archives, Paris.

BOYHOOD LANDSCAPES. MÁLAGA. CORUNNA

Anna Fàbregas

The environment which surrounded Pablo Ruiz Picasso throughout his childhood was, without doubt, a determining influence in the development of his vocation. His father—José Ruiz Blasco—painter, teacher of drawing at the "San Telmo" School of Arts and Crafts in Málaga and curator of the Municipal Museum, introduced his son to painting and drawing at a very early age.

The period before 1895—the year in which the Ruiz Picasso family came to Barcelona—is, certainly, little-known, and even less are the years of the family's residence in Málaga (1881-1891). The works from this childhood period[1] are few and have in common that they are pencil drawings, but in spite of a certain childishness, there is a markedly academic trend. However, in Málaga, Picasso not only draws everything, showing a great capacity for observation and a spontaneity of line, but he also paints. We know of two oil paintings on wood from this time (1889-1890): *The little yellow picador* (Z. 6, 3) and *The port of Málaga* (fig. 31). This last represents a view of the port of that city—a subject frequently used by the generation of painters in Málaga known as "marinista" (seascape painters) which included among others Martínez de la Vega, Ocón, Alvarado, Verdugo Landi, etc.,—with a ship, a boat, two sailing boats and a building in the background. Josep Palau i Fabre describes this painting as a view of the port "with the lighthouse, a rowing boat, and an anchored ship"[2], but it seems that we can say that the construction which appears is not the lighthouse but the customs house of Málaga and the tower of the cathedral, with a weathercock in the upper part.

In spite of the errors in perspective and the disproportion of the masses of the elements portrayed—defects appropriate to a painter who is learning—the brushstrokes charged with paint, full and spontaneous, the young Picasso's use of colour (the bluish background of the horizon) and the attempt to reflect the variations of light in the objects represented allow us to speak, as does Palau, of painting incipient and not of childish painting[3]. Picasso knew of the Málaga school of painting made up of Antonio Muñoz Degrain, José Moreno Carbonero, Joaquin Martínez de la Vega, etc., among others, but to look for non-paternal influences in Picasso's work in these years is premature, although this work presents a certain similarity with a painting by Emilio Ocón, a painter who had a decisive influence in the formation of the "marinista" school. This similarity

would be explained by the fact that José Ruiz Blasco not only painted doves, lilacs and still-lifes—which were his favourite subjects—but also religious subjects and landscapes. We know that he did very good copies of the contemporary Málaga painters, among them *View of the port of Málaga* by Emilio Ocón, which he copied in 1887 without making any personal changes and acknowledging that it was a copy (fig. 32). We have to assume, then, that Picasso would have seen this picture.

According to Picasso himself and the critic Palau, *The port of Málaga* is the painter's earliest work. Palau showed a black and white photograph of it to Picasso who said, "That has to be the first thing I did, the oldest of all ..."[4]. To insist that this painting is the oldest is, of course, exaggerated, but we can certainly accept that it is one of the earliest because, as Penrose points out, "in a visual sense, Picasso's memory is extraordinarily clear in everything regarding the things, important or trivial, which made an impression on his imagination"[5].

The termination of the post of curator at the Municipal Museum in Málaga at the end of 1890 created certain financial problems for the Ruiz Picasso family, and they decided to move to Corunna where José Ruiz had been appointed professor of "*figurative drawing*" and "*decorative drawing*" at the Fine Arts School on 4th April 1891. We do not know for sure the date of the journey. Sabartés[6] and Daix[7] coincide in saying that it took place in the middle of September 1891, while Palau[8] thinks that it was October of that year. What is certain is that it was a journey by ship through the Straits of Gibraltar, coasting round the Atlantic seaboard—practically without stops—to Vigo, where because of a bad storm José Ruiz decided to disembark and continue to Corunna by train.

It was at Corunna that Picasso's artistic vocation became clear. The boy drew and painted a great deal and helped his father with his paintings of doves. In spite of the fact that Picasso did not matriculate at the Fine Arts School, without doubt because of his age, he began the courses for the Baccalaureate at the Da Guarda Institute. "What I most enjoyed at the Da Guarda Institute was when, as a bad student, they sent me to the cells. Because in the Da Guarda Institute there were cells. They were a place with whitewashed walls and a bench to sit on. I liked it when they sent me there because I took a pad of paper and drew without stopping. So the punishments were a treat for me and I think I even created situations when the teachers had to punish me. I was left alone, with nobody to bother me, drawing, drawing, drawing ... I would have liked to go on drawing all my life, without stopping ... (...) In the Da Guarda Institute I must have had to do a lot of drawings and stories, which were my exercises for the exams. I suppose that at the end of the courses they destroyed the students' exercise books. It would be curious to find them now and see my development at that time"[9].

The start of artistic studies at the Fine Arts School meant an important step in the training of the young Picasso. For the school year 1892-1893 he was entered in the class of "*Decorative drawing*" given by his father; the following course he took the "*Figurative drawing*" class and in 1894 he went to the classes of "*Figurative drawing (plaster section)*", "*Plaster copy and painting*" and "*Copying from nature*". But Picasso's

31. *The port of Málaga.* Málaga, 1889-1890. Oil on panel. 18×24 cm. Private collection, Málaga. Palau 1980, no. 3.

32. Copy made by José Ruiz Blasco, Picasso's father, of *View of the port of Málaga* by Emilio Ocón.

33. *Santa Margarita mountain at Corunna.* Corunna, 1895. Oil on wood. 9.7×17.3 cm. Heirs of Picasso. Zervos 6, 38.

production is not limited to this academic activity which follows the norms of the 19th century pictorial tradition. He himself says that "In Galicia I began to take initiatives. I was learning by myself; I was copying perfectly the academic features of my father's drawings. But I took initiatives too, of course I did"[10].

House in the country (cat. no. 1), done about 1893, signed, curiously, on the two lower corners of the canvas[11], is an example of the initiatives which he took. The composition is characterized by the lack of domination of perspective, a fault that Picasso would overcome—a year later—thanks to the disciplines of the teaching at the Fine Arts School which gave him a progressive command of technical resources (squaring the form, line and shading). On the other hand, the use of rose, yellow and white tones gave a new treatment to the colour and light of the composition. This fact is surprising because we know that José Ruiz did not use light paint. The use of these tonalities can be associated with the influence that Isidoro Brocos had over the young Picasso. Brocos, professor at the Fine Arts School at Corunna since 1880, had been to Paris and to Rome and knew, therefore, of the pictorial and sculptural trends of recent years and the beginnings of impressionism. It is possible, then, that he talked to Picasso of the currents which were dominant in Paris and that the young artist decided to use colours that were not very common in the painting done at Corunna at the end of the century, where the artistic environment was more provincial and academic than in other cities like Málaga or Barcelona.

At Corunna, Picasso already preferred making notes from nature to the academic drawings that he had to do with great care and attention, following the stereotyped and impersonal instructions proper to the Fine Arts School. Out of class, Pablo let himself be carried away by fantasy and invention in drawing, on loose sheets of paper or in albums, all the figures and objects which surrounded him, with a notable spirit of observation and great vivacity in his pencil. These drawings allowed him to explore new compositions demonstrating, in relation to the academic exercises, a greater freedom of style and interpretation.

The first album known from Corunna, dated 1894, contains drawings in pencil and/or ink—done between 1st February and 20th September—of various subjects: male and female figures, portraits of the artist's mother and father, landscapes, horses, dogs and cattle, among others. The first drawings in this album are some views of the surroundings of Corunna which, according to Palau[12] could have been suggested by his parents saying to Pablo that they would serve as a record for the future. These drawings are on the odd-numbered pages in the album to "make them easy to see"[13], while on the page opposite appears only the name of the place in the drawing: "Churro-vendor's house in the New road" (cat. no. 2), "The road to Santa Margarita" (cat. no. 3), "From Riazor" (cat. nos. 4-6). But, as Palau also points out, "soon the order is broken, pencil alternates with pen, and the sense of the pages is taken, at times, in reverse, that is, upside-down with respect to the beginning"[14].

Palau and John Richardson[15] agree in pointing out that the fact that the pages of the album are signed, dated and with the places identified, is a first attempt by the young

35. Various notes. Corunna, 1894-1895.
Lead pencil on paper. 19.5×13.5 cm.
MPB 111.510 R.

34. The Tower of Hercules as a "Toffee
Tower" on a page from a manuscript
newspaper. Corunna, 16th September
1894. Indian ink on paper. Zervos 21, 10.

artist to define and fix his work at a specific time and place. According to Palau, Picasso is already aware of doing something that can be preserved and will be permanent[16].

The fairly small size of this album (19.5×13.5 cm) meant that Picasso could carry it in his pocket and so could put in it, at any moment, what he found around him. Drawings like *Principal facade of a house in the outskirts of Corunna* (cat. no. 2), *Facade of a house in the outskirts of Corunna* (cat. no. 3) or *Boat* (cat. no. 5) have an air of being done quickly and spontaneously, revealing Picasso's curiosity about everything he saw. However, in spite of the rapidity of execution and the air of simplification that characterizes the drawings in this album, the young Picasso captures the situations and places which are familiar to him and puts them down in a true and essential way without going into recording unnecessary details. So that *Farmhouse* (cat. no. 4) shows a Galician country house with a child crying outside the door, piles of hay at the side and a small cart and a hen in front of the house, thus capturing the atmosphere of the Galician countryside. In all the drawings a naturalistic intention predominates, with sure and firm lines—in spite of some small doubts or waverings—which show the intensity of his learning at the Fine Arts School. The freshness of scenes such as *Afternoon in the country* (cat. no. 7) and the ability of synthesis in drawing in *Road* (cat. no. 6), *Hamlet in Galicia* (cat. no. 8) and *Country house and porch* (cat. no. 9) make these works evidence, in relation to the first works done in Málaga, of a clear transition to a more secure and firm phase in form and spatial construction.

Pierre Cabanne[17] points out the similarity of line, observation and subject in these drawings by Picasso with an album by Isidoro Brocos which is preserved in the Picasso

Museum in Barcelona[18], to the point of considering that the drawings of the one could almost be confused with those of the other. In addition, Miguel González Garcés[19] also says that by subject, style and manner of capturing the form there is an intense relationship between these drawings by Picasso and those of Brocos, a fact that makes us think that the two went together around the various places in Corunna. We cannot confirm this supposition, but what certainly is true is that Brocos was always recalled affectionately by Picasso and is the only teacher whose pupil he acknowledges that he was.

The drawings of the Corunna albums have, as Cirlot says[20], a more conservative character than other productions of that time. From the years 1894 and 1895 we have some canvases and panels done in oils, of small dimensions (10×15 cm approx.)[21], in which Picasso shows not only the command which he had attained in this technique, but also the progress he had made in composition. The subjects represented are mostly country scenes and landscapes, but we must mention especially—for their meticulous detail and exactness—the two interior scenes of the residence of Ramón Pérez Costales, politician and doctor, a great friend of the Ruiz Picasso family[22].

Colour and technique are the principal elements of these freely conceived panels. In *Santa Margarita mountain* (fig. 33) the chromatic richness and the freedom of brushwork give the work a great expressive quality. *Houses on the outskirts* (cat. no. 10) shows us the facades of two rural Galician houses. The colour is subdued; burnt tones dominate, ochres and earthy reds. The brushwork, thick and pasty, shows a true freedom. Picasso only allows two incidental details. In one, the laundry hung out on the left side of the work allows a play of contrast of white with the more muted colours of the rest of the painting. In the other, the facades of the houses are only varied by a tiny addition: Picasso has put in the numbers of the houses on the doors, as he did in *Principal facade of a house in the outskirts of Corunna* (cat. no. 2) and *Facade of a house in the outskirts of Corunna* (cat. no. 3).

Besides the landscapes which show the surroundings of Corunna, Picasso painted various seascapes, characterized by a great spontaneity and agility in the execution. In *Seascape: The beach at Orzan* (cat. no. 12) it seems that what interested him most was to get the effect produced by the waves when they broke against the rocks. The sailing boat that appears on the horizon is the only object introduced, following, perhaps by intuition, the lines of his academic training[23].

Seascape (cat. no. 13) shows a coastal landscape with some rocks and with the Tower of Hercules[24]. Picasso explained that he liked this spot on the Corunna coast and that "looking for aesthetic sensations, I escaped from the house and spent hours by the Tower of Hercules making notes (...) Even although it was raining buckets I would always go to the Tower of Hercules to paint or make notes"[25]. Sabartés[26] believes that the Tower of Hercules was undoubtedly a constant topic of conversation in Picasso's family because the artist himself said that his father called it the "Toffee Tower". It is no surprise, then, that Picasso portrays this monument on a double page of the handwritten news-sheet *La Coruña*[27], dated 16th September 1894, with a caption below the draw-

ing which says "sketch for a toffee tower" (fig. 34). The Picasso Museum in Barcelona also has another album of drawings done in Corunna between 1894 and 1895 (MPB 110.923). One of the drawings (fig. 35) contains various notes of male and female figures, a dog and a sketch of doves. Behind, a landscape with a tower can be made out. The outline of this building makes us think that this also could be the Tower of Hercules.

Picasso's production is impressive not only for its abundance and for the diversity of its inspiration, but also because he uses a variety of techniques (pencil, pen, watercolour, inks, oil, ...) and various surfaces, the fruit, without doubt, of his curiosity in trying out new things. From the years at Corunna works are preserved on very different surfaces: tambourine leather, ceramic plates, fans, ... *Hay cart* (cat. no. 11) which represents a landscape with a hay cart pulled by oxen and driven by a carter, is an oil on silk, the two pieces of which correspond to the two sides of a Chinese fan. In this work, like the landscapes on panel, the young Picasso is not interested in miniaturist work but in the capturing of reality and achieving the atmosphere of local customs. A proof of this fact is that the carter is only traced with some very sketchy black brushstrokes, while on the other hand, the contrast in the thick brushwork of the hay cart or of the mountain with the smoothness of the background shows the command which Picasso already had of this technique.

Various reasons made the Ruiz Picasso family decide to leave Corunna. The death of.Conchita Ruiz Picasso, the artist's sister, the cold and rainy climate, the lack of friends for José Ruiz and the little regard which his colleagues seemed to have for the work of his son Pablo, were enough reasons for making a change. A Royal Order of 17th March 1895 authorized an exchange between José Ruiz Blasco and Román Navarro García, a Galician and teacher of drawing who wished to leave Barcelona and go home to Corunna. Before leaving Corunna, however, José Ruiz definitively gave up painting and passed all his brushes on to his son with the full knowledge of a man who recognizes in his son a finer painter than himself. "Then he gave me his paints and his brushes, and never painted again"[28].

The Ruiz Picasso family left Corunna in 1895 to go to Málaga, where they spent the summer. After the hard voyage by ship when they had gone to Corunna, they decided to go by train, via Monforte and León. However, they stopped in Madrid[29] so that José Ruiz could take his son to the Prado for the first time. "The only thing that compensated for the move was the journey. I loved travelling and changing atmospheres. As we went through Madrid, I had the opportunity to come face to face, for the first time, with my idols. 'They were waiting for me' in the Prado Museum"[30].

From this stop in Madrid we know of copies of two Velázquez faces[31], in an album which is kept in the Picasso Museum in Barcelona (MPB 110.913), and a landscape (fig. 36), an authentic study of nature, although we do not know the exact location. The spatial distribution of the elements portrayed, the security of brushwork and the skill in observation which are found in this composition make it a clear example of the abilities that Picasso had gained from the teaching of the Fine Arts School, the guidance of

36. *Madrid landscape.* Madrid, 1895.
Oil on canvas. 27×39 cm. Zervos 21, 50.

his father and his own intuition. The shaggy kind of nature shown in this landscape—an indication that it is still summer—confirms, according to Palau, his thesis that Picasso left Corunna during the spring of 1895.

After spending the summer at Málaga in his uncle Salvador's house, the Ruiz Picasso family took ship in September for Barcelona, taking advantage, certainly, of the reductions in the fare that Salvador, Health Director of the port of Málaga, was able to obtain for them. Richardson[33] says that the small freighter "Cabo Roca" took 8 days for the voyage to Barcelona, stopping at the coastal towns of Cartagena, Alicante and Valencia. Picasso made notes on panels or canvas of these stops and also of a cabin in the ship and the captain and his dog[34].

These landscapes—a prelude to his production two years later—are true studies of light and colour. *The rock at Cartagena* (cat. no. 14) shows thick brushwork, full and spontaneous, far from any academicism. The sense of volume dominates and the perspective and the essential nature of the objects portrayed, to the detriment of detail and richness of colour. *Seascape* (cat. no. 15), which represents a port with moored vessels, is structured in three very clear horizontal bands: the sea in the foreground, with a thick and sure brushstroke which does not cover all the surface; the vessels and the port with some house merely sketched in quickly, and the sky in the third band. The free brushwork and the play of shade and light are an evident forerunner of the more abstract seascapes that he did in the following year.

Seascape (cat. no. 16) represents a view of the Valencia coast and is a study in the colours of the sea and the warm golden light of the Mediterranean. In the background is a jetty with some moored vessels, which could be there so that the work is not quite so sketchy. In *Seascape* (cat. no. 17), however, there are no concrete references, only a range of mountains on the horizon.

These seascapes by Picasso show a certain influence from Emilio Ocón. Daix[35] says that during the summertime when the Ruiz Picasso family was in Málaga, Picasso saw works by his father's friends. It is possible, then, that he saw paintings by Emilio Ocón, who was appointed professor at the "San Telmo" School of Arts and Crafts and who, as a disciple of Carlos de Häes[36] enjoyed a high reputation as a seascape painter.

NOTES

1. We use the word *boyhood* because it seems the most suitable in view of Picasso's age at these times, although in some remarks made to Hélène Parmelin, Picasso said that "One curious thing (...) is that I never drew as a child. Never. Not even when I was very small" (Parmelin, 1968, p. 80). Besides, in some remarks to Brassai, Picasso said that "My first drawings could never have been in an exhibition of children's drawings ... They had scarcely even the clumsy attemps of a child nor the imagination ... I overcame that stage of marvellous vision rapidly ... I did academic drawings. Their meticulousness, their exactness, appall me ..." (Brassai, 1966, p. 113).

2. Palau, 1980, p. 35.

3. Palau, 1980, p. 35.

4. Palau, 1980, p. 35.

5. Penrose, 1981, p. 22.

6. Sabartés, 1953, p. 13.

7. Daix, 1977, p. 13.

8. Palau, 1980, p. 37.

9. Olano, 1971, pp. 61-62.

10. Olano, 1971, p. 62.

11. In the lower left corner can be read *P. Ruiz*, but it seems that Picasso has erased the signature and then signed the work in the lower right corner.

12. Palau, 1980, p. 48.

13. Palau, 1980, p. 48.

14. Palau, 1980, p. 48.

15. Richardson, 1991, p. 48.

16. Palau, 1980, p. 48.

17. Cabanne, 1982, p. 49.

18. MPB 112.705.

19. González Garcés, 1985, p. 39.

20. Cirlot, 1972, pp. 10-11.

21. Small wood panels had already been used by Mariano Fortuny, and Bernardo Farrándiz, who was director of the San Telmo School of Fine Arts at Málaga and under the influence of the former, also adopted their use.

22. *Two rooms* (MPB 110.193) and *Alcove* (MPB 110.194).

23. Subirana, 1979, p. 32.

24. The Tower of Hercules, originally erected by Phoenicians, reconstructed in the time of Trajan and restored on various occasions later, is an essential feature of the Corunna coastline and gives it a characteristic outline.

25. Olano, 1971, pp. 52 and 56.

26. Sabartés, 1953, P. 37.

27. *La Coruña* and *Azul y Blanco* were the two little papers which Picasso created at Corunna, in which he recorded the environment and the events of the town, accompanied by personal commentaries. He sent them to the Málaga family instead of letters. John Richardson says that Picasso also did a small diary with the name *Torre de Hércules*, but that this did not survive (1991, p. 46).

28. Sabartés, 1953, p. 38.

29. We do not know the length of this stopover in Madrid. According to Palau (1980, p. 72) Picasso himself told him that it was no longer than one day. Besides, John Richardson (1991, p. 57) says that they were there for a few hours between trains. Sabartés (1953, p. 243) and Cirlot (1972, p. 19), however, say that the stop in Madrid lasted a few days.

30. Olano, 1971, p. 65.

31. *Copy of "The clown Calabacillas" by Velázquez* (MPB 111.170R) and *Copy of "The Vallecas child" by Velázquez* (MPB 111.172R).

32. Palau, 1980, p. 72.

33. Richardson, 1991, p. 61.

34. *Cabin in the ship* (MPB 110.209) and *Seated man with a dog* (MPB 110.144 R).

35. Daix, 1994, p. 7.

36. The important development which Carlos de Häes contributed to landscape painting—with the introduction of open air painting—had a considerable influence on the painters in Málaga, who, with this stimulus, began to study nature.

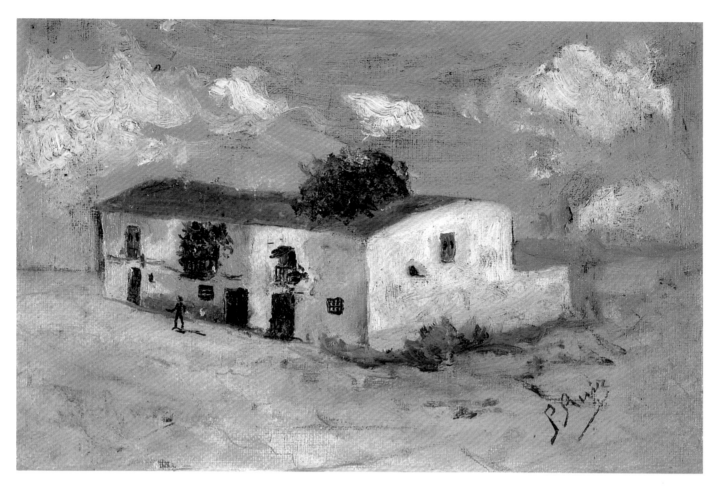

1. HOUSE IN THE COUNTRY
Corunna, c. 1893
Oil on canvas, 15.8×23 cm
Museu Picasso, Barcelona

2. PRINCIPAL FACADE OF A HOUSE IN THE OUTSKIRTS OF CORUNNA
Corunna, 1894
Lead pencil on paper, 13.5×19.5 cm
Museu Picasso, Barcelona

4. FARMHOUSE
Corunna, 1894
Lead pencil on paper, 13.5×19.5 cm
Museu Picasso, Barcelona

3. FACADE OF A HOUSE IN THE OUTSKIRTS OF CORUNNA
Corunna, 1894, Lead pencil on paper 13.5×19.5 cm
Museu Picasso, Barcelona

5. BOAT
Corunna, 1894
Lead pencil on paper, 13.5×19.5 cm
Museu Picasso, Barcelona

6. ROAD
Corunna, 1894
Lead pencil on paper, 13.5×19.5 cm
Museu Picasso, Barcelona

7. AFTERNOON IN THE COUNTRY
Corunna, 1894
Lead pencil on paper, 13.5×19.5 cm
Museu Picasso, Barcelona

8. HAMLET IN GALICIA
Corunna, 1894
Lead pencil on paper, 13.5×19.5 cm
Museu Picasso, Barcelona

10. Houses on the Outskirts
Corunna, April 1895
Oil on wood, 10×15.6 cm
Museu Picasso, Barcelona

9. Country House and Porch
Corunna, 1894
Lead pencil on paper, 13.5×19.5 cm
Museu Picasso, Barcelona

11. HAY CART
Corunna, c. 1895
Oil on silk cloth, 17.5 cm Ø
Museu Picasso, Barcelona

12. SEASCAPE: THE BEACH AT ORZAN
Corunna, c.1895
Oil on canvas, 10×17.8 cm
Museu Picasso, Barcelona

13. SEASCAPE
Corunna, c. 1895
Oil on panel, 10.3×15.4 cm
Museu Picasso, Barcelona

14. THE ROCK AT CARTAGENA
Cartagena, September 1895
Oil on canvas, 28×34.7 cm
Museu Picasso, Barcelona

15. SEASCAPE
Alicante, September 1895
Oil on panel, 9.9×15.4 cm
Museu Picasso, Barcelona

16. SEASCAPE
Valencia, September 1895
Oil on panel, 10.1×15.5 cm
Museu Picasso, Barcelona

17. SEASCAPE
Malaga-Barcelona voyage, 1895
Oil on panel, 10.1×15.5 cm
Museu Picasso, Barcelona

The Consolidation of the Skill

M. Teresa Ocaña

Barcelona: the city. October 1895-1897

During the first years that the Ruiz Picasso family lived in Barcelona their lives were centred in the heart of the old city, which until 1859, just a few years before they arrived, had been enclosed by walls. However, the old part of the city, and in particular the family home from October 1895 to October 1896 at 5 carrer Llauder, was very close to the sea. Everywhere that the artist lived or worked from 1895, the year that he arrived in Barcelona, until 1904, the year of his definitive departure to Paris, was located in the centre of the old city.

For this reason the landscape work done by Picasso then was centred on these familiar surroundings. He converted them into a depiction of Barcelona encompassing his youthful experiments.

The first urban landscapes in Barcelona show a continuity with respect to those of Corunna, tied in with the more recent seascapes made during the sea voyage from Málaga to Barcelona in September 1895. These are landscapes, in general, of small format and with a spontaneous line, which in this first moment capture the city as with a photographic lens, and which in reality are a reinforcement and broadening of his academic work, dominated by a concentration on drawing from nature and sculptural and pictorial models.

This constant landscaping exercise, parallel to his determination to demonstrate his command of portraiture, which was another facet of the young man's artistic training, was not at any odds with the guidance which his father, José Ruiz Blasco, gave him at this time. José Ruiz, a teacher at La Llotja Fine Arts Academy, kept up the insistence that his son should follow the steps that would enable him to become an important figure within the ambit of official painting. Picasso at this time was undergoing the standard training, reinforced by the presence of his father, who set out in a very definite fashion the steps which his son must follow to reach a proper level of achievement in the profession. Thus, it is clear that his age and the pressure exercised on him by the Academy and the family circle did not allow him at this time to launch himself into innovative experiments, far from the routine teaching which was imparted at La Llotja, and from

the extreme conservatism of the world in which his father moved. Nevertheless, outside these official areas, new currents and innovations were stirring in the city, in which the cultivation of the landscape genre had a special preponderance. It is significant that the more restless students and those anxious to create a new type of painting—among whom were good young artists such as J. Torres García, J. Mir, J. Nonell, X. Gosé, J. Sunyer and Oleguer Junyent—had abandoned the Llotja Fine Arts Academy a year before the arrival of Picasso in Barcelona, through disagreement with the obsolete systems which governed it. An exception to this was such a dedicated figure as Modest Urgell, who was appointed professor of landscape in 1896.

Three drawings (cat. nos. 20-22) are evidence of his strictly academic landscape exercises, indeed, the first of them bears the rubber stamp of the Provincial Fine Arts Academy of Barcelona. However, between the last quarter of 1895 and the summer of 1896, the city, this time Barcelona, is the new scenario, the immediate object of the artist's attention: the sea, the Barceloneta beach, the Ciutadella park, the roofs of the city and some churches, were turned into subjects which, as Cirlot notes, allowed him "a process of constant broadening of form, a tendency which would continue in the following years".[1]

From the end of 1895 and during 1896 there was a notable development in his conception of landscape. Two of the first urban landscapes which are known from his arrival in Barcelona are two views of the same roof: *Landscape* (cat. no. 18), dated Barcelona October 1896, and *Rooftop parapet and water tank* (cat. no. 19). Both are views of the roofs of Los Porxos d'en Xifré (fig. 37)[2], seen from his home in carrer Llauder, the beginning of a series of attempts and studies of gradations and chromatic combinations which he would develop throughout the whole of that year's course. In *Landscape* the mountain of Montjuic can be seen in the background, with, on the back of the little panel, a sketched nocturnal note of "full moon", which he was to deal with also in *Full moon from a roof* (cat. no. 26), possibly done in 1896.

The Ciutadella was another of the places frequented by Picasso due to its proximity to carrer Llauder, and also because it was very close to La Llotja Arts Academy. There are two sketches *The Lake in the Ciutadella Park* (Z 6, 28) (fig. 38) and the *Waterfall in the Ciutadella Park* (Z 6, 27) (fig. 39) probably done shortly after his arrival in Barcelona, in which the meticulousness of the line and the fidelity of the modelling of the image show already the gifts of an experienced sketcher.

The false mountains of Montserrat (cat. nos. 27-29), reproduced in the Ciutadella Park, and of which the young artist made three versions, where the brushwork is already much smoother, could have been done at the turn of the year from 1895 to 1896.

It is without doubt through these little panels in which the artist tried to escape from the rigidity of the Llotja, while working on painting in the open air, that during 1896 some definite changes were brought about in his style; the line gives way to thicker brushwork, losing its precision in favour of an increase in aesthetic effects which provoke new sensations in the viewer. We can include here a series of views from the roofs

37. Old photograph of the "Porxos d'en Xifré" in the Pla del Palau, Barcelona.

of Barcelona (cat. no. 30), a continuation of the first two undertaken on his arrival in Barcelona.

An impact which made an impression on his development as a landscape artist was to see the works which some of the artists who had abandoned the Llotja before he arrived there presented in the Exhibition of Fine Arts and Industrial Arts, 1896. This to a degree constituted a strengthening of the painting with intense tonalities carried out by the group of artists of the "Colla de Safrà", a name given to them by the domination of the yellowish tones they used. This was the first exhibition in which Picasso took part, with a painting on a religious subject, *The first communion*[3]. In spite of being a work of challenging dimensions to the young artist, it was another step in the plan that his father had laid down for his career. It is not surprising, then, that the artistic uncertainties of the young man were encouraged by the contemplation of paintings such as *The rector's garden* and *The orange seller* by Mir, or the *Morning sun* by Isidre Nonell, among others, which opened a window to the most innovative currents and a glance towards impressionism.

It would be bold for us to assert that in the landscapes of these first moments there was a before and an after regarding the Fine Arts Exhibition, or that he found the impulse which the Academy was denying him at this point of time. The young artist threw himself into the creation of a series of little landscapes in which overflowing light, yellow tonalities and bold brushstrokes prevailed: *Woodland* (cat. no. 31), *Landscape with trees* (cat. no. 32) and *Stall in the park* (cat. no. 33). The first two have been placed up until now in Málaga, by Cirlot and by the Museum, but Palau disagrees and sets them

in Barcelona[4]. These small panels include partial aspects of the Ciutadella park, proba-
bly done before he left for Málaga in the spring of that year, and were the likely prelude
to the landscape explosion which developed during the summer in Barcelona. *Wood-
land* is bold in its composition, in which the stridencies of the tonalities and the rapid
and fluid brushwork achieve an evocation of the charged atmosphere of a summer day.
The landscape with figures *Stall in the park* is also freed from contained brushwork
towards a command of shading while recalling to us a daily scene in 19th century Barce-
lona, the typical stalls which used to be set up in the squares and parks and which other
artists also had previously recorded.

Málaga 1896 the anti-academy

Picasso arrived in Málaga in the summer of 1896 with the intention of opening
new paths in his career. His most recent paintings done in Barcelona were the prelude
to the outbreak through landscape painting which marked his first distancing from the
official teaching. He still did not have the necessary base nor probably the maturity of
judgment to understand the movement that he was trying to establish in opposition to
the academy, but his intuition and the more advanced atmosphere which he had known
in Barcelona stimulated him to attempt the practice of more free painting. At this time
it is probable that he knew only by reference the more avant-garde currents which were
dominating Europe, but the fact is that during these weeks spent in Málaga, landscape,
whether the principal part of the composition or as background, became the centre of
his pictorial production for that summer. We must not overlook, however, that in this
same period he painted the *Portrait of Aunt Pepa*, the most important portrait in this stage
of his development.

In the predomination of landscape work during these months, various factors clear-
ly influenced him. In the first place, the majority of the landscapes painted that summer
were of the Montes of Málaga and their surroundings, and correspond to the visit of the
family Ruiz Picasso to the farm which Pablo's godparents, Juan Nipomuceno Blasco Bar-
roso and his wife, María de los Remedios Alarcón Herrera, had in Llanes[5]; in the second
place, the landscapes with luminous tonalities initiated in Barcelona found an auspicious
culture medium in these days spent in country places; and lastly, the tedium and restric-
tions which the academic teaching imposed on him found at this moment for the first
time, and as would happen again in 1898 in Horta, an auspicious atmosphere for him
to try to escape from the imposed disciplines, but without, however, presenting a open
challenge to the paternal guidance. Certainly there was an unconscious test of rebellion
against the Academy in these landscapes, but his youth still did not allow him to reach
the true creative dimension which would launch him into more innovative investigations.

An exhaustive examination of the surroundings of Málaga resulted in a series of
oils, most of them small, in which the artist caught the momentary impressions and the

38. *The lake in the Ciutadella Park.*
Barcelona, 1895. Lead pencil on grey
paper. 19.9×27.5 cm. Heirs of Picasso.
Zervos 6, 28.

39. *Waterfall in the Ciutadella Park.*
Barcelona, 1895. Lead pencil on grey
paper. 18.2×31.4 cm. Heirs of Picasso.
Zervos 6, 27.

diversity of forest land which surrounded the farm. The most ambitious work, which is outstanding for its audacity and scale among the landscapes of this period, is *Mountain landscape* (cat. no. 35), for which there were preparatory works. Among these the most important are *Study for mountain landscape* (cat. no. 36), smaller but very close in its composition to the definitive canvas[6], *Landscape with thickets* (cat. no. 37) and *Landscape* (cat. no. 38).

The bold and rich brushwork, the absence of the line in favour of a daring combination of lively tonalities, the luminosity of the atmosphere, turn this painting into the first serious effort to establish his artistic personality.

The study of a series of small landscapes prepared on little panels, which he habitually used at this time, has made us bring together a series of landscapes which up till now have been thought to belong to Barcelona, but clearly are dealing with different aspects of the Montes of Málaga[7] and of the surroundings of the property of the Blasco Alarcón family in Llanes.

The views of *Landscape with mountains* until now located in Barcelona (cat. no. 39) and *Landscape of a mountain* (cat. no. 40), dated in Málaga 1896, refer us to two canvases probably from the following year, *Mountainous landscape* (cat. nos. 41, 42) which constitute two versions of the same place, the subject of a detailed study in this catalogue. The Montes of Málaga serve as a background for a series of compositions (cat. nos. 43-50)[8] with a lively and spontaneous brush in which the artist is seeking to attain a result to summarize all these studies in which the surroundings of Llanes are exhaustively analysed. The diverse vegetation, the thickets and the agaves, the luminous gradations of the different moments of the day, constitute a rich and detailed exercise by which the artist directed his steps towards achieving an important landscape which would consolidate all his work in this genre.

Within this exercise on Llanes and its surroundings there is a small oil *Landscape* (cat. no. 51), rapid in its conception and with a smooth brush, up till now unlocated, which we believe could be a schematic view of the Llanes farm itself with the Montes of Málaga in the background.

In parallel to these small panels our attention is drawn to some pages of an album (dated June 1896), scenes which must have been preparatory to the execution of a work of an historical nature, with the Montes of Málaga again as a background, and which must have been in parallel with the exercises referred to. We refer to a page in an album of drawings (MPB 110.918), with the date "Barcelona June 1896" on one of the initial pages. The page in question, *Two people in the country* (cat. no. 52) contains what could be a sketch for an historical religious scene, perhaps related with *The Martyrdom of St Sebastian* (of which there are also several sketches in this same album),[9] and which has also some preparatory sketches[10]. The fact that the landscape in which this painting is made is that of the Montes of Málaga leads us to believe that the album was probably begun in June in Barcelona and continued in Málaga during the same summer. In relation with this historical scene are found *Mountain landscape* (cat. no. 53) and *Trees with a hill beyond* (cat. no. 54).

40. Emilio Ocón Rivas:
The port of Málaga, 1900.

There are two oil works from this summer of a Port, which we think are two views of the Port of Málaga from the fishermen's wharf[11] and not that of Barcelona. The first *The port* (cat. no. 55)[12] and the second (cat. no. 56) show some houses at the edge of the sea, traditionally placed in Barcelona. Eugenio Chicano, the director of the Picasso Foundation in Málaga, advises me that this view probably was also of Málaga and that the painter Ocón had a little oil very similar to it. (fig. 40).

I have willingly left on one side the two small panels named *Peasants in the country* (cat. no. 57) and *Fisherman and children* (cat. no. 58), and *Village house* (cat. no. 59), also executed in Málaga, as they are studied in the article on The Montes of Málaga.

A seascape (cat. no. 60) dated in Cartagena in July 1896 and a portrait of a woman (MPB 110.141) in August 1896 are the only indication that we have that he left Málaga for Barcelona at the end of July.

The seascapes 1895-1896. Early abstraction

We have wanted to place a special emphasis on the seascapes which Picasso made during this first year of his stay in Barcelona, through considering that they are an exercise by which the artist researched new technical possibilities, unconsciously opening new horizons for him which accelerate the successive links of his formative years.

The cities in which he lived during his childhood and adolescence had a common denominator: all of them were seaports. So it is unsurprising that, as we have seen in Málaga and Corunna, maritime scenes are a primordial theme in the landscape painting carried out in this early period.

The seascapes proliferate, especially in 1896, and what in the beginning constituted a new extension of previous works, like the sketches made on ship during his voyage from Málaga to Barcelona and, naturally, views of different aspects of the coast of Corunna, become an essential exercise which allowed him new advances in the command of form through subtle combinations of chromatic ranges, finally reduced in many of these little panels to essentially chromatic studies.

Apart from a sketch of a port scene (cat. no. 61) which forms part of the drawing notebook, in which some of the drawings are dated October 1895, the first small panel which we record is dated February 1896, *Seascape with sailing boat* (cat. no. 62), which to some extent began the distancing of the previous realism in the search for new sensations which find in *Seascape* (cat. no. 63) and in the water colour *Seascape* (cat. no. 64), a certain inclination to the ethereal vapour of seascapes by Whistler, who was fairly well known in Catalan artistic circles. The notes of horizons in which the sea joins its chromatic gradations with the sky of the background became an exhaustive exercise. Colour controls the little compositions and marks the guideline for a sequence of studies in which the realism of *The wave* (cat. no. 65) and *Seascape* (cat. no. 66) give way gradually to an abstraction of forms, denoting the artist's progressive command in the combination of rose, blue and green tonalities, so achieving the great object of representing "the sea", in spite of the small size of these little panels and fabrics. *Seascape* (cat. no. 67) dated Barcelona 1896, *Man seated on a beach* (cat. no. 68) are two views taken from the Barceloneta beach which bring together this chromatic variety and the gradual disappearance of line, culminating in *Seascape* (cat. no. 69), *Horizon* (cat. no. 70) and *Sunset* (cat. no. 71) dated already in December 1896.

Along with these notes in which the chromatic nuances cancel any other concept, there are landscapes with views of the Barceloneta beach, in which the treatment is very different. *Barceloneta beach* (cat. no. 72) synthesizes the chromatic experiments carried out in *Seascape* (cat. no. 67) and in *Man seated on a beach* (cat. no. 68), the diagonal which establishes the division between the beach and the sea marks the conjugation between the realism of the beach—with the horses and the particular buildings of this part of the Barcelona sea shore—and the indefinition of the middle ground, where the coastal landscape and the maritime horizon are inscribed within his constant exercise at this moment, making the line lose ground to the chromatic impressions[13].

This panorama of Barceloneta is completed by a dreamlike vision of dusk in the port (cat. no. 73) in which the shading prevails over the line, leading us to date it between the second half of 1896 and the winter of 1897[14], and a painting entitled by the artist himself *Barceloneta* and dated in January 1897 (cat. no. 74), in which the rapid and schematic brushwork, and the mastery of colour in the configuration of the forms reveal to us the advances which the artist had made outside the Llotja.

It is difficult to be exact over the chronology of this landscape exercise which Picasso undertook. What we are sure of, as we have already seen, is that during 1896 the landscape acquired a capital importance and that together with the innumerable seas-

capes and sketches of Barcelona and Málaga views, the artist paused occasionally in different religious buildings, such as the three small panels done in December 1896 in Barcelona which displayed aspects of two Barcelona churches: *Angle of the cloister of Sant Pau del Camp* (cat. no. 75)[15] and two views of Barcelona cathedral, *Man leaning in a gothic doorway* (cat. no. 76) which portrays the doorway between the chapel of Santa Lucia and the cathedral cloister, and *Detail of the cloister of Barcelona Cathedral* (cat. no. 77) probably done at the same time as the detail of Sant Pau del Camp.

From this same month there is another small panel, (cat. no. 78) which gives again a view of a landscape, now in dark tonalities, not only for the time of the year but also from a definite inclination to paint landscapes in tones more subdued, a prelude to his later experiments.

Between December and January Barcelona continued to be the object of Picasso's attention and apart from the luminous vision of Barceloneta (cat. no. 74) already mentioned, the artist continued his inclination to depict the Barcelona roofs which were so often the subjects of his pictorial analysis during these formative years. A schematic view, dated in Barcelona January 1897 *Cupola of the church of La Merced* (cat. no. 79) was probably taken from the roof of the studio at 5 carrer de la Plata, which his father had rented, very close to their new home in carrer de la Merced. Perhaps *Urban landscape* (cat. no. 80) is a view from this same studio.

The first influences of Modernism and the break with the Academy. Madrid 1897-1898

One of the assignments chosen by Picasso in order to study in the Royal San Fernando Fine Arts Academy in Madrid was *Landscape* (elemental section) of which Antonio Muñoz Degrain was the professor. He had been a friend of Picasso's father since the time when both were teachers in the Fine Arts Academy of San Telmo in Málaga. The reputation of Muñoz Degrain in the world of official painting was beyond all question, and Picasso had declared himself his disciple at the presentation of *Science and Charity*. Curiously it was during these months in Madrid that Picasso distanced himself from these colleagues and friends of his father who had the highest authority in the field of official painting. The oft-mentioned letter which Picasso wrote to his friend Bas[16], setting out all his ideas, shows the clear rupture with the Teachings of the Academy.

There is no known strictly academic sketch, but there is in existence within the little work of this period a series of notes and little paintings resulting from the Picasso's experiments in Madrid.

As the Ciutadella Park in Barcelona had been, the Retiro was a place where the artist went most frequently with his easel, to paint and sketch various corners. The rebellion which the young man was experiencing during this interval in Madrid had a dimension more ideological than real, as in reality the paintings of this period in Madrid were

a continuation of those previously done in Barcelona. They are paintings far from any academicism and in which appear a tendency to darkness and opacity in the brushwork. The distancing from the family atmosphere was reaffirmed however in his incisive rejection of all academicism, and these Madrid landscapes are already the prelude to the modernistic tendencies which he echoed two years later.

As a prolongation of the landscapes painted in Barcelona there are some views of the Park of El Retiro; *Man by a lake* (cat. no. 81), *Park* (cat. no. 82), very close in their structure and conception to *The couple* (fig 41) and *Road among trees* (cat. no. 83)[17]. They show references to the first dreamy and melancholic Granada gardens by Santiago Rusiñol, whose faded colour and balanced and architectural composition impinge upon these little Madrid paintings by Picasso. A second set of views by Picasso with more muted tonalities are the two versions which he made of the El Retiro lake (cat. nos. 84,85), the ochre and greenish tonalities of which give these two compositions an almost absolute monochrome effect. The treatment of the pavillion reflected in the water in one of the versions (cat. no. 85) is surprising, as is the thicket, with imperceptible lines, in favour of a palette in which the easy combination of tonalities makes the spectator part of this world of dreams which he feels and wants to transmit to us. Within this dark palette we are going to include *Woodland* (cat. no. 86).

Together with these versions of El Retiro there are two paintings whose chronology and location have been questioned, but which together with those above comprise some of the few views of Madrid.

The little painting *Salón del Prado* (cat. no. 87) is dated by some authorities as to the first and flying visit by Picasso to Madrid in 1895[18], or in the more prolonged Madrid sojourn[19]. The command of the lively and rapid brushwork, the background of the woodland in which the individuality is lost in the whole, the wise combination of the chromatic ranges of the rainy afternoon, lead us to place this work in his second visit to Madrid.

The work *Urban landscape with cupola* (cat. no. 88) comes from a palette in which the luminosity contrasts with the obscurity of some of the previous landscapes. This view of the roofs which has always been placed in Barcelona in 1897 has been disconcerting as we have not been able to place it exactly. However, there is a sketch (cat. no. 101)[20], belonging to an album dated in Madrid in 1898, in which one can see a dome with a window in the form of a horseshoe arch, similar to that which appears in this view. The inscriptions and the architectural scheme of the background we are not able to identify.

There are three albums of drawings made in Madrid (cat. nos.89-106) and another album done between Madrid and Barcelona (cat. nos. 107-109) which create a chronicle of the doings of Picasso during this year. Exteriors, interiors, El Retiro, notations of different bits of the immense park, of the various species of trees, the study of and approach to nature which would be continued in Horta, notes of a stall in the park (cat. no. 99), of the lake (cat. no. 96), one of the entrance to the Atheneum from the Cafe of the Prado

Museum (cat. no. 92), the account of an excursion to the outskirts of Madrid, the hill of Los Angeles (cat. no. 89) which then had a little hermitage on its summit, with an inscription "the centre of Spain, 11 km. from Madrid", a drawing *Dark sketch (Trees and thickets)* (cat. no. 91), probably a view of El Retiro in winter, which ties in with the paintings of el Retiro, a sketch of the tower of the "Casa de la Panadería" in the Plaza Mayor in Madrid (cat.no. 100) and the account of his adventures counterposed to the depiction of the interiors of his room and the Prado cafe.

NOTES

1. Cirlot, 1972, p. 25.

2. The buildings which form the group known as "les cases d'en Xifré" constructed in 1836 by Josep Buixareu and Francesc Vila, were the first buildings in Barcelona where the water deposit tanks were placed on the roof. Josep M. Carandell attributes a Masonic significance to these domes. (Hª del Restaurant de les 7 Portes 150 anys de la vida catalana. Edicions 62, Barcelona, 1989).

3. MPB 110.001

4. Palau, 1980, p. 113.

5. These documents, like all those referring to locations in Málaga, have been supplied by the Document Centre of the Pablo Picasso Foundation in Málaga. The Llanes farm is situated in the valley, to the east of the road to the Montes of Málaga, which used to be the road from Colmenar towards Granada.

6. Manuel Blasco Alarcón, in his book *Picasso insólito* sets this work in the foothills of the Cueva de la Negra, at a spot near the track which leads from the main road towards Llanes to the south. The Document Centre of the Pablo Picasso Foundation in Málaga raises a doubt as to whether this spot is as steep as is suggested by the oil or *Landscape* (cat. no. 38).

7. This has been photographically corroborated by the Document Centre of the Pablo Picasso Foundation in Málaga.

8. These small panels had been dated until that time in Barcelona 1896.

9. MPB 111.391 and 110.117R.

10. MPB 111.390 and 111.391R.

11. Information supplied by the Picasso Foundation in Málaga.

12. Palau, 1980, had already located it in Málaga and the Picasso Museum of Barcelona had catalogued it in Barcelona.

13. Barceloneta in the second half of the 19th century had acquired an new look with the construction of various bathing establishments and dwellings, as well as an industrial zone as a consequence of the industrial explosion which took place in Catalonia.

14. Palau dates it in 1895.

15. There is a preparatory sketch in a sketchbook MPB.

16. Xavier de Salas, in his introduction to the facsimile of the *Carnet Picasso Madrid 1989* reproduces a fragment of this letter which had been published years before in an article "Some notes on a letter of Picasso" in the Burlington Magazine, 1960, p. 482 et seq.

17. There are doubts over whether these landscapes were done in Barcelona or Madrid. Palau in *Picasso Vivent (1881-1907)* sets them in Madrid, we think correctly.

18. Rosa M. Subirana, 1979, pp. 54-55.

19. Palau i Fabre in *Picasso Vivent (1881-1907)* and Paloma Esteban in *Madrid pintado* prefer this option.

20. MPB 112.575.

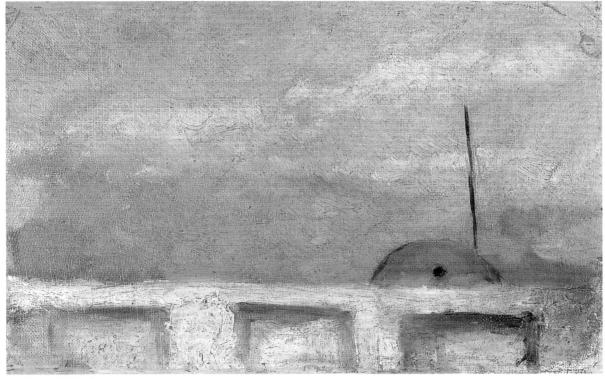

18. LANDSCAPE
Barcelona, 4 October 1895
Oil on panel, 10×15.4 cm
Museu Picasso, Barcelona

81 b, fig. 41. THE COUPLE
Madrid, 1898
Oil on canvas, 52×44 cm
Private collection

19. ROOFTOP PARAPET AND WATER TANK
Barcelona, October 1895-June 1896
Oil on canvas glued on cardborad, 16.5×25.1 cm
Museu Picasso, Barcelona

20. ACADEMY DRAWING
Barcelona, 1895-1896
Lead pencil on paper, 23.8×30.6 cm
Museu Picasso, Barcelona

25. NOTE OF MOUNTAIN LANDSCAPE
Barcelona, 1895
Lead pencil on paper, 8.2×12 cm
Museu Picasso, Barcelona

21. ACADEMY DRAWING
Barcelona, 1895-1896
Lead pencil on paper, 36.5×26.5 cm
Museu Picasso, Barcelona

22. ACADEMY DRAWING
Barcelona, 1895-1896
Lead pencil on paper, 31.5×24 cm
Museu Picasso, Barcelona

23. BUSHES AND SHRUBS
Barcelona, 1895
Lead pencil on paper, 12×8.2 cm
Museu Picasso, Barcelona

24. SKETCH
Barcelona, 1895
Lead pencil on paper, 12×8.2 cm
Museu Picasso, Barcelona

26. Full Moon from a Roof
Barcelona, 1896
Oil on panel, 9.9×13.9 cm
Museu Picasso, Barcelona

27. The False Mountains of Montserrat in the Ciutadella Park
Barcelona, 1895-1896
Oil on panel, 10×15.5 cm
Museu Picasso, Barcelona

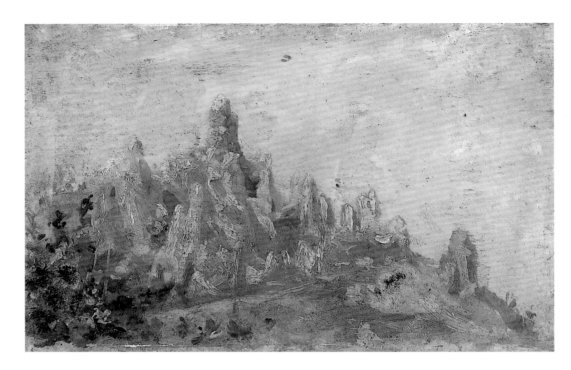

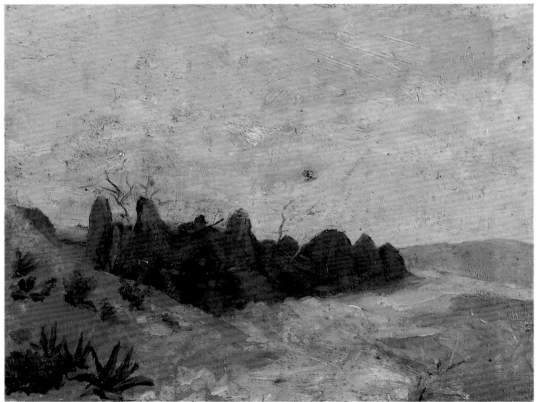

28. THE FALSE MOUNTAINS OF MONTSERRAT IN THE CIUTADELLA PARK
Barcelona, 1895-1896
Oil on panel, 10×15.6 cm
Museu Picasso, Barcelona

29. THE FALSE MOUNTAINS OF MONTSERRAT IN THE CIUTADELLA PARK
Barcelona, 1895-1896
Oil on panel, 13×16.5 cm
Museu Picasso, Barcelona

30. URBAN LANDSCAPE
Barcelona, April 1896
Oil on canvas, 20.2×28.1 cm
Museu Picasso, Barcelona

31. WOODLAND
Barcelona, 1896
Oil on panel, 10×15.6 cm
Museu Picasso, Barcelona

32. LANDSCAPE WITH TREES
Barcelona, Spring 1896
Oil on panel, 10.1×15.5 cm
Museu Picasso, Barcelona

33. STALL IN THE PARK
Barcelona, Spring 1896
Oil on panel, 10×15.5 cm
Museu Picasso, Barcelona

34. GARDEN
Barcelona, April 1896
Oil on canvas, 38.5×27.4 cm
Museu Picasso, Barcelona

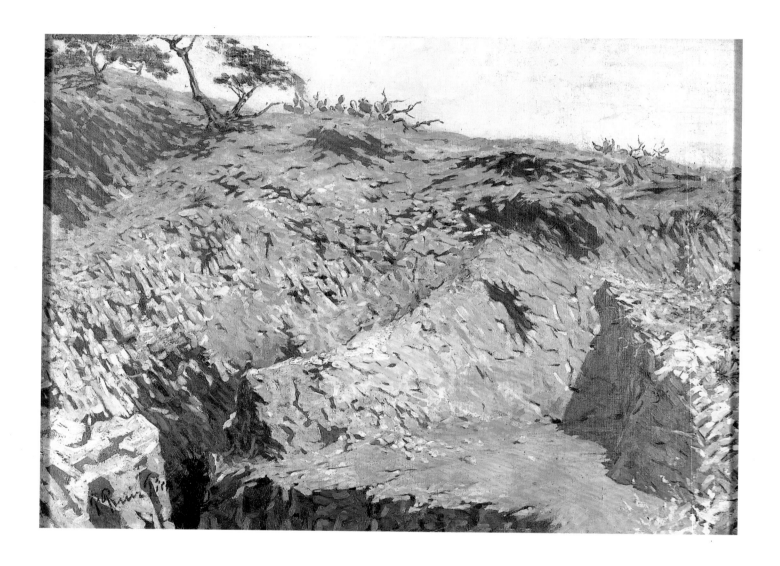

35. MOUNTAIN LANDSCAPE
Málaga, June-July 1896
Oil on canvas, 60.7×82.5 cm
Museu Picasso, Barcelona

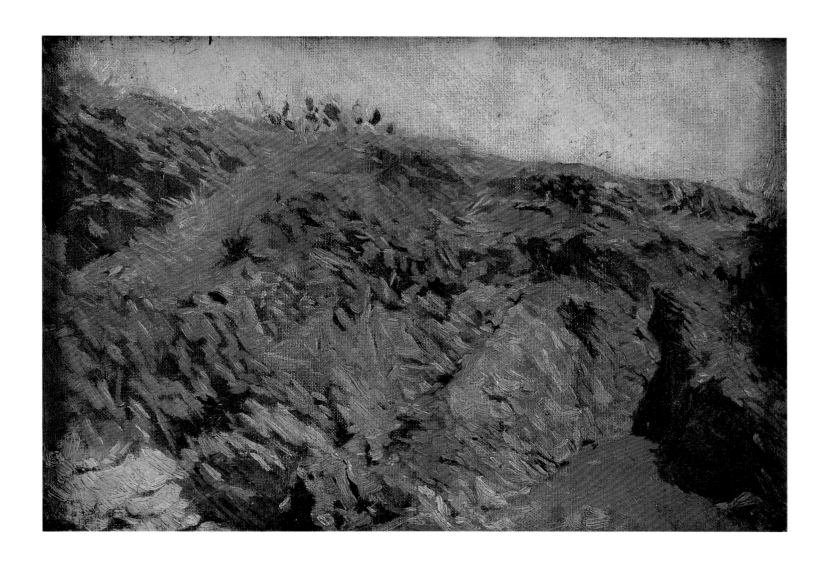

36. STUDY FOR MOUNTAIN LANDSCAPE
Málaga, June-July 1896
Oil on canvas, 28.2×39.8 cm
Museu Picasso, Barcelona

37. LANDSCAPE WITH THICKETS
Málaga, June 1896
Oil on panel, 10.2×15.6 cm
Museu Picasso, Barcelona

38. LANDSCAPE
Málaga, Summer 1896
Oil on panel, 13.6×22.2 cm
Museu Picasso, Barcelona

39. LANDSCAPE WITH MOUNTAINS
Málaga, 1896
Oil on panel, 13.7×22.1 cm
Museu Picasso, Barcelona

40. Landscape of a Mountain
Málaga, June 1896
Oil on panel, 10.2×15.5 cm
Museu Picasso, Barcelona

41. MONTES OF MÁLAGA
Málaga, 1897
Oil on canvas, 60.5×82.5 cm
Georges Encil Collection, Bahamas

42. MONTES OF MÁLAGA
Málaga, 1897
Oil on canvas, 34×54 cm
Private collection

43. MOUNTAIN LANDSCAPE
Málaga, 1896
Oil on panel, 10.1×15.5 cm
Museu Picasso, Barcelona

44. LANDSCAPE WITH TREES
Málaga, June-July 1896
Oil on panel, 10×15.6 cm
Museu Picasso, Barcelona

45. LANDSCAPE WITH THICKETS
Málaga, June 1896
Oil on panel, 10.1×15.5 cm
Museu Picasso, Barcelona

46. COPPICE AND MOUNTAIN
Málaga, 1896
Oil on panel, 10×15.5 cm
Museu Picasso, Barcelona

47. ROAD BETWEEN BUSHES
Málaga, June-July 1896
Oil on panel, 9.9×15.6 cm
Museu Picasso, Barcelona

48. THICKETS
Málaga, 1895-1896
Oil on panel, 10.1×15.7 cm
Museu Picasso, Barcelona

49. LANDSCAPE WITH TREES
Málaga, Jule-July 1896
Oil on panel, 9.8×15.6 cm
Museu Picasso, Barcelona

50. SUNSET AND FLOCK OF SHEEP
Málaga, June-July 1896
Oil on panel, 9.4×15.5 cm
Museu Picasso, Barcelona

51. LANDSCAPE
Málaga, June-July 1896
Oil on panel, 13.7×22.2 cm
Museu Picasso, Barcelona

53. MOUNTAIN LANDSCAPE
Málaga, 1896
Oil on panel, 9.7×15.7 cm
Museu Picasso, Barcelona

54. TREES WITH A HILL BEYOND
Málaga, 1896
Oil on panel, 9.2×15.6 cm
Museu Picasso, Barcelona

52. TWO PEOPLE IN THE COUNTRY
Málaga, June-July 1896
Oil on paper, 18.5×13 cm
Museu Picasso, Barcelona

55. THE PORT
Málaga, June-July 1896
Oil on panel, 10×15.4 cm
Museu Picasso, Barcelona

56. SEASCAPE WITH HOUSES IN THE FOREGROUND
Málaga, June-July 1896
Oil on canvas, 23.5×29.4 cm
Museu Picasso, Barcelona

57. PEASANTS IN THE COUNTRY
Málaga, June-July 1896
Oil on panel, 10×15.5 cm
Museu Picasso, Barcelona

58. FISHERMAN AND CHILDREN
Málaga, June-July 1896
Oil on panel, 10×15.7 cm
Museu Picasso, Barcelona

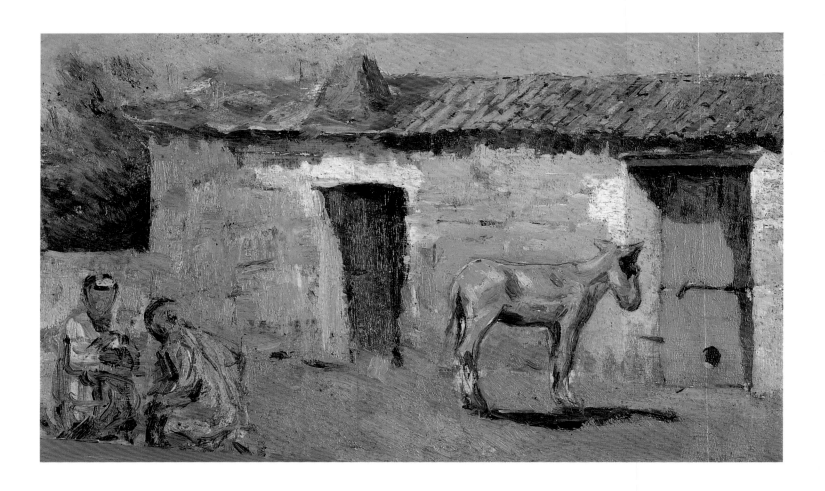

59. VILLAGE HOUSE
Málaga, 1895-1896
Oil on panel, 13.6×22.4 cm
Museu Picasso, Barcelona

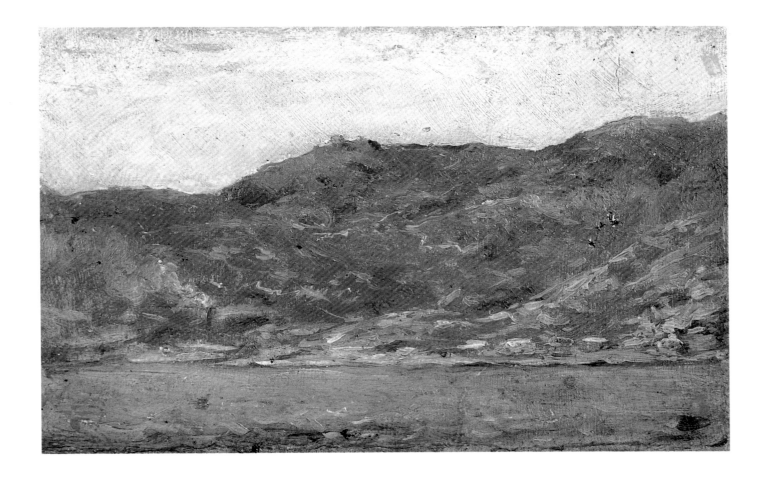

60. LANDSCAPE
Cartagena, July 1896
Oil on panel, 10.1×15.6 cm
Museu Picasso, Barcelona

61. NOTES OF A MARINE SCENE
Barcelona, 1895-1896
Lead pencil on paper, 8.2×12 cm
Museu Picasso, Barcelona

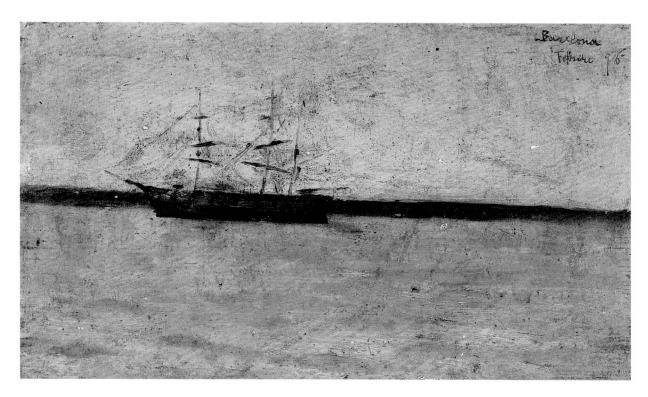

62. Seascape with Sailing Boat
Barcelona, February 1896
Oil on panel, 9.8×15.6 cm
Museu Picasso, Barcelona

62R. Seascape, Reverse
Barcelona, 1896
Oil on panel

63. SEASCAPE
Barcelona, 1896
Oil on panel, 9.2×15.6 cm
Museu Picasso, Barcelona

64. SEASCAPE
Barcelona, 1896
Watercolour on paper, 17.8×25.3 cm
Museu Picasso, Barcelona

65. THE WAVE
Barcelona, 1896
Oil on canvas, 28×39.5 cm
Museu Picasso, Barcelona

66. SEASCAPE
Barcelona, 1896
Oil on canvas, 19.2×16.5 cm
Museu Picasso, Barcelona

67. SEASCAPE
Barcelona, 1896
Oil on canvas, 12×19.2 cm
Museu Picasso, Barcelona

68. Man Seated on a Beach
Barcelona, 1896
Oil on panel, 9.7×15.5 cm
Museu Picasso, Barcelona

69. SEASCAPE
Barcelona, 1896
Oil on panel, 10×15.6 cm
Museu Picasso, Barcelona

70. HORIZON
Barcelona, 1896
Oil on panel, 11.4×22.3 cm
Museu Picasso, Barcelona

71. SUNSET
Barcelona, December 1896
Oil on panel, 7.5×15.6 cm
Museu Picasso, Barcelona

72. Barceloneta Beach
Barcelona, 1896
Oil on canvas, 24.4×34 cm
Museu Picasso, Barcelona

73. THE PORT
Barcelona, 1896
Oil on panel, 18×12.7 cm
Museu Picasso, Barcelona

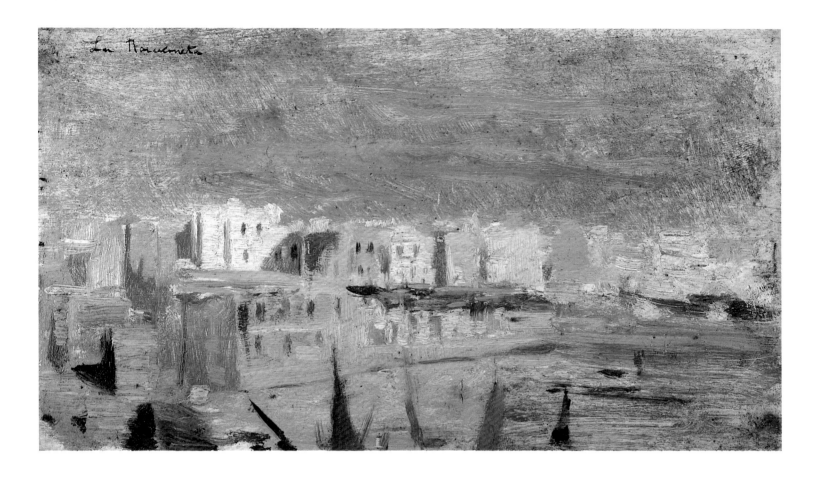

74. BARCELONETA
Barcelona, January 1897
Oil on panel, 13.8×22.4 cm
Museu Picasso, Barcelona

75. ANGLE OF THE CLOISTER OF SANT PAU DEL CAMP
Barcelona, December 1896
Oil on panel, 15.5×10.1 cm
Museu Picasso, Barcelona

76. MAN LEANING IN A GOTHIC DOORWAY
Barcelona, 1896
Oil on panel, 20.2×12.8 cm
Museu Picasso, Barcelona

77. Detail of the Cloister of Barcelona Cathedral
Barcelona, 1896
Oil on panel, 22.1×13.8 cm
Museu Picasso, Barcelona

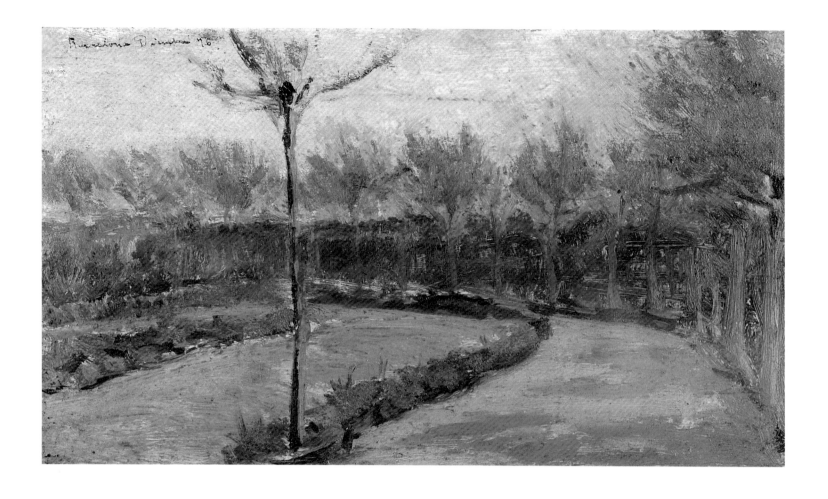

78. Two Roads in a Park
Barcelona, December 1896
Oil on panel, 13.8×22.5 cm
Museu Picasso, Barcelona

79. CUPOLA OF THE CHURCH OF LA MERCÈ
Barcelona, January 1897
Pastel and conté pencil on paper, 18×25.2 cm
Museu Picasso, Barcelona

80. URBAN LANDSCAPE
Barcelona, 1896
Oil on panel, 13.7×22.2 cm
Museu Picasso, Barcelona

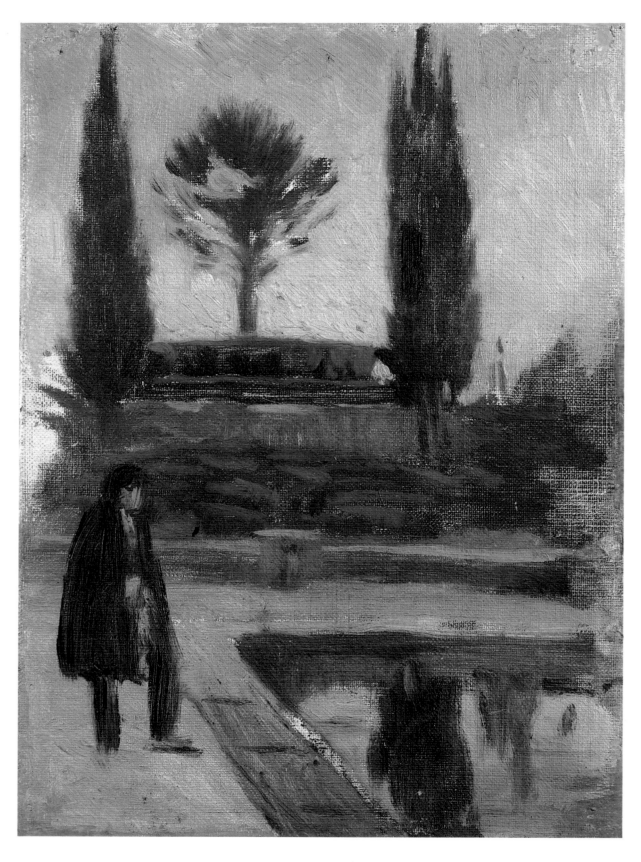

81. MAN BY A LAKE
Madrid, 1897
Oil on canvas, 28.3×20.2 cm
Museu Picasso, Barcelona

82. PARK
Madrid, 1897
Oil on canvas, 18.5×26.5 cm
Museu Picasso, Barcelona

83. ROAD AMONG TREES
Madrid, 1897-1898
Oil on canvas, 28.1×39.6 cm
Museu Picasso, Barcelona

84. POND AT EL RETIRO
Madrid, 1897-1898
Oil on canvas, 19.6×26.7 cm
Museu Picasso, Barcelona

85. POND AT EL RETIRO
Madrid, 1897-1898
Oil on canvas, 16×25.2 cm
Museu Picasso, Barcelona

86. WOODLAND
Madrid, 1897-1898
Oil on canvas, 28.1×37.5 cm
Museu Picasso, Barcelona

87. SALÓN DEL PRADO
Madrid, 1897
Oil on panel, 10×15.5 cm
Museu Picasso, Barcelona

88. URBAN LANDSCAPE WITH CUPOLA
Madrid, 1897
Oil on canvas, 31×46.5 cm
Museu Picasso, Barcelona

El centro de España
A 11 kilometros de Madrid

90. BALCONY
Madrid, 1898
Conté pencil on paper, 10.5×17.5 cm
Museu Picasso, Barcelona

89. LANDSCAPE
Madrid, 1897
Conté pencil on paper, 10.5×17.5 cm
Museu Picasso, Barcelona

93. SKETCH
Madrid, 1898
Brown pencil and sanguine on paper, 17.5×10.5 cm
Museu Picasso, Barcelona

92. DR. BENJAMIN TAMAYO ENTERING THE ATHENEUM IN MADRID
Madrid, 1898
Brown pencil and sanguine on paper, 17.5×10.5 cm
Museu Picasso, Barcelona

91. TREES AND THICKETS
Madrid, 1898
Conté pencil, sanguine and watercolour on paper, 10.5×17.5 cm
Museu Picasso, Barcelona

94. NOTE OF EL RETIRO
Madrid, 1898
Siena pencil on paper, 19.5×12 cm
Museu Picasso, Barcelona

95. EL RETIRO PARK
Madrid, 1898
Siena pencil on paper, 12×19.5 cm
Museu Picasso, Barcelona

97. TREES
Madrid, 1898
Siena pencil and watercolour on paper, 19.5×12 cm
Museu Picasso, Barcelona

96. POND AT EL RETIRO
Madrid, 1898
Siena pencil and watercolour on paper, 12×19.5 cm
Museu Picasso, Barcelona

98. TREES
Madrid, 1898
Siena pencil on paper, 12×19.5 cm
Museu Picasso, Barcelona

99. EL RETIRO CANTEEN
Madrid, 1898
Siena pencil on paper, 12×19.5 cm
Museu Picasso, Barcelona

101. SKETCH
Madrid, 1898
Colour pencil on paper, 12×19.5 cm
Museu Picasso, Barcelona

100. SKETCH
Madrid, 1898
Siena pencil on paper, 19.5×12 cm
Museu Picasso, Barcelona

103. View of El Retiro
Madrid, 1897-1898
Sanguine on paper, 12×20 cm
Museu Picasso, Barcelona

104. Steps and Ramp in the El Retiro Park
Madrid, 1897-1898
Sanguine on paper, 12×20 cm
Museu Picasso, Barcelona

106. Note of Salón del Prado
Madrid, 1897-1898
Sanguine on paper, 12×20 cm
Museu Picasso, Barcelona

105. VIEW OF EL RETIRO
Madrid, 1897-1898
Sanguine on paper, 12×20 cm
Museu Picasso, Barcelona

102. EL RETIRO
Madrid, 1897-1898
Lead pencil on paper, 12×20 cm
Museu Picasso, Barcelona

108. VARIOUS SKETCHES
Madrid or Barcelona, 1898
Conté pencil on paper, 13.5×9 cm
Museu Picasso, Barcelona

109. CHIMNEYS
Madrid or Barcelona, 1898
Conté pencil on paper, 13.5×9 cm
Museu Picasso, Barcelona

107. STREET SKETCH
Madrid or Barcelona, 1898
Conté pencil on paper, 13.5×9 cm
Museu Picasso, Barcelona

FREEDOM OF LINE: HORTA DE SANT JOAN

Lluís Bagunyà

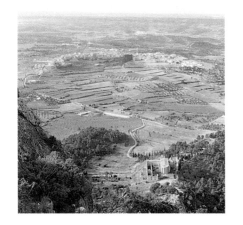

42. Photograph of Horta de Sant Joan from the summit of Santa Bàrbara mountain, 1993.

In June 1898 Picasso went to Horta with his friend and colleague, Manuel Pallarès, who was born in 1876, and whose home and family were there, to spend a time of relaxation and to convalesce, according to various art historians, from the scarlet fever which he had suffered in Madrid. His first stay was prolonged until January 1899, when he returned to Barcelona.

Horta[1] was at times named Horta d'Ebre by Picasso to distinguish it from the Barcelona district of Horta, according to Palau i Fabre, on the initiative of Pallarès himself. In 1910 it acquired officially the name Horta de San Joan, from the dedication of its church and during the Civil War, in the period of secularization, it was given the name Horta de Terra Alta.

This village in the Catalan region of the Terra Alta, on the banks of the river Algars and the border of the Aragon district of Matarranya, is set on the top of a hill from which one can see, dominating the landscape, the mountain of Santa Bàrbara or Sant Salvador (it is known by both names) with at its feet the convent of Sant Salvador d'Horta, which strongly attracted Picasso. This building originated at the end of the 12th century, the epoch of the Templars, of whom rich relics have recently been discovered buried under the village itself. It is now in the process of being restored. The sojourn of the Franciscan friar, to whom healing powers are ascribed, attracted a great number of pilgrims during the 16th century. The mountain also has little hollows and caves which attracted hermits, as did Montserrat. From the summit at 750 m. above sea level, where there are the ruins of the ancient hermitage of Santa Barbara, one can see the whole valley of the Ebro, the Ports of Horta-Tortosa-Beseit and the Franja of Aragon.

With slight variations, many authors mention Picasso's comments referring to the fact that everything that he knew he learned in Horta, and there is no doubt of the great importance of the role which Horta played in the life of the young artist. Picasso shared with Pallarès the delight of painting and drawing and came to know country tasks, village life and nature in the raw. He went all over the area on foot, swam in the river and even spent some time living in the Ports in a little grotto, until bad weather one night spoiled a good part of the works which he had done and he decided that the time had come to return to the shelter of the village.

When they arrived at Horta after a journey by mule and foot from Tortosa, where they had left the train, Pallarès and Picasso stayed in the family home of the former, Can Tafetans. But soon their longing to draw and get close to nature drew them to the Santa Bàrbara mountain, where they made their sketches directly from nature during their first stay outside the village, and which would subsequently become the subject of many works in Picasso's second stay in 1909, either alone or as a background for Fernande. Pallarès himself also produced a picture, today of unknown whereabouts, of the mountain with the convent at its feet (fig. 22), which was reproduced by Richardson[2].

There is an album which is an excellent witness to this excursion, whether on this first occasion or on a later one[3]. In it are various stages of the ascent. From the village road towards the hill we find them in front of the convent of Sant Salvador (cat. no. 110). This is the first page of the notebook, it is fairly faded and there is a big smudge on the paper in the lower right hand part.

In the foreground we can see a row of six cypresses, a tree which is found in many parts of the path which leads to the summit, and in the middle ground the convent mill, already very worn by time. We see, all the same, great perfection in the proportions and a splendid facility for architectural sketching. The central shading stands out, defining the archway which gives access to the atrium of the church, the only shadow on the facade.

This image was fixed in the mind of Picasso, as he showed subsequently in making a drawing from memory from a similar perspective, but without the realism of the pencil note and with the elements of the building distorted, in a work in oil and pastel where the convent is the counterpoint to some women with wide skirts in the foreground who are going there in procession (fig. 44).

To go up the mountain, Picasso at that time followed the path to the left of the convent, which led to a little shady place on the north slope. He turned at a distance of about 300 m, after a corner, to look at the road by which they had come and made the drawing *Horta Landscape* (cat. no. 111). Here again the vertical component of the cypresses dominates, another six, on a darker slope with little detail, but in which, however, we see the path which they had followed after passing the trees. The pencil lines are long and sure. In the centre-ground we see the tiled roofs and steeple of the convent and also, half-concealed by a cypress, the chapel dome nearby. Further in the background is the village of Horta, merely outlined by a geometric profile of its tiled roofs against the light, which Picasso, years later, would often use in his cubist works during his second stay.

The next page of the album (cat. no. 112) contains a pencil sketch of one of these characteristic mountain cypresses, with a smooth form, but attractive through its irregularites.

Continuing the ascent, in the sunshine, we find the hermitage of Sant Antoni del Tossal, today in ruins. This drawing (cat. no. 113) is much more luminous, as would correspond to a time of strong sunlight, and also shows cypresses, but only the lower part

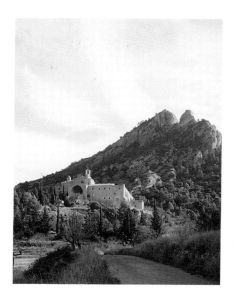

43. Photograph of Sant Salvador convent, 1993.

44. *Procession towards the Sant Salvador convent*. Horta de Sant Joan, 1899. Oil and pastel on canvas. 60×71 cm. Heirs of Picasso. Zervos 21, 89.

as a frame to the building. The sensation of light comes in great part from the fact that the large cypress on the left is merely outlined, from the little shadows of the window and door frames and from the little passage which passes under the left part of the building. This contrasts with the completely dark cypresses of the previous sketch.

This album also includes four views of bare fruit trees, without leaves, typical of a winter landscape in the fields which surround Horta (cat. nos. 114-117), which must have been done towards the end of his stay. All of these are sketches with straight lines which make the bareness of the branches stand out, both when the tree is alone and when there is a whole orchard.

The last two bear the signature P.R.P. surrounded by three circles, which appears in many of his sketches at this time. One of them in particular (cat. no. 117) is done in an incomplete way because the lead of the pencil was finished and the line is only partial.

The first of these drawings shows three trees in a line, with the one in the foreground partially outside the sketch, something that gives depth to the perspective. However, the most interesting thing about this sketch is, in our opinion, that Picasso, for the first time, depicts the surroundings of the branches of the central tree, if in a very soft way. The technique of highlighting the surroundings of the drawn figures is generalized in Picasso's works after his return to Barcelona in 1899. In a manner not so accented, the drawings of human figures in this album show this technique at Horta.

Another tree relating to this stay at Horta which also offers this characteristic (Z. 6, 64) in a more accented way is shown in this exhibition (Z. 6. 66, cat. no. 118). It is a sketch of a white pine, also characteristic of the area of the Ports and Santa Bàrbara mountain. The branches are traversed in their multiple facets by a heavier line, which

marks also the sinuous base of the trunk. That it is a white pine is confirmation of the fact that it was done at Horta, as this is a mountain tree which is not found in the surroundings of Barcelona. Perhaps it was thought that it was painted in Barcelona because on the back there are sketches of an Andalusian kind, certainly done in Barcelona: the couple in the lower left corner is in preparation for *The Andalusian patio* (done in Barcelona in 1899, MPB 110.024) and figures of this style do not appear until his return to the city. Palau (no. 281, Z. 6, 133) seems sure of the dating by Zervos of November 1899 in Horta for a page of sketches which has a strong parallel with the back of the sketch we are considering, even though Zervos does not set out the source of the dating, but this seems to us unlikely.

Another landscape sketch by Picasso in Horta with the convent of San Salvador is called *Trees* (cat. no. 119). In the foreground we see a undefined thicket of shrubs and perhaps a tree, but behind, with less intensity in the line and at times scarcely perceptible, we can see clearly enough two rows of cypresses and the principal facade of the convent. It is unfinished; Picasso stopped with the specific detail of the vegetation of the foreground and with short lines squeezed together, but the rest of the paper is empty.

Also the trees in *Landscape* (cat. no. 120) are very much worked. With a foreground without vegetation the composition presents a dense thicket of shrubs which has in front of it two trees, certainly fruit trees, which flank it and with it form a "U", which in a certain manner invites the glance into the distance where some buildings and trees are outlined on the horizon. At the centre can be seen a young tree which has not still grown as tall as the shrubs. As in the previous drawings the fact that part of the two trees remains outside the frame contributes to giving depth to the landscape. As an example of the human presence in the countryside, beside the left hand tree-trunk is seen an implement which could well be a sieve.

This and the following drawings were done in the summer. In them the centres of interest, besides the human figures which may appear, are the trees. The plants, the ground and the background are quickly done, in the manner of a first thought, but Picasso concentrated on the trees, which he drew in detail. In *Peasant in an apple orchard* (cat. no. 121), the centre of attention is the two apple trees weighed down with fruit. The

apples, round, are sharply differentiated from the leaves, perfectly defined. Under them, a countryman is bending down working, in a parallel position to that of the two trees.

Another example of the sketch from nature in the country is that of *Peasant in a field* (cat. no. 122). In this one can see an orchard in the background, while in the foreground, with his legs concealed by the shrubs, is a peasant with his back to us, a cap and a scarf round his neck, carrying a staff taller than himself which could be either a shepherd's crook or a stick for beating the olive trees. The figure itself is done with great ease, combining a slender line with one somewhat thicker for the outlines, a recourse which he would continue to use in the succeeding years. In the middle, there are two low borders of stones which go from one side of the drawing to the other. The paper shows an oval smudge on the upper part and is darkened on the right hand side.

Related to these drawings of the country, there is the *Woman with her son in a landscape* (fig. 48), but which could be dated later in Barcelona. It is evidently a reminiscence of the Horta countryside, but it is clear that the female figure and even the hens relate to those in a drawing which he prepared for the review "Joventut" in 1900, of which there are several drafts in the Picasso Museum in Barcelona. The few details of the landscape and of the rather phantasmagorical individuals in the middle ground confirm that this is not a note but comes from memory.

On the other hand, with a very different and smaller aspect, there is a note called *Mountain landscape* (cat. no. 123) which shows large rocks and a little tree to the left. The paper has a watermark "Canson & Montgolfier Vidalon. Les an...". This drawing has on the back several drafts of a banderillero, a bull, men and boys and a square with the signature Picazzo (sic). Numerous works from Horta have the signature P.R.P. within three circles, as a stage between the P.Ruiz and P.Ruiz Picasso which he would use subsequently, as Palau noted[4]. Various sketches and notes from Horta are accompanied by experiments and tests of his signature, which denote a change in the personality of the artist.

More elaborate, on the other hand, is *Landscape* (cat. no. 124). Drawn on legal paper, a bit stained and with a small strip restored on the upper part, it presents a luxuriant group of trees in the centre of the composition, at the end of an promenade which could belong to a park. The typology of the landscape is difficult to place and may not relate to Horta. On the reverse there are some figures, of which one is especially interesting: a man with a bare torso, which could be Picasso himself, for the strong similarity to his self-portraits catalogued by Zervos, 6, 61 and 6, 63 (figs. 49-50). Palau[5], from the information given by Zervos, concludes that both sketches could have been made in Barcelona, some days before he went to Horta. It seems clear that all three sketches were done at the same time. So that Picasso more than once used the backs of earlier sketches later, in this case it leads us to believe that it could be a Barcelona park and that it was also drawn during the time referred to.

Another drawing which shows works by Picasso attributed to Horta is that of the *Three washerwomen* (cat. no. 125). They are on the river bank, kneeling and bending

over their bundles of laundry, not seen because they have their backs to us. They have shawls on their heads and each one has her washtub behind her. The three figures and the three receptacles are the centre of the composition, with only the turf in the foreground and the water of the river scarcely noted.

These washerwomen are also portrayed in a little oil on wood (cat. no. 126) but in this case only one woman is seen with her back partially to the painter, while the other two are more facing him, even if they are in the same position as in the sketch, so that they are actually face down to the ground. It is clear that what attracted Picasso was the movement and also the position of the bodies, so that he gives no details of the faces. In the two works, but especially in this oil, the position of the arms and the inclination of the backs, particularly of the woman in the foreground, gives them with very little effort and a thick brushstroke, the force of drubbing the piece of clothing which they are washing. The tablet has, besides, a special luminosity; the sky is an intense yellow, the undefined ground is greyish, the clothes are dark, but the white splashes stand out of the rolled-up sleeves of their blouses, the water and the sheet inside the washtub in the foreground and, principally, the water where they are doing the washing, so that it is not clear whether it is a river, a fountain, or a washing place, nor if the whiteness of the water is a reflection from the sky or from the soap, but it stands out within the whole.

49. *Picasso, with nude torso.* Barcelona, 1897. Conté pencil. 33×23.5 cm. Zervos 6, 61.

50. *Picasso, with nude torso.* Barcelona, 1897. Conté pencil. 33×23.5 cm. Zervos 6, 63.

48. *Woman with her son in a landscape.*
Barcelona, 1900. Pastel and charcoal on paper.
31.5×48 cm. Jan Krugier Gallery, Geneva.
Zervos 21, 69.

From the road to the Ports and from the mountain area near Horta, some works remain. The *Mountain landscape. Note of Els Ports* (cat. no. 127) is an example of them. This little canvas shows unreal colours, from a palette surprisingly full of violet, purple, scarlet, mauve and yellow, lit up for the sky, which shows us a Picasso little tied to the realistic note, but which despite all shows the typical forms of the region, including the white river. It has not been located with certainty[6].

According to Palau[7], "the splendid composition which Picasso prepared there, for which he had the canvas and the frame brought from Barcelona, was called *Idyll* (Pallarès started one which was called 'Woodcutter'), but it seems that this was destroyed by the wind during a stormy night. This composition was to have represented a shepherd courting a shepherdess before the immense scenery formed by the mountains. Many projects remain, in which the positions of the shepherd and the shepherdess constantly change." Here, Palau is referring to sketches in the possession of Picasso's heirs and others in the Picasso Museum in Barcelona, such as MPB 110.746, and he later adds, "Of this 'Idyll' there also remains a small picture which only describes the landscape into which the individuals were to have been inserted. This 'Note from the Ports' is, in spite of its size, an immense landscape, seen as a great natural theatre".

One of these preparatory drafts of the couple who were depicted in the "Idyll", on paper which has the watermark of the house ALSINA, has on the back a pencil sketch of a *Valley between mountains* (cat. no. 128) which could also be thought to be a preparatory work for the great painting.

Another *Mountain landscape* (cat. no. 129) is an oil on canvas (subsequently reworked). Its subject is a grey millstone which rests on a bed of brushwood with a diagonal border of vegetation, all of this typical of the orography of the approach to the Ports. Picasso has only used green and various tonalities of grey to reproduce the mountain against the light, showing the sky as almost white and with small yellow areas at the summit and the upper part of the blanket of trees. This is a picture done with large brushstrokes, but realist, as the cracks in the rock show. It is simple, but it perfectly reflects the majesty of the scenery.

More simple still is the *Snowy mountain range* (cat. no. 130). All the attention in this small picture is centred on describing the forms of the snow on the mountains in the distance. Both the sky and the space between the viewer and the snow are nothing more than a complement of that and are made with broad brushstrokes depicting nothing. Logically, it would relate to the last months of his stay at Horta, through the presence of the snow, which is no stranger to Els Ports in the winter.

Another oil, traditionally called *Mountain landscape* (cat. no. 131) displays very much softer land, with a farm at the foot of a little hill and surrounded by trees. The forms of all the elements together are sketched with large features and different borders of ochres and greens, which outline the fruit and olive orchards, scarcely defining the fields which surround the building. This painting does not relate to the Ports, but to the smooth prominences of the Terra Alta, full of crops and the farms which work them.

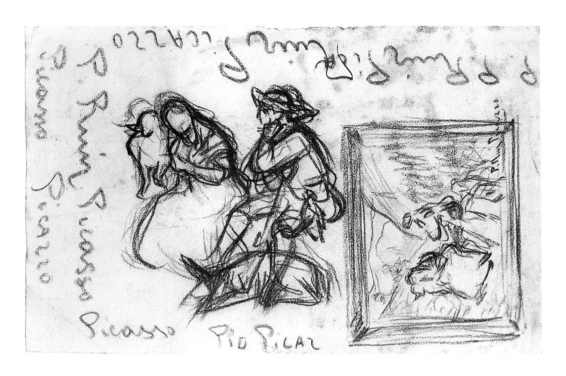

51. *Shepherd and shepherdess.* Horta de Sant Joan, 1898-1899. Conté pencil on paper. 24.7×16.3 cm. MPB 110.746.

The *Mas de Tafetans. Rural landscape* (cat. no. 132), the largest oil painting preserved from this first stay in Horta, precisely depicts the Pallarès family farm outside the village in the cultivated area on the road leading to the village of Lledó. This painting, subsequently reworked, has the upper left corner unpainted, which leads to the belief that it is unfinished. The farm, which still exists,[8] and the sunlight which inundates all the landscape are the central features of the work, with the conspicuous splash of a cereal field, perhaps wheat, though from the colour it appears that it has not yet been harvested. For this reason it can perhaps be dated in the months of June or July of 1898, shortly after his arrival at Horta.

Perhaps the best-known canvas of this year is *Mas de Quiquet* (cat. no. 133, also reworked). It is the most important from his stay at Els Ports. This house, now restored and used for cultural activities in the nature park, was then the last place inhabited on the road towards the wilder places and, on more than one occasion Picasso and Pallarès must have come into contact with the countryfolk who were living in a fairly isolated and self-sufficient manner, with their cattle and their garden produce. Palau commented that Salvadoret, Manuel Pallarès small brother, went there to buy bread, because he had neglected to bring any when he took provisions from Horta up to the two friends[9]. It is certain that Picasso held this picture in great esteem because he hung it on the wall with his other work *The one-eyed man* (fig. 53) of 1899, sketched either in Horta or Barcelona.

The farm, whose walls were then roughcast and not of exposed stone as they are now, gathers the low sun of the late summer on its high walls, while the entry facade is in shadow and the door and two windows are surrounded by white wall, a charac-

teristic feature of the painting. Although it is a small building, it is not a simple structure, but one which is composed of different prismatic volumes. The geometric complexity and perspective already strongly attracted Picasso.

The village of Horta itself also was the subject of Picasso's attention. This is the case with two little paintings on fabric, glued onto wood, *Horta houses* (cat. no. 134) and *View of a street in Horta* (cat. no. 135) which display partial views of the village in summer, judging by the height of the sun. In the former, the narrow facades of the one-storey houses in the shade are the counterpoint of the roofs and ground, touched by the sun. In the latter, we see a typical sloping street of the village, with all the facades in the sun and with splashes of distant colour which could be people. The two were done with a thick brush but with a great sense of perspective and light..

One of the more interesting works, which also portrays the village, is the small panel *Partial view of Horta* (cat. no. 136). This displays various low buildings on the way out of the village, irregularly distributed, but with the volumes splendidly moulded. In the foreground are two verges, treated with a short brush, compressed and impressionist, habitual in Picasso's work in landscapes of Malaga in 1896 (cat. nos. 35-38), which make us think that this was one of the first paintings done at Horta. In the background are glimpsed the greys of the Ports mountains; in the centre, a tree cuts the monotony of the ochres of the facades and roofs; finally, in the upper left corner, at the top, emerges a building with a steeple, which is none other than the old hospital, nowadays the Picasso Centre in Horta. This, on the other hand, is the only oil painting signed by Picasso on this visit, even if it is only signed "Pablo". On the back of the bevelled panel he made several trials of his signature, with "Pablo Ruiz", "Ruiz" alone, and other inscriptions.

Another page of the album mentioned at the beginning of this chapter, *Horta houses* (cat. no. 137) is the preparatory work for the oil *Houses in Horta de San Joan* (cat. no. 138). The composition of the two works is interesting, with the perspective of the facades seen from a low viewpoint, the geometric intervals formed by the eaves, the visible structure of some of the houses, the chimneys and the buttresses. The houses are those of the Carrer Bonaire and are close to those of the promenade of the modern children's park (fig. 55).

The drawing, signed P.R.P. within three circles in the lower right hand corner, has some small differences from the oil: it lacks the lower wall with the door on the left hand side, a stone in the foreground and also the sheet is in the higher window.

The canvas is very sombre, with its ochre tones, crossed with greys, the white splashes of a facade, the frame of a balcony, and the stone and sheet already mentioned. This is work of surprising maturity and represents a point of inflection in Picasso's work which, on his return to Barcelona, would give way to family pressures to return to an academic environment, but which for certain had sown in Picasso's spirit a taste for discovering the hidden structure of nature and things, which made him return ten years later to Horta to strengthen the basis of cubism.

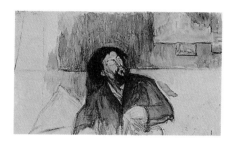

52. Photograph of Mas de Quiquet, 1993.

53. *The one-eyed man.* Horta or Barcelona, 1899. Watercolour and charcoal on paper. 32×50 cm. Heirs of Picasso. Zervos 6, 109.

54. Old photograph of Horta de Sant Joan. On the left, the houses appearing in works 137 and 138, pp. 182-183.

NOTES

1. Today, Horta de Sant Joan has a very active Picasso Centre, on the former site of the old hospital. There are activities organized and facsimile reproductions of the works of Picasso done in Horta or related to it are shown. From its Director, Joaquim Ferras, we have received most of the information regarding the location of certain landscapes, for which we are most grateful. Picasso's visits to Horta have been the subject of publications by the Centre, such as that by Francisco Francín in 1981 and more recently, Joan Perucho in 1993, and include an excellent documentary work by Nuria Poch.

2. Richardson, P. 100. It also appears on the wall in several photographs taken by Picasso in 1910 in his studio in Boulevard Clichy (Baldassari, *Picasso, Photographer*, fig. 90-92, pp. 119-121).

3. This album MPB 110.926, 16 x 24 cm, has 25 pages of drawing paper, kept together. Of these, clearly, 19 are of the same type of cream paper, with the 6 centre pages (MPB 111.571-111.576) being grey[4] and light green. Both these centre pages and the last in the album belong to later dates, in Barcelona.

4. *Picasso by Picasso*. Barcelona: Joventut, 1970. Commentary on the work 6.

5. Palau, *Picasso Vivent*: commentary on work 250.

6. On p. 43 of the book by Joan Perucho, at the side of the reproduction of this work, is a photograph of the Ports which shows this resemblance. In addition the Vall del Salt de Ferrassó, just at the end of the village on the way to the Ports, could be the place that inspired this work, especially the waterfall.

7. Palau, *Picasso Vivent*, p. 150.

8. Perucho, p. 49, showing its actual condition in a photograph.

9. Palau, *Picasso Vivent*, p. 149.

10. Sketch in watercolour and charcoal, reproduced by Palau in *Picasso Vivent*, p. 154, no. 286.

110. HORTA LANDSCAPE. SAN SALVADOR CONVENT
Horta, 1898-1899
Conté pencil on paper, 16×24 cm
Museu Picasso, Barcelona

111. HORTA LANDSCAPE
Horta, 1898-1899
Conté pencil on paper, 16×24 cm
Museu Picasso, Barcelona

115. NOTE OF A TREE
Horta, 1898-1899
Conté pencil on paper, 24×16 cm
Museu Picasso, Barcelona

112. SKETCH OF A TREE
Horta, 1898-1899
Conté pencil on paper, 24×16 cm
Museu Picasso, Barcelona

113. HERMITAGE OF SANT ANTONI DEL TOSSAL
Horta, 1898-1899
Conté pencil on paper, 16×24 cm
Museu Picasso, Barcelona

114. SKETCH OF TREES
Horta, 1898-1899
Conté pencil on paper, 16×24 cm
Museu Picasso, Barcelona

116. Note of an Olive Orchard
Horta, 1898-1899
Conté pencil on paper, 16×24 cm
Museu Picasso, Barcelona

117. Winter Landscape
Horta, 1898-1899
Conté pencil on paper, 16×24 cm
Museu Picasso, Barcelona

118. TREE
Horta, 1898
Charcoal on paper, 25×16.5 cm
"Marina Picasso Collection (Inv. 0069)
Courtesy of Jan Krugier Gallery"

119. TREES
Horta, 1898
Conté pencil on paper, 15.6×21.5 cm
Museu Picasso, Barcelona

120. LANDSCAPE
Horta, 1898
Conté pencil on paper, 24.5×32.1 cm
Museu Picasso, Barcelona

121. Peasant in an Apple Orchard
Horta, 1898-1899
Conté pencil on paper, 16.2×24.3 cm
Museu Picasso, Barcelona

123. Mountain Landscape
Horta, 1898-1899
Conté pencil on paper, 16×24.5 cm
Museu Picasso, Barcelona

124. LANDSCAPE
Horta or Barcelona, 1898-1899
Conté pencil on paper, 23.8×31.8 cm
Museu Picasso, Barcelona

122. PEASANT IN A FIELD
Horta, 1898
Conté pencil on paper, 24.2×31.8 cm
Museu Picasso, Barcelona

125. THREE WASHERWOMEN
Horta, 1898-1899
Conté pencil on paper, 16.2×24.3 cm
Museu Picasso, Barcelona

126. THREE WASHERWOMEN
Horta, 1898-1899
Oil on panel, 10×15.6 cm
Museu Picasso, Barcelona

127. MOUNTAIN LANDSCAPE. NOTE OF ELS PORTS
Horta, 1898
Oil on canvas, 16.5×22.2 cm
Museu Picasso, Barcelona

128. VALLEY BETWEEN MOUNTAINS
Horta, 1898
Conté pencil on paper, 11×13.3 cm
Museu Picasso, Barcelona

129. MOUNTAIN LANDSCAPE
Horta, 1898-1899
Oil on canvas, 28.2×39.5 cm
Museu Picasso, Barcelona

130. SNOWY MOUNTAIN RANGE
Horta, 1898-1899
Oil on canvas, 19.1×27.1 cm
Museu Picasso, Barcelona

131. MOUNTAIN LANDSCAPE
Horta, 1898
Oil on canvas, 28.5×39.5 cm
Museu Picasso, Barcelona

132. MAS DE TAFETANS. RURAL LANDSCAPE
Horta, 1898
Oil on canvas, 33×44 cm
Museu Picasso, Barcelona

133. MAS DE QUIQUET
Horta, 1898
Oil on canvas, 27×40 cm
Museu Picasso, Barcelona

134. HORTA HOUSES
Horta, 1898-1899
Oil on canvas, 10.7×19.5 cm
Museu Picasso, Barcelona

135. VIEW OF A STREET IN HORTA
Horta, 1898-1899
Oil on canvas, 9.4×14.1 cm
Museu Picasso, Barcelona

136. PARTIAL VIEW OF HORTA
Horta, 1898-1899
Oil on panel, 10×15.5 cm
Museu Picasso, Barcelona

137. HOUSES IN HORTA
Horta, 1898-1899
Conté pencil on paper, 16×24 cm
Museu Picasso, Barcelona

138. HOUSES IN HORTA
Horta, Summer 1898
Oil on canvas, 27×39 cm
Private collection

CONTACT WITH THE AVANT-GARDE

Malén Gual

Barcelona 1899-1900

After Picasso returned to Barcelona in January 1899 following his beneficial stay in Horta, the relationship between the artist and the city was substantially changed from his first stage of youthful discovery. For one thing, Picasso had matured, he had distanced himself from the family influence for eighteen months, first in Madrid, where he showed his rejection of the academic world, and subsequently in Horta. For another, his interest in seeking new expressive forms found fertile ground in the clear discovery of the artistic currents coming from the north of Europe, essentially from Paris. These were the subject of discussions in the cafe "Els Quatre Gats" (The Four Cats) which opened in 1897, although Picasso only frequented it during this new period in Barcelona.

Picasso could now understand the political/social situation in Barcelona at the end of the last century. This was characterized by a strong Catalan resurgence and active anarchist disturbances which had produced several attacks in previous years, but which now was modified by new feelings after the loss of the last American colonies, which had so much influence on the Spanish artists and writers. In Catalonia, it was viewed in a more concealed form, with a literary renaissance led by Maragall and the awareness of social problems on the part of some artists such as Isidro Nonell and Ramon Casas who, with their real and vivid sketches of the repatriated colonists and their circumstances, influenced without question the series of sketches by Picasso of the street beggars[1].

The city, in full reforming effervescence, and expanding through the Cerdà plan, encouraged the activity of a considerable number of architects, artists and modernist craftsmen and presented a new modern face when trams appeared in the streets as a method of public transport (electrification was begun at the end of 1898), the few motorcars were sporting vehicles which still had to give way to the carts and carriages. Miguel Utrillo, artist, writer and one of the regulars of Els Quatre Gats, an enthusiast of the modern spirit, was one of the first victims of this sporting fever; after suffering an accident he commissioned the young Picasso to make him a votive offering, to which the latter replied wittily with the *Parody of a votive offering* (cat. no. 139).

Rejecting the family protection, Picasso became independent and set up a studio with the Cardona brothers, Santiago (an artist) and José (a sculptor), at no. 1, carrer Escudillers Blancs, near the Plaza Real. It was in this studio that he met Jaime Sabartés, who was his friend for life and who, in his memoirs, describes it as a little room where the artist painted and drew indefatigably[2], and tells us that he was the last habitué of Els Quatre Gats to meet Picasso as the young artist had visited the cafe and made contact with the previous generation of artists, Casas, Rusiñol, Utrillo, Canals, Nonell, Junyent and the younger Casagemas, the Reventós brothers, Gosé, Gargallo, Vidal Ventosa, etc.[3]. Picasso's visits to the cafe had great importance, since they allowed him to demonstrate his art through different activities such as the menu designs, and to present his works in his first individual exhibition, becoming the ring-leader of the younger group, as Ramón Casas was artistic leader to the older. He acquired direct knowledge of art influenced by the impressionist style. He also came to know the work of those artists belonging to "la colla de Safrà" (the saffron group), which had erupted into the artistic life of Barcelona in 1896 with a series of landscapes of great luminosity and bold colour as a reaction against the nostalgic tone of rural landscapes and those close to the city and its suburbs.

Picasso's production from 1899-1900 was centred fundamentally on the human figure and, above all, on portraits of his friends at Els Quatre Gats. However, as Sabartés remembers, he loved to stroll through the city without a fixed destination, capturing street scenes or corners which attracted his attention and which he sketched rapidly. *Woods on a mountain slope* (cat. no. 140) is possibly one of the first works that he did on his return from Horta, since it is dated Barcelona 1899, in it still prevails, through the dark woodland tones and the paleness of the sky, the deep naturalistic feeling of the works made in the mountains in the province of Tarragona. The little oil is an important document in determining the date of his return to Barcelona and was the close of a chapter of seeking expression in nature. From this moment his work was inspired by subjects and landscapes much more urban, leaving the gentle hills surrounding Barcelona as a backcloth for some sketches, like the charcoal one of the port, *Inner harbour* (cat. no. 141), which with its line and lack of light is consistent with various sketches made in 1898 and which the artist himself baptised as "dark sketches"[4]. It is not surprising that Picasso took his first footsteps towards the port, as the family homes had

59. *Seminarists*. Barcelona, 1899.
Pen and wash. 14×17.5 cm.
Zervos 21, 74.

58. *The end of the road*. Barcelona, 1899.
Watercolour and conté pencil on paper.
45.5×29.8 cm. The Solomon R.
Guggenheim Museum, New York,
Foundation Justin K. Thannhauser.
Zervos 21, 79.

always been very close to the sea. From the situation of perspective of the wharf this could be a corner of the "Moll del carbó" (the coal wharf) where sailing and coastal vessels alternated with propeller-driven steamships with metal hulls.

One of the subjects most frequently treated by Picasso in this period is the view from the windows of his successive studios, starting when taking possession of a studio, which he did throughout his life. In the studio in Escudillers Blancs he began this series of windows and balconies, a subject frequently repeated in these years, building up to broader and more panoramic views of roofs and rooftops. In this way Picasso joined one of the mainstreams of subjects most represented in the long history of art, such as facades, shapes of windows, people in the windows, exterior views, etc. The canvas *Closed balcony* (cat. no. 142) could be, as Palau i Fabre has pointed out[5] one of the first works done in this studio, since there was a scarcity of this type of material in the works from Horta. In the closed balcony of the building in the street Lleona the dominating tones are yellow and grey which give a dramatic sense to the balcony which is hiding some mystery behind its door. The window as a step from the interior to the exterior has a special importance in *Balcony with net curtain seen from inside* (cat. no. 143) where the window forms the whole of the picture; the quality of the pictorial material is an element of interest as much as the colour or the line, obtained by the density of impasto. The same richness of material and strong backlighting are used in *View of snowy landscape from an interior* (cat. no. 144) which, through a strong contrast

between the dark and warm interior and a lighter and colder exterior, invites the look towards the beyond, towards the unknown.

At the beginning of 1900 and up to September of that year, he lived with his friend Carlos Casagemas in a studio in 17, carrer Riera de Sant Joan, a street which has now disappeared with the opening of Via Layetana. According to Sabartés, they occupied the top flat of an old house, with large windows[6]. The two friends prepared here for their journey to Paris in the autumn and their respective exhibitions in the large diningroom of Els Quatre Gats. Picasso had changed his studio but continued working on the same theme. During these nine months he painted various urban landscapes seen from the windows and the flat roof of his new studio. In *Lola in the studio in Riera Sant Joan* (cat. no. 145), the backlighting of the figure enclosed in a dark interior space lets us share the exterior, more luminous space. The face, in shadow, has lost all detail, becoming an area framed by the black hair and the white dress. The same view is glimpsed behind the figure appearing in *Rooftops and Santa Marta church* (cat. no. 146), a work traditionally dated 1897 but which, on verifying that it is indeed the cupola of Santa Marta (fig. 74) which could only be seen from the studio of Riera de San Juan, means that it was painted at the beginning of 1900. Its brushwork and lively colouring in yellowish and orange tones bring it close to the portrait of Lola and other works of this period.

The street of Riera Sant Joan itself became the subject of a sketch and a small oil called *The street of Riera Sant Joan from the artist's studio window* (cat. nos. 147, 148 see also fig. 76). In the drawing, from the same perspective as the oil, one can appreciate the outlines of windows in the foreground and male and female figures, well differentiated, with the facade of a church in the background. On the other hand in the oil, the artist, with an extended brushstroke, produces a semi-defined effect. The buildings and figures have been simplified in perceptible lines, very dense, which together with the general structure and light, give a sensation of profundity and movement infrequent in his previous work.

Nevertheless, Picasso did not only concentrate on painting landscapes glimpsed from his studio windows, but during these years he worked on a series of compositions on themes related to poverty, illness and death. He adopted one of the ideas most widespread among the artists of Els Quatre Gats: that of decadence, inspired by the legends and mythology of north and central Europe, and strengthened by the social situation in certain sectors of Barcelona. With the works *At the end of the road* (fig. 58) and *A Country Funeral* (cat. no. 149) he breaks free from naturalism, giving priority to the pictorial rhythm and the brushstroke, as did Nonell in his series of "the cretins of Bohí"[7], making use of expressive distortions and simplified and closed silhouettes with heavy outlines. Both works present the same composition: two files of persons on the way to a hermitage at the end of the road, surrounded by a landscape without vegetation, which helps to emphasize the sensation of movement towards a final point.

In his works *Figures in a square with trees* (cat. no. 150) and *Black figures in a square with trees* (MPP, no. 422) he simplifies the silhouettes to the point where they

60. *Gypsy in front of La Musclera*. Barcelona, 1900. Pastel and oil. 44.5×59.7 cm. Private collection, Paris. Zervos 21, 167.

are reduced to a simple black shadow. However, in another sketch (fig. 59) the artist comes closer to the people who turn out to be be priests reading and walking in front of the monastery or seminary.

The dramatic tradition of nordic aesthetics and themes inspired Picasso to doing two compositions to illustrate two poems by Joan Oliva Bridgman, a defender of the ideology of Nietzche, in the review "Joventud" (no. 12 and 27 of 1900). The sketches to illustrate the first of these *The Virgin's Claim* (MPB 110.341, 110.341 R, 110.669) are very close to some works by the Norwegian Edvard Münch, but for *To be or not to be* (cat. no. 151) Picasso chose a man struggling in a rough sea and menaced by huge storm clouds, in order to represent the relativity of being and the continuous fight for human existence[8].

Now, at the same time as he was producing these introspective works, youth and vitality took Picasso and his friends to places of leisure and relaxation. Palau confirms that Picasso and the Reventós brothers frequently visited a bar on the shore called "La Musclera" (The Mussel Seller) to eat mussels and drink wine from the porron[9], a bar which he painted in two versions. In the first of these (cat. no. 152) with dense brushwork and subdued and wintry tones, he concentrated exclusively on the building, without even noting its proximity to the sea. Through his brushwork, full of paint and sombre colour, we can date it in the winter of 1900. On the contrary, the second version, *Gypsy in front of La Musclera* (fig. 60), done with oil and pastel in lively colours and a smooth brushstroke which give it a more spring-like aspect, is related with a series of luminous works which he did in the summer of 1900. Here the tavern has ceased to be the object of attraction to the painter, who gives prominence to the figure and the marine surroundings, with the sun reflected in the sea which bathes the shore, where a sailing boat is anchored next to the tavern (the Picasso Museum has a preparatory sketch for this painting, cat. no. 153).

In this summer of 1900 Picasso used the technique of pastel, or pastel mixed with oil, in order to portray "Spanish" subjects, full of sun and Mediterranean luminosity, which he thought perhaps he would be able to sell in Paris, following in the steps of his friend Ricard Canals, who had already tasted the honey of success in Paris with this folkloric theme[10]. Maurice Raynal considered that in these pastels the intensity of the colour approximated to a play, already "fauve", of pure and brilliant tones. *Spanish couple in front of an inn* (cat. no. 154) is one of these pastels, coloured with great intensity and liveliness, which recall the line of Steinlein through the perfection of the drawing, an artist whose work Picasso knew from the magazine "Gil Blas" which was regularly received in Els Quatre Gats. Picasso highlighted the importance of this review when he drew the letters of the name on the topcoat pocket of his portrait of his father, done in 1899 (MPB 110.032). The Spanish couple in this composition followed the idea of representing typical scenes, which also motivated the atmosphere in other pastels of bullfights and their surroundings, as in *Entrance to the bullring* (Z. 21, 141). The Mediterranean luminosity and the blue sea of the background in the painting lead us to place the work either in Barcelona in the summer of 1900 or in Málaga in December of that year, after he had been some months in Paris. The Andalusian costume of the central couple could lead us to place it in Málaga, but Picasso had already devoted several drawings and paintings belonging, without question, to his Barcelona period, to this Andalusian subject matter (for example *Andalusian patio*); in consequence we prefer, as does Pierre Daix, to live with the ambiguity and date it 1900 without being definite as to Barcelona or Málaga.

The structure with awnings depicted in the background of *Spanish couple in front of an inn*, on the road to the sea, forms the subject of the work *Snack-bar* (cat. no. 155). With less intense colours, as if the awning protected it from the intense Mediterranean sun, it shows some people seated at a table, handled with simplified forms, with marked volumes and an absence of meaningful features. The sea in the distance does not have

61. *Lovers in the street*. Paris, 1900. Oil. 65×50 cm. Private collection, United States. Zervos 1, 25.

62. Front cover of the preliminary issue of the review *Arte Joven*. Madrid, March 1901. Copy belonging to Museu Picasso.

the intensity of the preceding work. Although it is done in pastel, its formal character and colour place it well into the winter of 1900, rather than in the summer, when luminosity broke out in his work. *Snack-bar*, the title of which appears in pencil on the back, was shown in the exhibition of Modernist Art in Bilbao, August 1900[11].

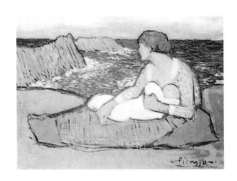

63. *Motherhood.* 1901. Oil on card. 52×67 cm. Private collection. Not catalogued by Zervos.

Paris, autumn 1900

The Universal Exhibition in Paris, which opened on 14th April 1900, motivated intense work on the part of the Catalan artists who wanted to present their works there. Picasso, who showed his work entitled *Last Moments*, wanted to join the group which had already travelled to Paris and together with Casagemas began the journey in October 1900. In Paris, they established themselves in the studio which Isidro Nonell passed to them at 49, rue Gabrielle, in Montmartre.

Picasso received there the direct visual impact of that impressionist art so venerated in Els Quatre Gats. His painting now became more brilliant, more colourist and with less literary content. It acquired rapidity in the line and ease of rhythm and accentuated the simplification and abandonment of detail. If the impressionist influence was a determinant in his work of this autumn, its complete assimilation did not appear until his return to Spain.

Nonell, in addition to lending him the studio, introduced the young Catalan to Pere Mañach, who had set himself up in Paris as an art dealer and who, in his turn, put him in touch with Berthe Weill who had an art gallery and who bought from him three pastels of bullfights.

During the autumn of 1900 Picasso lived and worked essentially in Montmartre and painted street scenes with the flat colours and simple lines of Steinlein's style. The open-air scenes *The Embrace* (cat. no. 156) and *Lovers in the street* (fig. 61), are variants of a whole series dedicated to the embrace and the lovers' kiss, begun in Barcelona although less passionately[12], and developed in Paris and Madrid in various interior scenes[13], indicating his route of research into the same theme through a series of canvases, such as Münch had also done in a series of sketches and woodcuts on the embrace between 1897 and 1902.

In the two scenes of the embrace in the open air, the couple are deliberately disproportionate in relation to the landscape, which is treated with a normal perspective. Thus the background underlines the disproportion, making it as though the space of the couple were isolated within the urban space, which acts as a support for the principal theme, the embrace in public. In *The embrace* (cat. no. 156) there is no preoccupation with the detail of the faces, nor for the folds of the clothes, only for the passion of the embrace. The flat and simple colours indicate the translation to the pastel and to the oil of the simplifications of the lithograph. In *Lovers in the street* the landscape is sharper and is identifiable as a street of La Butte (Montmartre), confirmed by Picasso himself to Pierre Daix[14].

Madrid 1901

Picasso's first stay in Paris lasted only a few months and in December he returned with Casagemas to Barcelona and then moved almost immediately to Málaga. After a few short weeks with his Andalusian relations, Picasso moved on to Madrid and Casagemas returned to Paris.

In Madrid, with his friend Francisco de Asis Soler, a young Catalan who had managed the modernist magazine "Luz" in Barcelona he tried to take the modernist Catalan spirit to Madrid through a magazine entitled "Arte Joven", which tried to replicate the Barcelona artistic reviews, such as "Quatre Gats" and "Pèl i Ploma". "Arte Joven", which was only published five times betwen March and June 1901, enjoyed the collaboration of some members of the generation of 1898, such as Pio Baroja y Azorín and some important representatives of Catalan modernism, such as Rusiñol.

During this Madrid period he maintained two different styles at the same time: the first, a luminous style with energetic brushstrokes and lively colours, a consequence of what he had discovered in Paris and similar to the work of Anglada Camarasa at this time; the other a series of paintings and sketches close to the work of Zuloaga who at this time bought some drawings from him (now in the Museo del Cau Ferrat). In this line, he painted two small oils which represent village life from the centre of Spain: *Village Bullfight* (Z. 21, 309) and *In front of the church* (Z. 21, 308), in which, without attaining the pungency of "the cretins" by Nonell, there is the trimming back of the people and the brevity of the brushstroke. Picasso brought these paintings with him to Paris and they relate to the numbers 43 and 44 in the catalogue of the exhibition which he had with Francisco Iturrino at the Galeries Vollard[15]. Pierre Daix's researches have listed most of the works exhibited there and, probably, one of the easiest to identify is the pastel entitled *Toledo* (Z. 6, 363) which was no. 45 and was called "Spanish village". A preparatory drawing *Old man from Toledo (Le Cchemineau)* (cat. no. 157) also done in Spain in 1901 was taken to Paris by Picasso and dedicated to Berthe Weill in June. As Palau i Fabre points out[16], these two works and the cover for the preliminary number of the magazine "Arte Joven" (fig. 62) are the result of a trip to Toledo, certainly motivated by his admiration for El Greco. The landscape which they represent does not correspond exactly to any real part of the city, but they are evocations or synthesized memories of the views from the train between Madrid and Toledo. The town is shown compacted around the church with the smooth mountains in the background, scarcely sketched. The people are kept in the line mentioned above, and only the male figure which appears in the three works seems to be the fruit of direct observation, with detail in the features and expression and in the typical attire of the region. The dedication to Mlle. Weill which appears on *Le Chemineau* demonstrates the progressive abandonment of his paternal surname and the adoption of his mother's name as his artistic name, which culminated exactly on his second trip to Paris.

Picasso left Madrid in the spring and returned to Barcelona before beginning his second visit to Paris, accompanied this time by Jaume Andreu Bonsems. The stay in Barce-

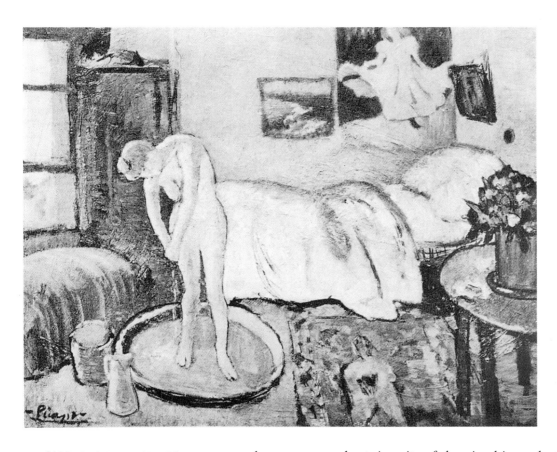

64 *The bath*. Paris, 1901. Oil on canvas. 51×62.5 cm. The Phillips Collection, Washington, D.C. Zervos 1, 103.

lona was very short, in spite of showing his works together with those of Ramón Casas in the Sala Parés from 1st to 14th June[17].

Paris 1901

Mañach had managed to arrange a exhibition for Picasso in the Galeries Vollard, jointly with Francisco Iturrino, which was the reason for the brevity of his stay in Barcelona and his rapid move to Paris. This time he stayed at 130, Boulevard Clichy.

It was now that the division of brushwork and heightening of colour appeared in his work, but without abandoning his search for realist inspiration which he recomposed very freely. With this divided and brilliant brushwork he painted a series of seascapes with violent chromaticism. These can be seen to be influenced also by the Joaquim Mir's Mallorcan period, whose works Picasso could have seen in the Sala Parés, as they were preparing an exclusive exhibition for him for October.

In the two versions of *The Mediterranean* (cat. no. 158 and Z. 21, 150), the short brushstrokes, with pure and lively colours, densely charged with paint, depict the sea breaking on the cliffs and the bushes in the foreground; the clouds in the sky are worked with a flatter and longer brushwork. There is a version of the same landscape, *Maternity*

193

(fig. 63), in which a woman is shown with her son, looking at the rough sea, which is a prelude to one of the most characteristic subjects of his next period. The two versions of *The Mediterranean* were shown in the Vollard exhibition as nos. 49 and 50. Picasso must have been satified with the result achieved by the small oil *The Mediterranean* (cat. no. 158) because in his painting *The bath* (fig. 64) which shows a scene in his studio in Boulevard Clichy, it appears hung on the wall beside a reproduction of a Toulouse-Lautrec poster for Mary Milton. It is also shown (fragmented) in the upper right hand part of one of the portraits which he did of Gustave Coquiot (Z. 6, 16).

In the studio in Boulevard Clichy Picasso approached again the subject of the landscapes seen from his window, as he had done in Barcelona, first in the calle Escudillers Blancs and subsequently in the studio which he shared with Casagemas in Riera Sant Joan. Picasso now occupied the flat in which Casagemas had lived before his suicide in February 1901.

The artist, curious and unsettled by the Parisian life, painted many scenes reflecting the Parisian customs, new and different for him. From the studio in Boulevard Clichy he painted two oils, one of the square and buildings in front entitled *Boulevard Clichy* (fig. 65) with a rain of multicoloured brushstrakes, strident and light, well defined, and another called *Blue Roofs* (cat. no. 159), both painted in the short time between his arrival in Paris and the opening of the exhibition in Galeries Vollard, where they were shown with the nos. 30 and 23. Picasso ceased to use the strident colour in his *Blue Roofs* and, with a technique remote from drawing, constructed the composition with brushstrokes divided and broad, perceptible, that marked the volumes of the tiled roofs and contrasted with the short and rapid strokes of the view of the Boulevard. The dominant blue of the roofs is supported in light yellow or green touches to set off the light and shade. The white brushstrokes which represent the clouds, with thick paint and in an oblique sense to all the rest, give the composition a definite imbalance accentuated by the diagonal line from the bases of the roofs. With these works Picasso followed his enthusiasm for representing his immediate environment and its surroundings, a theme which would continue in his blue period and the many subsequent representations of windows in 1919 and studios throughout his whole life.

The city offered a thousand possibilities and Picasso took an interest in every aspect of the urban life, from Montmartre to the streets of Auteuil and Longchamps, from the Moulin Rouge and the night-life to the activities of children and their mothers or nannies in the daytime. He continued in his chromatic research with great freedom, going further than impressionism, "recomposing, through the freedom given to the colour, a new plastic world, the same as the Fauves or Bonnard"[18]. Some art historians have seen in these works a "pre-fauvism", equivalent to what was being done at the same time by Matisse and Marquet. Although Picasso did not reach the chromatic exaggeration of fauvism he had in common with the future Fauves the feeling of doubling the reality of the construction through colour, overcoming the fleeting light effects of the impressionists by turning it into a means of expression by itself.

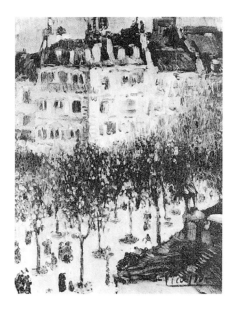

65. *Boulevard de Clichy.* Paris, 1901. Oil on canvas. 61.5×46.5 cm. Private collection, Houston, Texas. Zervos 1, 72.

NOTES

1. See MPB 110.634, 110.706R, 110.783, 110.784, 110.791.

2. Sabartés: Portraits et souvenirs, p. 20.

3. ibid. p. 25.

4. See MPB 11.354

5. Palau i Fabre: Picasso vivent, p. 164.

6. Sabartés op. cit. p. 40.

7. Nonell went to Bohí in 1896 with Juli Vallmitjana and Ricard Canals. He showed the series "the cretins of Bohí" in Barcelona, 1898.

8. The Picasso Museum in Barcelona possesses a series of preparatory drawings: MPB 110.769, 110.769R, 110.801 and 110.801R.

9. Palau, op. cit. p. 192.

10. Daix, Picasso 1900-1906, p. 118.

11. Rivero; Fine Arts Museum Annual, Bilbao, 1993, p. 59.

12. See MPB 110.754, 110.735, 110.724, 110.414R.

13. Zervos, 1, 26 and Picasso Museum, Paris, no. 433.

14. Daix, op. cit. II, 13, p. 123.

15. "Exhibition of pictures by F. Iturrino and P.R. Picasso at the Galeries Vollard, Paris, from 25th June to 14th July, 1901"

16. Palau, op. cit. p. 215.

17. Miguel Utrillo, organizer of the exhibition, published an enthusiastic article in "Pèl i Ploma", no. 69, of 6th June, 1901.

18. Daix, op. cit. p. 42.

The strolling flowerseller (cat. no. 160) is part of this series of daily scenes set in public places in which Picasso recomposed actuality with great liberty, above all in the colour. This oil, of strong chromatic intensity, constructed by long broad brushstrokes for the people closest and with little touches of colour for the vegetation in the park, the flowers and other details, brings together a series of people and elements which are shown in other works of this same period. The similarity of the buildings with those in *Lovers in the street* by Picasso himself, one of the sloping Montmartre streets, locates for us the flowerseller's route through the streets of La Butte. For some reason this flowerseller caught Picasso's attention and he represented her in three paintings, as though he followed her around. The same girl, accompanied by a child, is shown in *Bar in Montmartre* (Z. 21, 282), trying to sell her flowers to the bar customers; we also see her walking with her basket full of flowers in *Public Gardens* (Z. 1, 78) and finally perhaps in another corner of the same gardens in the *Strolling Flowerseller*. Behind her, some little girls are running away, by their reddish hair, white clothes and the movement of their legs, we can identify them as the same children as in the *Children's Roundabout* (Z. 21, 302), which was shown in the Vollard exhibition as no. 16, which enables us to pinpoint the painting of this work as in the period immediately before the opening of the exhibition.

Picasso, in this series of depictions of Parisian life, as opposed to the impressionism which made the human beings disappear into the background, and like the Nabis and other contemporaries, was attracted by the bustle of the city and on many occasions the background and architecture are no more than a decoration for the human activity and the variety of people living in the great city.

139. Parody of a Votive Offering
Barcelona, 1899-1900
Oil on canvas, 55.6×40.8 cm
Museu Picasso, Barcelona

140. WOODS ON A MOUNTAIN SLOPE
Barcelona, January 1899
Oil on canvas glued to panel, 22.4×27.3 cm
Museu Picasso, Barcelona

141. INNER HARBOUR
Barcelona, 1899
Conté pencil on paper, 23.5×33.5 cm
Museu Picasso, Barcelona

142. CLOSED BALCONY
Barcelona, 1899
Oil on canvas, 38.5×28 cm
Museu Picasso, Barcelona

143. BALCONY WITH NET CURTAIN SEEN FROM INSIDE
Barcelona, 1899
Oil on canvas, 21.8×13.7 cm
Museu Picasso, Barcelona

146. ROOFTOPS AND SANTA MARTA CHURCH
Barcelona, 1900
Oil on canvas, 21.1×22.5 cm
Museu Picasso, Barcelona

144. View of Snowy Landscape from an Interior
Barcelona, 1900
Oil on canvas, 50×32.6 cm
Museu Picasso, Barcelona

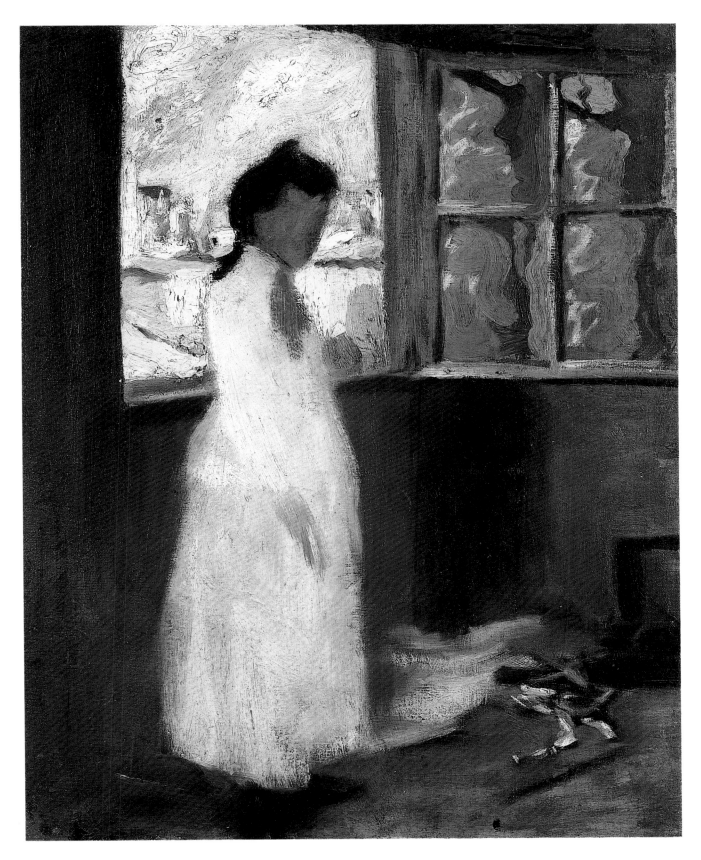

145. Lola, the Artist's Sister, in the Studio in Riera Sant Joan
Barcelona, 1900
Oil on canvas, 55.7×46.2 cm
Museu Picasso, Barcelona

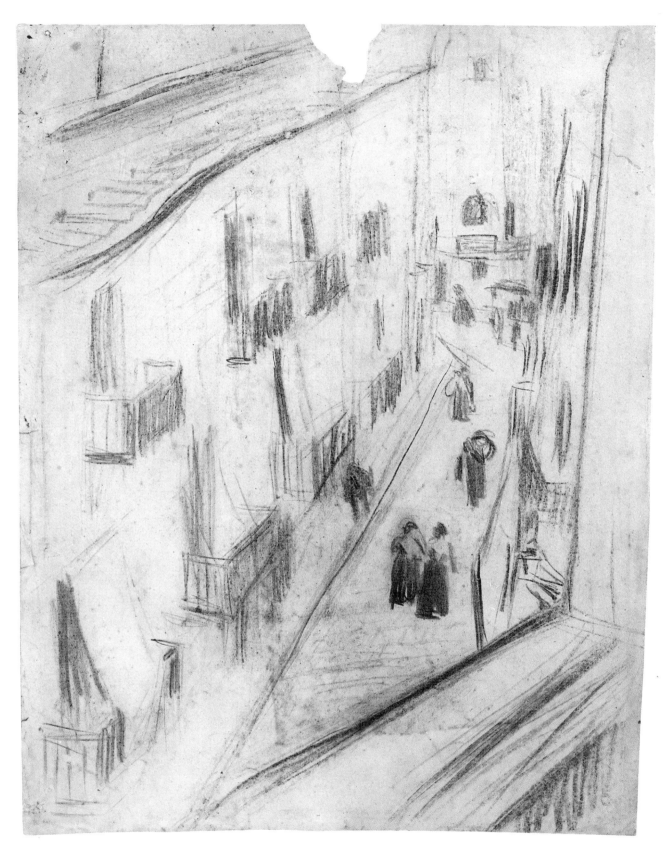

148. The Street of Riera Sant Joan from the Artist's Studio Window
Barcelona, 1900
Charcoal and conté pencil on paper, 34.8×26.1 cm
Museu Picasso, Barcelona

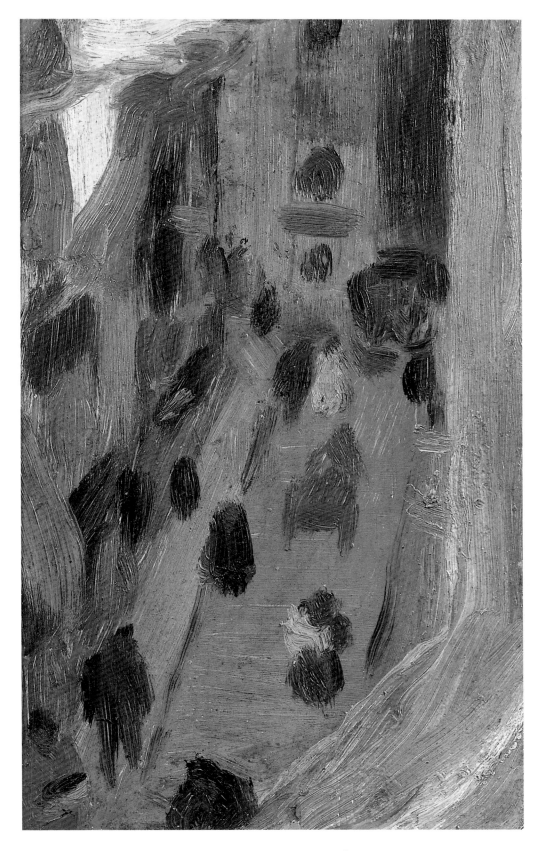

147. THE STREET OF RIERA SANT JOAN FROM THE ARTIST'S STUDIO WINDOW
Barcelona, 1900
Oil on panel, 22.3×13.8 cm
Museu Picasso, Barcelona

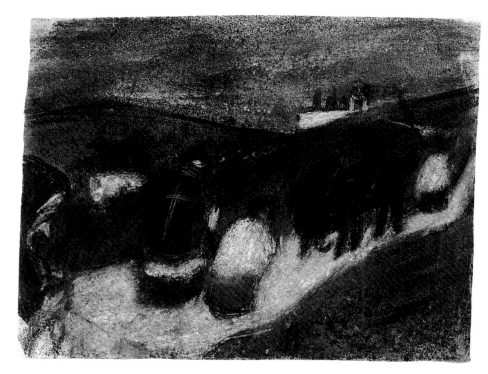

149. A COUNTRY FUNERAL
Barcelona, 1900
Pastel on paper, 24×30.6 cm
Museu Picasso, Barcelona

150. FIGURES IN A SQUARE WITH TREES
Barcelona, 1900
Charcoal and conté pencil on paper, 16.2×23 cm
Museu Picasso, Barcelona

151. TO BE OR NOT TO BE
Barcelona, 1900
Charcoal on laid paper, 29.5×40 cm
Museu Picasso, Barcelona

152. "La Musclera"
Barcelona, 1900
Oil on canvas, 48.1×48.3 cm
Private collection, Paris

153. WOMAN SEATED ON A WHARF
Barcelona, 1900
Pen on paper, 21.8×31.8 cm
Museu Picasso, Barcelona

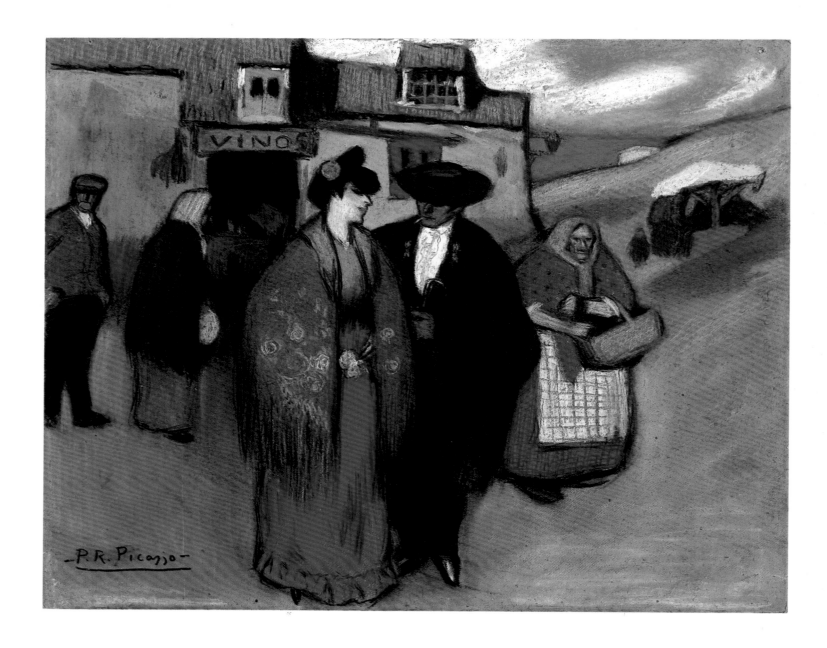

154. SPANISH COUPLE IN FRONT OF AN INN
Barcelona, 1900
Pastel on paper, 40×50 cm
Kawamura Memorial Museum of Art, Sakura

155. SNACK-BAR IN THE OPEN AIR
Barcelona, 1900
Wash, pastel and charcoal on card, 24.6×30.6 cm
Museo de Bellas Artes, Bilbao

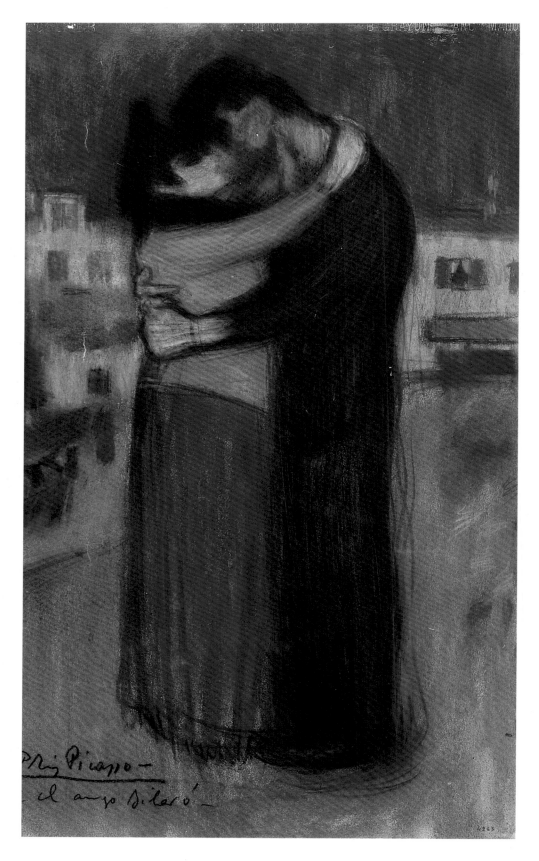

156. The Embrace
Paris, 1900
Pastel on paper, 59×35 cm
Museu Picasso, Barcelona

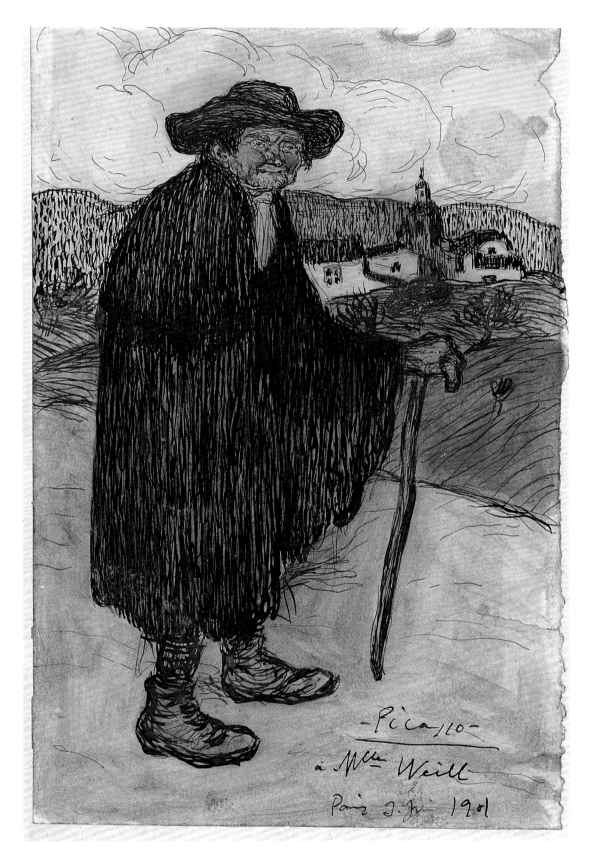

157. Old Man from Toledo (Le Chemineau)
Toledo, 1901
Pencil and wash on paper, 20.4×12.4 cm
Musée des Beaux-arts, Reims

159. BLUE ROOFS
Paris, 1901
Oil on cardboard, 40×60 cm
The Visitors of the Ashmolean Museum, Oxford

160. THE FLOWER SELLER
Paris, 1901
Oil on cardboard, 33.7×52.1 cm
Glasgow Museums: Art Gallery and Museum, Kelvingrove, Glasgow

158. THE MEDITERRANEAN
Barcelona, Spring 1901
Oil on cardboard, 27.5 36.5 cm
Private collection, Paris

THE BLUE PERIOD

Claustre Rafart

Between the autumn of 1901 and the end of January 1902 Picasso's work underwent a radical thematic and chromatic change. New protagonists emerged under the pressure of the heavy load of personal concerns, circumstances, social and cultural factors which the artist here discharges freely, while the subtlety of a monochrome blue[1], of infinite nuances, creeps into his canvases creating an atmosphere in which "Tout cela c'est du sentiment"[2].

The predominance of blue became so general that it gave a name of Picasso's work between 1901 and 1904, a period in which, according to the personal reminiscences of Sabartés, "he believed that art emanated from sadness and pain. We agree, he and I. That sadness fosters meditation and that pain is fundamental to life"[3].

Landscape appears in some drawings and paintings of this period although in many cases it is subordinated to figures. Generally they are rural and impersonal scenes clearly influenced by symbolism.

The sea, which had enjoyed a privileged place in the artist's formative years, now reappears. The greenish and bluish tonalities which spread from it, rich in romantic and decadent associations, and the grandeur that they bring, awake in the spectator a feeling of melancholy and mystery which is fully adapted to the artist's ideas at this time, which are, without doubt, in good part those which he assimilated at the time of his links with Catalan Modernism.

In some works from this time, such as *Mother and child by the sea* (cat. no. 161)[4], the influence of ancient art is clear[5]. The small panel is impregnated with the old Mediterranean through one of the most classical traditions portrayed by Puvis de Chavannes[6]. This artist often took the mythological landscapes from the paintings of ancient Rome in the representation of scenes in his own works. Picasso, through his predecessor, connects with this type of landscape and like him uses it, for example in this little panel where, as in other works of the time, the beginnings of Mediterranean antiquity, rooted in the Greek sense of human values and with nature in second place, are present. The treatment of the outlines of beach, sea and sky form the background frame, as in Roman murals. The bluish, red and ochre tonalities, combined with the anonymity of the figures with their backs to us, accentuate the symbolism of the work.

Between 1901 and 1902 several drawings and paintings by Picasso have the sea as a background for a series of scenes in which two themes predominate, motherhood and the activities of the port. *Mother and daughter by the sea* follows the thread of a series of works, of great plastic beauty, done in Barcelona in 1902, among which *The fisherman's farewell* (fig. 66), *Mother and child in profile* (fig. 67) and *Mother and child by the sea* (fig. 68)[7]. In all these works the mothers and their children, either in their arms or by their sides, are beings brought forth by a world of misery and desperation, sinful and melancholy, set on beaches without any specific association, in front of a calm blue sea. They are seascapes without time and outside real space, "des limbes bleus" as Richardson calls them, which Picasso uses to create authentic atmospheric impressions.

The following year, the beach and the sea are again the frame against which poor and marginal elements of society are assembled. The seascape is more inhospitable than ever and the visual vocabulary of the artist is the most frightful of the whole Blue Period, achieving more than ever the synthesis in mood between landscape with figure[8].

Drawing has a predominant role during this period. It is, in the beautiful words of Raynal, "(...) discreet, severe, often sharp, always expansive, easy, sure of itself, of the authenticity of the feeling which it inspires, and enlivened with curves of a soothing delicacy which temper the asceticism of the composition"[9]. Picasso values the intensity of outline and the graduation of chiaroscuro which give more drama to his works, in this way he obtains a greater liberty in the whole and more intensity and sensitivity for the structural form, as the pen drawing *Motherhood on the wharf* (cat. no. 162) shows, with great mastery of composition and scenic dynamism. Again the action is set on the edge of the sea, but, now, we have two blocks of figures before us, formed, one by the mother with her child[10] and the other by the boat and the men who are at work loading and unloading. This drawing is part of a series of drawings connected with *The fisherman's farewell*[11], very close to *The poor fisherman* (fig. 69) by Puvis Chavannes[12] and linked with the drawings of the boat and the seamen which appeared so frequently in Picasso's work during his training.

67. *Mother and child in profile.* Barcelona, 1902. Oil on canvas. 83×60 cm. Private collection, New York. Zervos 6, 478.

66. *The fisherman's farewell.* Barcelona, 1902. Oil on canvas. 83×60 cm. Private collection, Küsnacht, Zurich. Zervos 21, 365.

220

68. *Mother and child by the sea.*
Barcelona, 1902 or 1903. Pastel. 46×31 cm.
Unknown collection. Zervos 1, 381.

69. Pierre Puvis de Chavannes: *The poor
fisherman*, 1881.

The landscape, lacking any real reference, is transferred also to a group of pastoral scenes such as *The Golden Age* (cat. no. 163)[13]. The central theme of the composition here is a conversation between a shepherd, nude, with a lamb under his arm[14], the forerunner of the shepherd figure that we find in Picasso's later work, and a mother with a child in her arms. In the middle ground a peasant works the ground which the flock grazes. Picasso contours the figures with a firm line and with great command of technique and shading and achieves, by means of a continuous tracing, a delicate shading in the figure of the shepherd and in several areas of the landscape—again, more symbolic than perceived. The serene calm of the figures recalls the Arcadian landscapes, so much praised by the classical poets, above all Virgil, that great inspiration of landscape for Renaissance and later artists, which are the protagonists of a part of Picasso's work in 1905 and 1906.

The portrait of Juli González

The *Portrait of Juli González* (cat. no. 164) is a delicate watercolour in which Picasso blends together two artistic genres, landscape and portraiture, an uncommon alliance in the artist's Blue Period works.

The landscape, in spite of being the dominant element of the composition, becomes a prop to the human figure. The view of Barcelona from Tibidabo frames the work as a source of harmony in relation to the figure in the foreground, and in this way shows us, yet again, the great technical command which the artist had attained during his academic apprenticeship.

In contrast with many Blue Period works, in which nature has a more symbolic than actual role, the artist offers us in this drawing a natural view of the setting. The narrative and scenic elements that are used here are not common in Picasso's work in this period. However, from the technical point of view, the use of watercolour, and of gouache, coloured pencils and ink is fairly frequent in works of this time.

The dating of the work is not exact. Daix and Boudaille consider that from its execution it could be from 1901 or 1902[15]. Palau inclines towards a dating of 1902[16]. This author places the drawing in a context of time with the opening of the funicular tramway 'which goes up to Tibidabo[17] which took place in 1901, a moment when Picasso was still in Paris. When he returned to Barcelona, it is more than likely that his curiosity about this new form of transport led him to go up and try it, as did many Barcelona people of the time. The excursion was made, certainly, in the company of his friend González[18].

Picasso delights us with an exquisite description of the natural elements and of the figure of his companion, through the use of a sharp outline of the forms and a well resolved perspective. He projects the panorama through an ordered arrangement in three correlated planes. In the first is the mountain on which Juli González, with a slightly

melancholic expression, is relaxing while admiring the panorama of the city. In this am-
bit the landscape elements and the character present well-modelled outlines of the set-
ting, done in ink, clearly defining the volumes which, later, will be coloured in soft tones.
He works the grass with very elementary graphics which he also employed in *Summer
landscape* (fig. 70)[19], a work structured in a manner similar to this one, but where the
landscape is the only element of the composition. A second plane offers a general view
of the city, preceded by some fields, areas of colour which introduce us to the sketched-
in urban area of Barcelona at the beginning of the century, where, on the right of the
spectator, with a red line done with a brush, it seems that the artist outlines the quad-
rilateral silhouette of the "Eixample" or Expansion which was then in the course of con-
struction. Beyond, in the third plane, is the sea, of an intense blue, making a line with
the faded reddish colour of the sky. The structure of the landscape of this composition
recalls to us some of the landscapes by Dario Regoyos[20].

In fact for Picasso, notes Antonina Vallentin, landscape, at this time, is a lesser type
of art, "he seems to plunge into what he sees, prepared to take on a new subject—a bit
in the manner of an orchestra which tunes up before attacking a symphony"[21] and
though it is true that on some occasions the artist does landscapes, it is not a favourite
genre in Picasso's work during this period.

Portrait of Juli González is not the only work that Picasso devoted, that year,
to the portrait in nature. In *Self-portrait on the beach* (fig. 71)[22], he also uses this type
of composition, applied to himself, although in a more graphic manner than he employed
in the portrait of his friend. This drawing is formed of two correlating planes. In the
first, the figure of the artist stretched out on his side on the beach, in the manner of
the ancients, occupies all the perceptible space, with his body bare and a loincloth knot-
ted round his waist and covering his legs, his palette at his side. He contemplates the
immensity of the ocean which constitutes the second plane of the composition, as far
as the limit where the horizon meets the blue sky. This type of flat perspective brings
us again close to the classical description of nature which we have seen in others of Pi-
casso's works from this time.

Rooftops

In January 1902, Picasso returned to Barcelona after the sojourn in Paris[23]. Short-
ly after his arrival he set himself up in the studio which his friend Angel Fernández de
Soto[24], had rented in the street Nou de la Rambla. Sabartés describes it: "(...) The studio
is on the roof of one of the first houses, on the right, entering from the Rambla: just be-
side the Eden Concert. Angel F. de Soto rented it to live in during the absence of his fami-
ly, and the painter Roquerol paid half the rent, because he used it to work in"[25] ...

The arrival at the new studio aroused Picasso's curiosity about these new surround-
ings which he began at once to record. The results of this first look outside are the

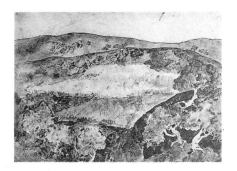

70. *Summer landscape*. Watercolour.
25×32 cm. Zervos 6, 296.

71. *Self-portrait on the beach*. Barcelona,
1902. Ink and coloured pencil on the back
of a business letter. 9×14 cm. Junyer Vidal
Collection, Barcelona. Zervos 1, 129.

73. *Barcelona rooftops.* Barcelona, 1902. Pastel. 37.8×50.9 cm. Zervos 6, 250.

72. *The blue house.* Barcelona, 1902. Oil. 50.5×40.5 cm. Heirs of Gertrude Stein Collection. Zervos 21, 280.

urban landscapes *The Blue House* (fig. 72)[26] and *Rooftops of Barcelona* (cat. no. 165). As he has done before, the artist takes us out sometimes precipitately towards the street and shows us perspectives of houses and scenes of great beauty and excellent compositional ingenuity. At other times he shows us a whole group of structures seen from the rooftops, something that has attracted him for a long time and which now leads him to produce a series of works in which he eliminates detail in order to penetrate further, towards the limit almost of abstraction, and focus on the silhouettes of the town seen from the tops of the houses.

Rooftops of Barcelona[27] is one of these views, in which Picasso offers us an urban perspective with a structure of lineal planes floating in a melancholy light, giving an architectural vision. It is, according to Cirlot, an admirable study of the construction of forms and a pleasant hymn to the night[28]. The twilight view of the townscape brings a new vision to the volumes, converting this oil painting into a magnificent study of composition of forms, achieved by means of colour. The blue is more intense than the grey-blue or greeny-blue that he used in Paris. The intensity of the sun in Barcelona makes the shadows more accentuated and the blue has a stronger tonality, which Sabartés will later call "the Barcelona Blues".

In this oil, the artist combines short and irregular brushstrokes with long, vertical and horizontal. This, together with the alternate use of very thick brushstrokes and others more diluted and the heavy outline painted in oil of some elements of the roof in the foreground, accentuates the contrasts of sun and shade and gives more projection to the perspective. On the back of the picture is a rural landscape with mountains in the distance. A succession of fields extends towards them, finally losing themselves in the valley formed by the mountains. In the cultivated area, of flat perspective, there are some peasants working on the land, while the dry grass which they have cut is burning on a bonfire. The oil shows very diluted brushwork, except in the carmine field in the dis-

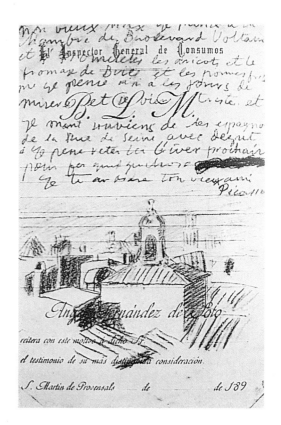

tance which is more granular. What is really surprising about this painting is the palette used by the artist, very unusual for him, with carmine mixed with white or with vermilion in some of the fields.

Picasso had worked on urban views before. Two works can be placed as immediately preceding this view of Barcelona. *Blue tiles*, done from his studio in Boulevard Clichy[29], an oil of exuberant chromaticism, and, especially, *Rooftops of Barcelona* (fig. 73)[30], with a portentous reduction of colour.

After some months of work in Barcelona, Picasso went back to Paris in October 1902. He stayed there until January 1903 when he returned to Barcelona in a desperate condition. Here, he set up in a studio in the street Riera de Sant Joan that Angel Fernández Soto had rented while he had been away. It was the same studio as Picasso had shared with his friend Carlos Casagemas[31] at the beginning of 1900. Again, the comments of Sabartés give us the surroundings in which his friend was working: "From the windows of the studio one can see the towers of the cathedral behind the closer tiled roofs and flat rooftops, and looking about one could make out the belltowers and facades of other churches"[32].

Sabartés tells us also of a letter which Picasso wrote to Max Jacob, which Hélène Séckel dates in the summer of 1903[33], in which he invites him to Barcelona for the holidays and remembers, as Séckel points out, the "days of misery" that he spent in Paris. The letter is illustrated with two sketches of the old city, in one is the cathedral and in the other the church tower and belfry of Santa Marta (figs. 74 and 75)[34]. We can admire the Baroque facade of this church in the oil *Barcelona by night* (fig. 76)[35] where the artist takes us into the narrow alley, giving us a good view of this passage which was to be demolished in the urban remodelling of the area. This rapid projection recalls to us the perspectives that he did of the same place in 1900[36].

75. Letter from Picasso to Max Jacob, from Barcelona. Summer 1903. Current whereabouts unknown.

74. Photograph of the Santa Marta chapel in the street Riera de Sant Joan, Barcelonal, about 1910.

76. *Barcelona by night*. Barcelona, 1903. Oil on canvas. 54×45.5 cm. E.G. Bührle Family Collection, Zurich. Zervos 30, 43.

77. *Barcelona Street and the Palau de Belles Artes*. Barcelona, 1903. Oil on canvas. 60×40 cm. Private collection, London. Zervos 1, 122.

These oils and *Rooftops of Barcelona* (cat. no. 166), produced during this new stay in Barcelona[37], show an excellent mastery in the plastic construction of the forms and an exquisite blue colour which dominates both compositions. Maurice Raynal later wrote: "It has to be noted that, also in this blue period, Picasso painted some architecturally organized landscapes (with reference to 1903), which show affinities with Italian pre-Renaissance painting. Perhaps we can see here an anticipation of the architectural concepts of cubism"[38].

Rooftops of Barcelona[39] is a lesson in how the artist submits the colour blue to the most diverse treatments, as a flat tint and as a contrast between light and shadow. He plays with blue tones which he shades down and intensifies, he superimposes blue-greens... thus creating within the work a whole amalgam of tonalities of an extraordinary plastic beauty.

Towards the end of this stay in Barcelona, he took a studio in the street Commerç, "(...) he rented a studio for himself alone (...)" Sabartés tells us. From there he prepared the last view of the city of Barcelona of the Blue Period, *Barcelona Street and the Palau de Belles Artes* (fig. 77)[40].

In April 1904 Picasso left Barcelona for good and went to live in Paris, where he rented a studio in the district of Montmartre in a building called "the trapper's house" later known popularly as Bateau-Lavoir[41]. Blue has not yet disappeared from his works, we now have what Daix and Boudaille call the Montmartre Blues, although, as Sabartés says, Picasso already knew that the Blue Period was over and, therefore, it is clear that he found himself on the brink of a change, "(...) But for that he had to change his environment, breathe other air, speak another language, change the conversation, exchange his ideas with others, see other faces and live another kind of life; throw himself into the hands of destiny (...)"[42].

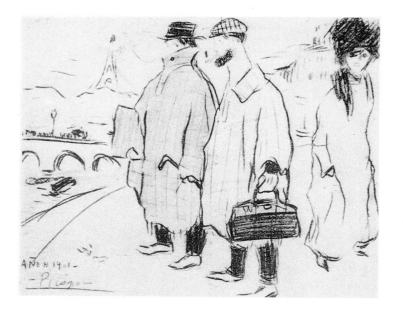

Looking for new motivations and discoveries, Picasso went all around the area where he lived, more receptive than ever. From these comings and goings through the hilly streets of the district, came the *Christ of Montmartre (Suicidé)* (cat. no. 167), inspired by a suicide who hanged himself in the locality. This figure, starved and impoverished, done in a mannerist fashion and with an expressive face and dishevelled hair, well represented in the Picasso iconography of the moment[43], dominates the composition. The urban landscape, a view of the suburb, is relegated to second place, acting as a scenic support to the figure, a true protagonist of tragedy. Palau refers to a text by André Warnold to explain the emergence of this composition in Picasso's work "Can a whole night's suffering be forgotten, of that painter to whom they had said that he looked like Christ and who stayed with his arms outstretched for hours together?"[44].

The view of Montmartre is finely worked in ink. The townscape is real. The houses are well structured and prolonged with a whole corner of roofs, merely sketched, showing a skeletal view of this quarter, so characteristic of the French capital. The tense atmosphere of the scene is accentuated by the muted treatment of the colour.

This picture surely is the work no. 16 which figures in the catalogue of the exhibition at Galeries Serrurier[45] in Paris and in all probability is the same as is referred to by Guillaume Apollinaire in his article *Les jeunes: Picasso, peintre*: "Pity made Picasso more bitter. The squares sustained a hanged man stretched out against the houses above the transient obliques. Those martyrdoms awaited a redeemer. The rope was hung miraculously from the skylights; the glass flamed with the flowers in the windows..."[46].

Strip cartoon of the journey to Paris

Picasso's Blue Period work, impregnated with an oppressive social burden in which, as Raynal says, art has a dramatic mission and is the fount of emotion more than of pleasure, is refreshed with work which is considered lesser, humorous and caricaturist, of a sarcastic and burlesque vein which the artist developed in parallel with more serious things.

80. *Sebastià Junyer and his vision of Mallorca.*
Ink and coloured pencils. 16×22 cm.
Zervos 6, 495.

81. *Sebastià Junyer painting by the sea.*
Ink and coloured pencils. 14×9 cm.
Zervos 1, 497.

The use of landscape as a means of plastic expression is not very common in the artist's humorous production at this time. In spite of that, it serves at times to put more emphasis on what he wants to communicate. These works surprise us, often, with scenes which are an amusing description, precise and immediate, of the atmosphere which surrounds him, at times depicted in a natural way, at times in an allusive manner. In any case, they are nearly always related to one or several human figures, the artist's own or those of his friends. They are an anecdotal account of the world in which he moves, in which, between 1903 and 1904, his friend Junyer has a privileged place[47].

Sebastià Junyer is his travelling companion on the fourth and final journey to Paris, on 12th April 1904. The story of the journey is reflected in the strip cartoon[48] which Picasso prepared. The series shows, with a great sense of humour, the ups and downs of the young people who, longing to take part in the currents of the avant-garde, direct their steps towards the capital of France, hopeful and dreaming of finding themselves a place there[49].

Picasso tells the story through six scenes—one has disappeared—on separate sheets: I. Picasso and Junyer depart on their travels; II. Picasso and Junyer arrive at the frontier; III. Picasso and Junyer arrive at Montauban; IV. Piccaso and Junyer arrive at Paris and VI. Junyer visits Durand-Ruel (cat. nos. 168-172). It is a strip cartoon with rhyming couplets which combine the descriptive with the narrative[50].

Three of the six drawings (I, II and IV) have a landscape background. The first is projected through the window of the train in movement. It is the nervous and rapid lines which suggest this more than the trees and the grass which are moved by the wind. The second, with a sure and flowing line, gives shape to the station house and the railway line. Lastly, the fourth, which is more carefully worked, is a scene of Parisian streets with buildings in the background and the Eiffel Tower in the distance[51]. In the other, III, the two young men are walking, with a decided air and well wrapped up, towards

82. *Sebastià Junyer wearing a toga and with a harp in his hand.* Coloured pencils. 27×37 cm. Zervos 6, 346.

83. *Sebastià Junyer.* Ink and coloured pencils. Zervos 6, 498.

the railway station. A last drawing closes the series (VI) in which Junyer and the dealer Durand-Ruel, the great merchant of the rue Lafitte as Ambroise Vollard calls him[52], exchange a picture of a landscape for a pocketful of money.

The scenes and figures have a common denominator, their comic tone of caricature. The descriptive elements are brief and the line, done in ink, is spontaneous and quick. In some areas he uses a cramped outline, while in others it is thicker, later he shades in the drawings with coloured pencils in soft tones.

The strip cartoon shows scenes from daily life which the artist mixes with youthful dreams. Desire is jumbled up with reality and hope and optimism wins, giving a happy ending, a good premonition, to the story: fame and money.

It is not the first time that Picasso has drawn a strip cartoon. Before leaving Paris in 1903, he dedicated one to his friend Max Jacob[53] which he called "The plain and simple story of Max Jacob" (fig. 78)[54]. He drew it in a bistrot on 13th January. It is divided into seven parts, done in ink, in which an extravagant and unreal tale unfolds about the literary doings of the poet. These cartoons have a precedent, being the first personal Picasso works in which school tasks had no place. Good examples of this are the Blue and White and Corunna diaries, full of notes about the family and the surroundings of that Galician town[55].

These early caricature drawings continue, developing in parallel with the rest of the artist's work. In these moments, in spite of the strong pressure which weighs on his serious work, Picasso keeps up this joking side in a set of works in which he amuses himself with the figures of his friends and himself. At times he shows the characters in fairly pungent or compromising situations, at others, he illustrates more innocent behaviour.

The attempt to reinforce the artistic language through caricature is shown also in the multiple drawings, refreshing and impudent, of Sebastià Junyer. In four drawings, Junyer is set in natural surroundings, enjoying the rocky coast and the sea, taking inspiration, or in the action of painting and even, in a true sublimation of the classic world,

setting him, dressed in a tunic, in front of the sea, with a harp in his hand, as though he is about to pluck a rhapsody, surely dedicated to the beauty of nature in Mallorca (figs. 80-83)[56]. Not in vain was he passionate about this place, "the delicate painter of Mallorca" Cirici called him. Junyer is distinguished for the poetic manner in which he painted the island landscapes[57]. Junyer was, according to Ocaña, "a poet, a lyricist of landscape", an opinion which agrees with that of the art critic Josep Junoy, a contemporary of Junyer[58].

NOTES

1. "(...) the symbol of evil, of darkness... of shame, of the chthonic, of matter, of the passive female, of night, of the idea of an Earthmother, is without doubt blue, the diabolical colour of the Egyptians, atmospheric traitor of the night, always the colour of mystery. A symbol of this human obsession, so popular in the growth of the romantic movement, is the blue flower of Novalis, which was certainly introduced to Catalonia by Juan Maragall's translations. And it is unnecessary to insist on the importance of the nocturnal in literature, shown as a vehicle for mystery, free in Shakespeare, sentimental in Young, and of an exalted mysteriousness in Shelley and D.H. Lawrence (...). Is it necessary to speak of so much full moon in German painting, from Altdorfer to Bröcklin? (...)" Cirici, 1946, pp. 126-127.

2. Zervos, quoted by Pool, Burlington Magazine 1959, no. 101, p. 177.

3. "We are passing through the period of life in which for everyone everything is still to be done: a period of uncertainty which each one considers from the point of view of his own misery, And because our life passes through a period of pain, sadness and misery, this, with all its torments, constitutes the fundamental basis of the theory on artistic expression" Sabartés, 1953, p. 75.

4. The Picasso Museum has a preparatory sketch: MPB 110.037.

5. This subject has been dealt with exhaustively in the doctoral thesis by Susan Mayer: *Ancient Mediterranean Sources in the works of Picasso*, Vol.I 1892-1937. Chapter IV. The Blue Period.

6. Picasso discovered the work of Puvis de Chavannes through the painter Santiago Rusiñol who was a devoted admirer. Rusiñol, as he was to be with El Greco, was a great partisan of the image of the French painter in Catalan society at the end of the 19th century. It could be that in the course of his first stay in Paris, in the months of October to December of 1900, Picasso visited the Pantheon where there are the Ste Geneviève frescoes; later, in January 1903, he made a sketch of the lower left section of the mural "Ste Geneviève arriving at Paris", MPB 110.468.

7. Daix/Boudaille, VII 19; Z. 6, 478; Z. 1, 381.

8. Daix/Boudaille, IX 4; Z. 1, 197; Z. 1, 208.

9. Maurice Raynal to Leymarie, 1971, p. 208.

10. Which links with the motherhood by the sea portrayals which we have already mentioned and with a series of drawings on this theme, among which are MPB 110.439 and 110.481, Z. 1, 137; Z. 1, 151.

11. MPB 110.444R; 110.447 and Z. 21, 354 and which have roots in others of that same year and the one before, Z. 1, 47, 127 and 141.

12. In 1898 the magazine "Luz"—2nd week of November—published a series of articles signed by Santiago Rusiñol and Raimon Casellas among others on Puvis de Chavannes. One of the reproductions used to illustrate the articles was "The poor fisherman".

13. Also Z. 1, 136.

14. Picasso broke up the figure of the shepherd in a series of drawings MPB 110.503; 110.490; 110.544R; Z. 6, 430, 431 and 432.

15. Daix/Boudaille, 1967, p.147.

16. Palau, 1980, P.304.

17. In 1899 a group of important Barcelona people decided to undertake the development of the mountain and construct a funicular railway to go up to the top. For this purpose they founded the company "El Tibidabo" in which the participants were Rómul Bosch i Alsina, Romà Macaya, Teodor Roviralta, Josep Gari and, especially, Salvador Andreu, "the soul of the work, a committed enthusiast, and honorable Barcelona citizen .." (El Funicular a Barcelona Atracción. December, 1926, num. 185, pp. 15-20). The *Tramvia Blau* was created in 1902.

18. Juli González (1876-1942) was part of what Palau, in allusion to people of the time, called "the González clan". He and his brother Josep, an artist, frequented Els Quatre Gats, where they met Picasso. The young men were soon friends. If the news published in the paper El Liberal on 20th October 1902 was true, Juli González and Josep Rocarol travelled to Paris with Pablo Picasso on 19th October 1902. Palau transcribed the press note: "The well-known artist Pablo Ruiz Picasso left yesterday by express train for Paris. He was accompanied by the distinguished artists Juli González and Josep Rocarol". Palau, 1971, p. 67 and Palau, 1980, p. 310, respectively. According to Richarson, Juli González was the only person with whom Picasso could discuss modern art. Richardson, 1991, p. 241.
A fine sculptor, González had a great influence on Picasso's sculptural work. This subject has been studied in depth in Spies, 1980.

19. Z. 6, 296.

20. Darío de Regoyos (1857-1913) was a painter from Cantabria who had strong links with the Catalan modernists. He is usually described as one of the most outstanding exponents of the so-called Spanish impressionism. Like the majority of Spanish landscape painters, he was a student of the Belgian artist Carlos de Häes who, as is well known, introduced to Spain the modern concept of landscape painted directly from nature.

21. Vallentin, 1957, p. 67.

22. Z. 1, 129. Palau calls it "Self-portrait with palette in hand". Palau, 1980, 743.

23. In May 1901 Picasso left Barcelona, accompanied by Jaume Andreu Bonsoms, to stay for a

time in Paris. It was his second journey to the French capital. He lived in a studio at 130 Boulevard de Clichy until January 1902 when he returned to Barcelona.

24. Palau i Fabre notes that it is possible that Picasso met Angel Fernández de Soto, "El Patas", as his friends called him, and his brother Mateu, the sculptor, in the social gatherings which took place at the Eden Concert. They all met together at Els Quatre Gats, too. Palau, 1971, p. 56. Cirici, 1946, p. 174.

25. Sabartés, 1953, p. 97. Palau locates the house at no. 6, Carrer Nou de la Rambla, Palau, 1975, p. 102 and 1966, p. 92. Cirlot also identifies it with this number, Cirlot, 1972, pp. 125-127. Palau, later, identified it with no. 10, Palau, 1980, p. 286. With regard to the name of the street, we see that it is variously called Conde del Asalto and Nou de la Rambla. The first name is that of the developer of this street, the Captain General of Catalonia, Count of Asalto. The other is the more popular name and is nowadays the more used. Victor Balaguer explains that "The townsfolk know it by the name of Nou de la Rambla or even just the Nou (New) street". Victor Balaguer, 1865, p. 237. There is another subject here which creates even more confusion: the location of the studio within the building. Sabartés puts it on "the flat roof" of the building. Palau agrees with Sabartés: "Picasso's and Rocarol's studio was situated, as we have seen, on the flat roof of the house next to the Eden Concert... / We do not know if it was from this studio or from its surroundings that Picasso painted that *Blue House*. In any case Sabartés speaks of 'neighbouring roof-terraces', which is not exactly the same", Palau, 1980, p. 288. Daix and Boudaille, however, put it on the ground floor. Daix-Boudaille, 1967, p. 56.

26. Daix/Boudaille, 7, 1. When he made the third journey to Paris, in the autumn of 1902, he took with him, among others, the painting which he would present at the exhibition of his works which took place at the Galeries Berthe Weill from 15th November to 15th December of that same year. It is no. 17, *House in Barcelona* in the catalogue of that show, which was published by Daix and Boudaille. Daix-Boudaille, 1967, pp. 206-207.

27. There has been a certain confusion about this oil. With regard to the dating, Cirlot says that it is from 1902, Cirlot, 1973, p. 133. Later, Subirana averred that it was from 1902 and later, simultaneously, he dates it 1902 and 1903, while at the same time he affirms, erroneously, that it was done in the studio in Riera de Sant Juan, Subirana, 1979, pp. 78 and 79, and in the Picasso exhibition catalogue 1881-1973, 1981, pp. 98, 99. Later, in the catalogue of the Picasso and Barcelona exhibition and in

the catalogue of Painting and drawing in the Picasso Museum in Barcelona it is reaffirmed that the oil is from 1902—1981, pp. 200-201 and 215, and 1984, p. 619, respectively. Where there is even more disagreement is in its identification. We believe that is the work that Sabartés mentions in his book *Retratos y Recuerdos* when he recounts the visit which he made to the studio in the street Nou de la Rambla, when he arrived at Barcelona from Paris in the spring of 1902: "In the studio I saw many drawings and some pictures. From what I could see at first glance I guessed that he had not been working there for long (...) What I did see was enough to satisfy me: his pictures continued to have the blue characteristics that link my ideas with his, recalling to me the time spent in Paris almost at his side (...) I saw, however, that now it is a stronger tone; but I forgot that at once because, seeing that the light is more intense in Barcelona, and that one's sight absorbs it, my eyes had become accustomed to see with this light". Later he says again: "(...) Picasso showed me the canvases which were turned face to the wall. One of them, perhaps the most recent, is an impression of the neighbouring roofs seen from the flat rooftop: one of the few of his townscapes of that time without figures" Sabartés, 1953, pp. 98 and 99. Daix and Boudaille thought: "it is possible that Sabartés misremembers. It seems difficult, for example, to attribute to the studio in the street Conde de Asalto, as he does, the canvas *Rooftops of Barcelona* (IX.2), where the grey in the blue seems to belong more to 1903, a circumstance which also corresponds to the fact that the studio in Riera de Sant Joan was on the top floor, and that of Conde de Asalto, on the contrary, was on the first and had no views of roofs". Daix-Boudaille, 1976, p. 56. It must be said, though, that in the *catalogue raisonée* of these two authors there is no reference to the oil *Rooftops of Barcelona* (cat. no. 165) which is the work to which we believe Sabartés refers.
A radiograph of the work shows the existence of an earlier painting, a male head in profile.

28. Cirlot, 1973, p. 134.

29. Z. 1, 82. See cat. no. 159.

30. Z. 6, 250. Zervos dates this in 1899 and Daix/Boudaille between 1899 and 1900.

31. According to Palau, when Picasso met Carles Casagemas he was "a boy of nineteen, who draws, paints and writes", Palau, 1971, p. 76. The relationship began at Els Quatre Gats and between the two young men a great friendship was established which was brusquely broken when Casagemas committed suicide on 17th February 1901, in Paris. This tragic death was one of the events that detonated the Blue Period.

32. Sabartés, 1953, p. 105.

33. Sabartés, 1953, 105. A photograph was published in *Documents Iconographiques*, il. 84 and 85, p. 311. Hélène Séckel transcribed it and reproduced it in the *Max Jacob* catalogue, 1994, p.20.

34. See cat. no. 146. The church of Santa Marta—the "Baroque chapel of the Pilgrims Hospital of Santa Marta"—had been built, according to Carreras Candi, in 1735, as a replacement for one that had been demolished in the Ribera quarter when the Ciutadella was built. Next to it was the pilgrims' hospital, on the corner of the street Avellana. The demolition of part of the old city between 1907 and 1913, brought about by the opening of Via Layetana and the consequent remodelling of the area, meant the disappearance also of the church, although the principal facade is preserved, backed onto the Hospital of Sant Pau and the Santa Creu.

35. Daix/Boudaille IX, 3. In this oil Picasso depicts the part of the street Riera de Sant Joan just at the cross-roads with the streets En Gracià Amat and Sant Christ de la Tapineria. The house which the artist shows in detail was at the junction. In the lower part of the facade, Picasso shows clearly that there was the chapel of Sant Crist, a saint much venerated in the district. The owner of the house explained to Ramon N. Comas "(...) when I let it, I charged the tenant with the obligation of seeing that the Sant Crist chapel was never without light (...)". Carreras Candi, 1913, p. 112.

36. See cat. no. 147 and 148.

37. Daix and Boudaille date them in the winter of 1903.

38. Maurice Raynal: *Peinture moderne. Traduit a* Combalia, 1981, p. 223-224.

39. The artist kept this work in his private colection. In a photograph taken between 1914-1916 in which Picasso is seated in his Parisian studio in the rue Schoelcher, this oil is seen hanging on the wall. Baldassari, 1994, fig. 113. After the death of the artist, his wife Jacqueline invited André Malraux to the house in Notre-Dame-de-Vie. In Malraux's description of the visit, he says, "(...) Jacqueline and I went into another room.. A drawing of Jacqueline's face. A landscape picture, a panoramic vision of roofs and chimneys. I asked her: 'Are these roofs in Barcelona? Do you recognize them?' I think I know the subject: the line cut short above the dawn sky when we were returning in the aircraft of our squadron... I also think I have seen a reproduction in black and white. It made me think of a small picture when in reality it is not; and grey, when in reality it already proclaims the blue period", Malraux, 1974, pp. 13-15.

After the death of the artist the work passed into the hands of the French State which ceded it to the Spanish State in 1990. It was delivered to Barcelona City Hall in order to form part of the Picasso Museum collections, where it arrived on 13th January 1991, although the official delivery took place on the 14th of that month.

40. Z. 1, 122. El Palau de Belles Arts was built for the Universal Exhibition of 1888. In 1940 it was demolished. Palau thinks that Picasso moved to the new studio at 28 Commerç between November and December of 1903; Sabartés thought it was at the beginning of 1904. The studio was passed on to him by the sculptor Gargallo who had gone to Paris and who took it back when he returned. Very close by was the studio of Isidre Nonell, the Catalan painter who had such an influence on the Blue Period of Picasso's work. Palau, 1980, p. 360 and Sabartés, 1953, p. 106.

41. Situated at 13, rue Ravignan on the flanks of La Butte de Montmartre. Picasso's studio was on the upper floor.

42. Sabartés, 1953, p. 114.

43. Picasso made a preparatory drawing for this Christ, see Daix/Boudaille. A. 18, p. 344.

44. Palau, 1980, p. 392.

45. This exhibition took place from 25th February to 6th March 1905. See Daix and Boudaille, 1988, p. 284, there is the transcription.

46. Apollinaire, 1964, p.41.

47. Sebastià Junyer-Vidal (1879-1966), painter, and his brother Carles, writer, frequented the literary and artistic groups of Barcelona at the end of the last century and beginning of this one. They met Picasso in the social gatherings at Els Quatre Gats, and their relationship was intensified during the years 1903 and 1904. Sebastià worked for a while in the Sala Parés from where he escaped after he and his brother inherited the fortune of an uncle. This financial well-being allowed them to change their way of life and they founded the paper El Liberal, in which Carles wrote the art and theatre criticisms. Palau, 1971, p. 66 and Palau, 1980, p. 346 and 351.

48. For a study of the strip cartoon, we are referred to the work of Joan Amades: *Les auques*, 1931.

49. The drawings have been erroneously dated by some Picasso biographers: Sabartés, Vallentin, Gaya Nuño and Rubin place them in 1902. Sabartés, 1954, I. 78; Vallentin 1957, p. 73; Gaya Nuño, 1975, p. 47 and Rubin, 1980, p. 47. Cirici-Pellicer dates them in 1903. Cirici-Pellicer, 1946, p. 173. Palau i Fabre clarified this point when he demonstrated that Picasso's third journey to Paris, in 1903, was when he was accompanied by the painter Josep Roquerol, as was announced by the two notes which appeared in El Liberal on 9th and 10th April 1902. Palau, 1980. p. 310.

50. The drawings are accompanied by rhyming couplets in which the artist mixes Spanish and Catalan: I.- In a wagon/3rd class they go/towards the frontier; II.-They arrive at one and say/shit, what a lot to pay; III.- And so they come to Montauban/wrapped in overcoats, each one; IV.- At nine o'clock next day/they're finally there in Paris; VI.- Durand-Ruel calls him up and gives him lots of money.

51. We find a perspective of the famous Parisian tower in the caricature drawing which illustrates the arrival of Picasso and Jaume Andreu Bonsoms in Paris in 1901 (fig. 79). Z. 6, 342.

52. Ambroise Vollare, 1983, p. 64.

53. We cannot forget the decisive role played by Max Jacob in the development of the Blue Period. Picasso met the Jewish poet at the Galeries Vollard in Paris, in June 1901. A great friendship was born which lasted until the tragic death of Jacob in 194.. It was Jacob who introduced Picasso to reading the work of the symbolist poets Rimbaud, Mallarmé, Baudelaire and, above all, Verlaine—whose poem *Cortège* he copied into a sketchbook in 1905—Folios 37R-38R, MP 1855. For the relationship between the two we are referred to the splendid catalogue compiled by Hélène Séckel for the Max Jacob exhibition in 1994.

54. Z. 6, 606.

55. Picasso created these diaries influenced by the press of the time, in which, we remember, humorous drawings and cartoons were the order of the day. One of the most read magazines was Blanco y Negro, which Picasso knew well—other reviews of the time: La Esfera, Nuevo Mundo, Cosmópolis ... were its rivals. Blanco y Negro had always taken care over the plastic arts, and so the staff included artists, although that was relatively frequent in newspapers as photography was only introduced very slowly. The first stage of this review—from 1891 up the the Spanish Civil War—coincided with the peak of the concept of the "Illustrated Press".

56. Z. 6, 495; 497; 498 and 346.

57. Cirici-Pellicer, 1947, p. 174. Palau notes that on 12th October 1902 Sebastià Junyer had an exhibition at the Sala Parés on themes from Mallorca, from where he had just come. On the 16th, Francisco de S. Aranyó published a criticism, accompanied by a portrait by Picasso, in El Liberal. Palau, 1980, P. 309.

58. Ocaña, 1979, P.14. In an art criticism about Junyer in 1912, Josep Junoy writes: "The magical transfiguration of the colours happens in his pictures as though a work of alchemy. The trees and the fruits in the thick foliage become shining metal.../The rocks become blocks of pearl./The mountains appear in the background like gigantic amethysts or huge topazes.../And luminous colourings, reflected, slide like jewels across the smooth surface of the waters..." and closes saying "A natural perfume comes off his latest landscapes". José Junoy, 1912, pp. 320-321.

161. Mother and Child by the Sea
Barcelona, 1902
Oil on panel, 26.8×13.4 cm
Museu Picasso, Barcelona

162. MOTHERHOOD ON THE WHARF
Barcelona, 1902
Pen on paper, 15.1×23 cm
Museu Picasso, Barcelona

163. THE GOLDEN AGE
Paris, December 1902
Pen and aquatint on paper, 26.1×40 cm
Museu Picasso, Barcelona

167. THE CHRIST OF MONTMARTRE (LE SUICIDÉ)
Paris, 1904
Pen and watercolour on paper, 36×26 cm
Bollag Collection, Zurich

164. PORTRAIT OF JULIO GONZÁLEZ
Barcelona, 1902
Watercolour and ink on paper, 29×24 cm
Private collection, Paris

166. BARCELONA ROOFS
Barcelona, 1902.
Oil on canvas, 69.5×109.6 cm
Museu Picasso, Barcelona

165 R. Rural Landscape with Mountains beyond
Reverse

165. Barcelona Roofs
Barcelona, 1902
Oil on canvas, 57.8×60.3 cm
Museu Picasso, Barcelona

168. Picasso and Junyer Depart on their Journey
Paris, 1904
Ink and coloured pencils on paper, 22 × 16 cm
Museu Picasso, Barcelona

170. Picasso and Junyer Arrive at Montauban
Paris, 1904
Ink and coloured pencils on paper, 22 × 16 cm
Museu Picasso, Barcelona

169. Picasso and Junyer Arrive at the Frontier
Paris, 1904
Ink and coloured pencils on paper, 22 × 16 cm
Museu Picasso, Barcelona

171. Picasso and Junyer Arrive at Paris
Paris, 1904
Ink and coloured pencils on paper, 22 × 16 cm
Museu Picasso, Barcelona

172. JUNYER VISITS DURAND-RUEL
Paris, 1904
Ink and coloured pencils on paper, 22×16 cm
Museu Picasso, Barcelona

Landscapes During the Pink Period
Between Impressionism and Primitivism

Brigitte Léal

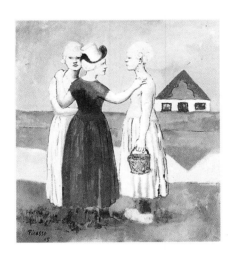

84. *The three Dutchwomen*. Schoorldam, 1905. Tempera on paper, glued on card. 77×67 cm. Zervos 1, 261.

Before the works kept by Picasso until his death in 1973, partly published by Palau in 1981 and then by the Musée Picasso in Paris 1987[1] were revealed, it could have seemed somewhat incongruous to talk about landscapes for Picasso's pink period since Zervos and Daix-Rosselet (1966) were unaware of the Dutch notebooks of 1905 and only recorded two landscapes in the year 1906: two views of Gósol: *Houses in Gósol* (fig. 102) and *Gósol landscape* (fig. 101) of particular documentary interest, quite quickly done and hardly any different from the "blue" views done in Barcelona two years earlier[2]. Could it be that Picasso had not retained anything other than the milky colours and the anonymous background silhouette of a farm of the Dutch landscape, sketched like a backdrop for *The Three Dutch women* from Schoorldam (fig. 84)? And could the mostly sandy or earthy tint background sketches (a reminder of the Dutch dunes according to McCully) of the *Bateleurs* of Washington (Zervos 1, 285) or the *Bathing horses* of Worcester (Zervos 1, 265) be qualified as landscapes?

A rather insubstantial collection, reflecting a lack of interest in the theme. At the same time, however, Picasso multiplied his portraits and nudes, in search— a search common to all his generation (Braque, Dérain, Matisse)—of a new concep of the human body, following in the footsteps of Cézanne's search, which would culminate in the major works of the 20th century like: *Blue nude, a reminder of Biskra* by Matisse, *Bathers* by Derain, *Great nude* by Braque and especially *Les Demoiselles d'Avignon*.

The recent revelation of a whole series of works and documents concerning the Dutch and Catalan exploits of 1905 and 1906—unique sources of landscapes for this period—have totally transformed our appreciation of the impact that these journeys had on his art. Assuming that the "marvellous images"[3] sent to Apollinaire from Gósol have probably been lost forever, we still have—as far as the landscapes themselves are concerned—the drawings and water-colours contained in two notebooks brought from Holland and a thick leather-bound album whose glacé paper pages conceal a true report about the pleasures of life in the small Catalan village[4]. Besides these, there is a large, crucial gouache with its preparatory study, not to mention the correspondence exchanged between Picasso, Fernande Olivier and the poets Guillaume Apollinaire and Max Jacob[5]

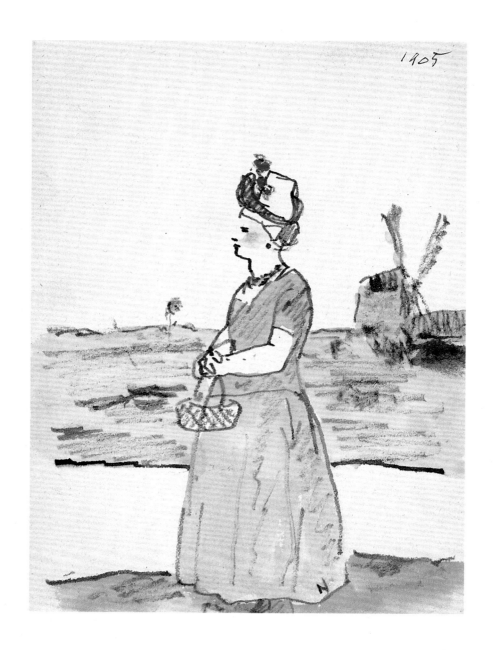

85. *Dutchwoman by a canal.*
Holland, 1905. Watercolour. 11.5×15.7 cm.
Musée Picasso, Paris. Album 1855, page 3R.

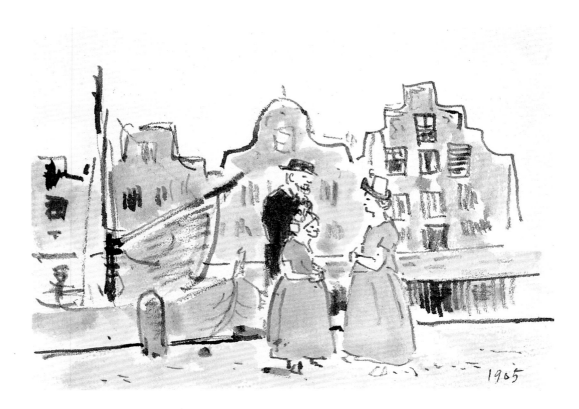

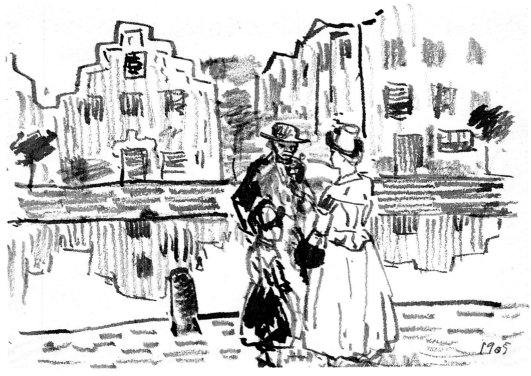

86. *By the canal.* Alkmaar, 1905.
Watercolour. 11.5×15.7 cm. Musée Picasso,
Paris. Album 1855, page 4R.

87. *Dutchmen by a canal at Alkmaar.*
Alkmaar, 1905. Watercolour. 11.5×15.7 cm.
Musée Picasso, Paris. Album 1855, page 5R.

1905

88. *Dutch landscape with windmills.*
Schoorldam, 1905. Graphite pencil, gouache,
black ink. 12.5×18.5 cm. Musée Picasso,
Paris. Album 1856, page 1R.

89. *Dutch landscape with windmills.*
Schoorldam, 1905. Graphite pencil, gouache,
black ink. 12.5×18.5 cm. Musée Picasso,
Paris. Album 1856, page 2R.

90. *Boat on a canal.* Schoorldam, 1905.
Gouache, pen, black ink. 12.5×18.5 cm.
Musée Picasso, Paris. Album 1856, page 6R.

91. *Landscape with windmill*. Alkmaar, 1905.
Gouache, pen, black ink. 12.5×18.5 cm.
Musée Picasso, Paris. Album 1856, page 7R.

that irreplaceably reconstruct "the heavenly atmosphere"[6] in which the two lovers bathed in Spain. If one adds the photographs brought back from Holland by Picasso to all of the above, as well as the meticulous field research done by G. Vlak (in Alkmaar) and Palau (in Gósol), there are hardly any clues left to follow. Here we will not cover the circumstances and details of these exploits as they have been fully dealt with in the recent catalogue of Barcelona[7]. We should remember that Picasso, at the invitation of a Bohemian journalist friend from Montmartre called Tom Schilperoort, stayed in the little towns of Schoorl and Alkmaar about 50 kilometres to the north of Amsterdam and at Hoorn, situated 25 kilometres to the east, on the coast, apparently for less than three weeks—with a stopover in Amsterdam—after 15 June and before 10 July, 1905.

The year after, it could be said that he chose to return "home" by setting off for Gósol (with a short stay in Barcelona), a small village lost in a valley of the southern Pyrenees, recommended by some friends as being a "magnificent" place.[8] He set off from Paris accompanied by Fernande Olivier and was given a send-off by his amusing peers Apollinaire and Jacob on 21 May, 1906, and did not return until mid-August.

It is worthwhile considering these two stays as sources of a decisive renewal of Picasso's art: the dawn of a new classicism (Daix after Barr) was extended in a primitivist vein largely inspired by Gauguin (McCully). These appreciations are undeniably well-founded so far as the treatment of the nudes is concerned: full forms (*Beautiful Dutch woman*, Zervos 1, 260), disjointed ones attached to face masks (*Sleeping nude, Fernande*, Zervos 1, 317) and then hieratical poses, copied from Greek statues (*The two brothers*, Zervos 1, 304), although they are more debatable when it comes to the landscapes. At first sight, McCully had a difficult time to put Picasso's Dutch period on the same plane as Gauguin's Pont-Aven period: the same desire to get away from it all and go to a lost corner of a sleepy province, to the reputedly rustic customs (one will recall the famous cry from the heart that Gauguin made to Schuffenecker: "I love Brittany, I find it wild and primitive [...]"), the same interest in individuals and of local customs, the same enthusiast's regard for the costumes—embroidered headdresses and clogs—that lend themselves to the decorative effect. It is, therefore, very clear to see that despite a little superficial resemblance linked essentially to appreciation of the "folkloric" clothes, Picasso found his Pont-Aven in Gósol and not in Holland.

In fact, if it is to Gauguin's *Belle Angèle* that the famous ladies of Schoorldam truly owe their heavy, rigid bodies, their hermetic faces and those strange slanty eyes and weird noses that disturbed Fénéon so much (he found "a cow-like resemblance" in Gauguin's Bretonnes), and even if Picasso had not attempted to find anything other than an ostensibly decorative (horse-shoe head-dresses) and primitive (clogs and farm attire) notion, one cannot find any trace anywhere of the synthetic, modern style created by Gauguin at Pont-Aven twenty years earlier, mixing an impressionist vision of nature, Japanese sources and the symbolist spirit, the whole being influenced by formal breaks which announce the art of the future. On the contrary, Picasso took great care to tame turbulent exoticism and the brutality of his figures by employing classical composition co-

92. *The street of the old St Jean hospital at Hoorn.* 1905. Graphite pencil. 12.5×18.5 cm. Musée Picasso, Paris. Album 1856, page 15R.

93. *Houses at Hoorn.* 1905. Graphite pencil. 12.5×18.5 cm. Musée Picasso, Paris. Album 1856, page 16R.

pied on the ancient model of the three graces, submerged in a *passe-partout* landscape and punctuated by a discreet touch of local colour: the remote farm in the background.

The gentle atmosphere can be found once again in the water-colours contained in the Dutch sketch-pads which, far from depicting the wildness of nature propitious to physical excesses as in Gauguin's Brittany, have the allure of small post cards or of holiday souvenirs which have the delicate charm of views brought back by the English water-colour painters from the "grand tour" of the continent in the 19th century. Immense skies, low horizons, faded colours, gentle, melancholic atmospheres, unsurprising compositions with all the ingredients of the genre: windmills, canals and women draped in lace as if they were dolls. Here, Picasso deliberately goes along with the tradition of Barbizon's landscape renewed by the impressionists in the years 1860-70 who, in the footsteps of Boudin and Jongkin, all went to Dordrecht or Scheveningen in search of the souvenir of Vermeer's fine, golden light. Could Picasso have known about the Dutch pictures—clearly bound to the naturalist tradition of Millet—brought back by Pissarro de Middelburg in 1899 or the explosively colourful and lively views based on this theme by Monet in Zaandam in 1871? He settles, in any case, for this type of unpretentious sketch with a gauged and conventional view of nature, only reserving the eternal qualities of his crayon, those of spontaneity, speed and precision, for two modest topographical sketches drawn on the spot and portraying the city of Hoorn's emblem, the Hospital of St John.

In Gósol one year later, there was a total change of decor: "Dear Guillaume, we're 5,000 metres up a mountain surrounded by snow and sun". Fernande. Gósol, 29 May, 1906[9]. The pretty Parisian, no doubt overcome by the altitude, clearly overestimated the height of the Pyrenean peaks, though it is true to say that Picasso, just like Fernande, was struck by the majesty and the ruggedness of this mountainous spot since, besides the omnipresent, earthy, muddy or bloody colour of the earth (the real trademark of the Gósol period), the only visible traces of landscape in his compositions are the snowy peaks that stick up behind the portraits of Fernande straddled across a donkey.

"The landscape!!... mountains in front, mountains behind, and even more mountains in between, sorts of plains, brush and gorse, where the heads of dead dogs grow, and not just heads of dogs, but heads of mules, donkeys, sheep and goats, too. Too many stones and not that many streams"[10]. There is in fact a huge distance between the smooth, civilised atmosphere, from the excessively cultivated and urban landscape of Holland and this menacing desert, inhabited by dead animals and stones! However, Picasso's heavily penned sketches of local life locked inside the pages of the Catalan sketch-pad evoke, in line with Fernande's recollections, a rugged existence, linked to the earth and to animals, though livened up by local dances and processions.

The only outstanding—monumental—landscape is a gouache: a distant-view panorama of this country where, still according to Fernande, "There's nothing, no cake shops, no sweet shops, no baker's, no grocer's, nothing, nothing...".[11] In fact, on this page there is nothing more than a pile of old houses, blocks of stone scrambling up the mountain,

94. *Peasant with a bundle of logs and the Pedraforca*. Gósol, 1906. 17.5×12 cm. Musée Picasso, Paris. Album 1857, page 53R.

95. *Peasant woman with loaves*. Gósol, 1906. 17.5×12 cm. Musée Picasso, Paris. Album 1857, page 54R.

96. *Child riding a mule*. Gósol, 1906.
12 ×17.5 cm. Musée Picasso, Paris.
Album 1857, page 59R.

97. *People riding horses.* Gósol, 1906.
12 × 17.5 cm. Musée Picasso, Paris.
Album 1857, page 66R.

98. *People riding horses.* Gósol, 1906.
12 × 17.5 cm. Musée Picasso, Paris.
Album 1857, page 67R.

101. *View of Gósol.* Gósol, 1906.
Oil on canvas. 51×92 cm. Zervos 6, 732.

with not life on the horizon, soulless: a symbolic image of a land turned in on itself, as tough and impenetrable as Josep Fontdevila's face.

An image which, above all, is a total break from the delicate Dutch water-colours and the picturesque oils of Gósol; indeed, this full, dense work with its heavy lines of construction and rigorously adjusted and simplified masses surrounded by a frame that accentuates the saturation effect on the space, makes us think of the massive, cutting structures of the village of Gardanne painted by Cézanne in 1885. This purely formal view is unquestionably the first part of monumental tryptic of Horta (1909) and, therefore, one of the decisive steps—just like the face-masks—towards the perfection of the Cubist language.

The last word should be Fernande's, Gósol's exuberant chronicler: "All in all, it's quite nice here, and if the temperature stays the same as it is today, that'll be lovely...".[12]

102 b. Cal ferrer, the house opposite Cal Tempanada. The facade shows the renovations that had been carried out and that Picasso details in his oil, in the same way as the doorway on the right of Cal Fuster, the next house.

NOTES

1. Palau i Fabre, *Picasso vivent* (1881-1907), Paris, Albin Michel, 1981. Richet, Michèle, *Musée Picasso Paris, Catalogue des collections—II*, Paris, RMN, 1987.

2. Notably, *A street in Barcelona and the Fine Arts School*, Barcelona, 1903, oil on canvas, Private collection, London, Zervos 1, 122; Daix-Rosselet IX, 1 and *Barcelona at night*, Barcelona, 1903, oil on canvas, Bührle Collection, Zurich, Zervos 30, 43; Daix-Rosselet IX, 3.

3. """It was not without great pleasure that I recieved on the day after the feast of St William, 25th June, an envelope which contained a letter from Fernande and some marvellous sketches from Picasso". A letter from Apollinaire sent to Picasso, to Gósol from Paris on 27 June, 1906, in *Picasso/Apollinaire—Correspondence* established by P. Caizergues and H. Séckel, Paris, Gallimard, RMN, 1992, p. 54.

4. A Dutch-made sketch-pad (11.5 x 16cm) containing 46 sheets of white paper, Schoorl, Alkmaar, summer 1905, Paris, Picasso Museum (MP.1855); English-made sketch-pad (12.5 x 18.5cm) containing 27 sheets of beige paper, Schoorl, Alkmaar, June-July 1905, Paris, Musée Picasso (MP. 1855); Sketch-pad, probably of Spanish origin (18.5 x 12.5cm) containing 68 sheets of white paper, Paris, Gósol, 1905-1906, Paris, Musée Picasso (MP. 1857).

5. Op. cit. note 3 and *Picasso/Max Jacob*, catalogue established by H. Seckel, Paris, RMN, 1994.

6. "It is a charming image that you both present to us, young and beautiful, in an atmosphere of Paradise", in a letter sent by G. Apollinaire to Picasso in Gósol, from Paris on 27 June, 1906, p.54, op.c it., note 3.

7. Catalogue *Picasso, 1905-1906*, Museu Picasso, Barcelona, Kunstmuseum Berne, Electa, Barcelona, 1992.

8. Quoted in Daix-Rosselet, 1966, p.292: "When we asked Picasso why he had chosen to go to Gósol as a place to stay, he replied: "Gósol? As always through friends. There was a sculptor in Barcelona called Casanova, and the son of a very famous Greek prime minister. They had just come back from Gósol. They thought it was magnificent"."

9. Extract from a letter sent from Gósol by Fernande Olivier to Apollinaire, 29 May, 1906, p.39, op. cit., note 3.

10. Extract from a letter sent by Fernande Olivier from Gósol to Guillaume Apollinaire, 21 or 22 June, 1906, p.51, op. cit., note 3.

11. Extract from a letter sent by Fernande Olivier from Gósol to Guillaume Apollinaire, 21 or 22 June, 1906, p.51, op. cit., note 3.

12. Extract from a letter sent by Fernande Olivier from Gósol to Guillaume Apollinaire, 21 or 22 June, 1906, p.51, op. cit., note 3.

TOWARDS CUBISM

Claustre Rafart

In April 1906 the dealer Ambroise Vollard visited Picasso at Bateau-Lavoir and bought some twenty works from him for the substantial sum of two thousand francs. Salmon writes that the artist had found his first important dealer[1].

This sale, an important event in Picasso's life, allowed him to travel afresh to Catalonia, which he had not visited for two years. On 21st May, with Fernande Olivier[2], he went to Orléans station to take the train to Barcelona. A small group of friends went to see them off[3].

After a short stay in Barcelona visiting his family and friends, they went to Gósol, a hamlet of the Alt Berguedà, where they intended to spend the summer. Gósol is located deep in the mountains right in the middle of the southern Pre-Pyrenees. It is situated in a valley closed by the spurs of Pedraforca on the right and the mountain of Cloterons on the left. In the background unfolds the Sierra of Cadí. It is a region of wild places of great natural beauty. The village, at an altitude of 1,423 metres, is dominated by the Tossal, a hill on which there are the remains of an old medieval village.

The region, traditionally pastoral and agricultural, was difficult of access, although much improved by the arrival of the Catalan Railway at Guardiola de Berga in 1904. A carters' service had to be organized to communicate from there to Gósol[5]. The route was really hard, some 30 kilometres of track, to be covered on muleback. Fernande explained: "To get there we had to make a journey of some hours on the backs of mules, taking narrow paths which on one side had a vertical wall which scraped the knees and hands, while on the other was a profound abyss which made me close my eyes in order not to suffer from vertigo. These precipices, which seemed to have no bottom, didn't trouble the mules in the least, there were accustomed to be careful and one could trust them (...)"[6]. In the Carnet de Paris, Gósol, 1905 and 1906[7], which Léal studies in the preceding article, there are some drawings which illustrate the route. One shows Fernande riding a mule in a steeply stepped spot. The figures are finely outlined and the landscape is full of the ochre colour of the earth[8]. There are two further drawings of the journey in which we see Picasso and Fernande on muleback, guided by a muleteer and his dog, filing along the steep path which skirts the mountains. They are pencil sketches made with a rapid and dynamic stroke which accentuates the sense of movement in the scenes[9].

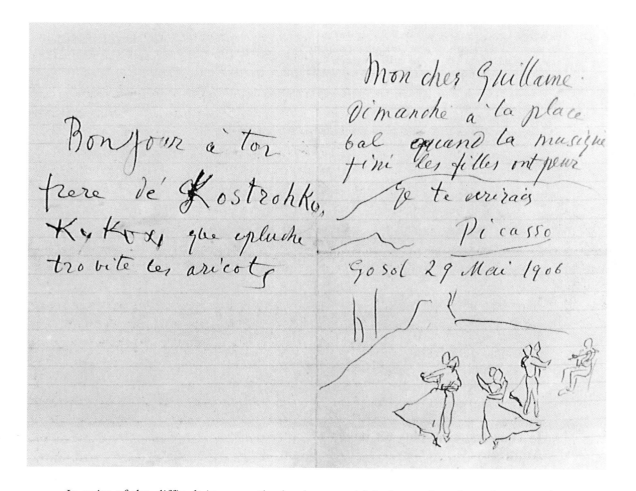

99. Letter from Picasso addressed to Apollinaire and dated "Gósol 29 Mai 1906".

In spite of the difficult journey, the landscape which they enjoyed on the route and when they arrived must have impressed them greatly. The austerity of the bare mountain which comes before Gósol and the terracings by which one ascends, together with the ochre and grey tonalities given by the light in striking on the surrounding rocks and scree and the rooftops of the houses, made a great impact on these young people. Again it is Fernande who describes it: "Gósol turned out to be a marvel (...) under the sun which gilds the houses with an ochre tinge, the stony soil, the sand absolutely white, under a sky of a smooth blue, so pure, so new for me (...)"[10].

Their arrival has been dated by Picasso's biographers as the middle of June. However, if we take into account the letter which they wrote to their friend Apollinaire, dated "Gósol, 29th May 1906"[11], it would be some days earlier. Certainly it would have taken place, as Séckel points out, between 22nd and 29th May. The letter, written by Fernande, was illustrated by the artist with a drawing in which some couples are dancing in the square to the music of a violinist. In the background there are some mountains, sketched, difficult to identify.

The correspondence which they kept up with their Parisian friends documents this stay in the Gósol area. The letters recount the immediate and fresh impressions of

102. *Gósol Houses*. Gósol, 1906.
Oil on canvas. 54×38.5 cm. Zervos 1, 316.

these young people who, accustomed to city life, were plunged, full of curiosity and looking for change, into one of the most authentic places of Old Catalonia, where Catalan customs and traditions are most strongly rooted.

They lodged at the only inn there was, Cal Tampanada, the patron being Josep Fontdevila. Fernande described him as "a man of about eighty, a former smuggler, he was determined to go to Paris with Picasso. A shy old man with a strange and wild beauty, in spite of his age he had kept his hair and all his teeth, worn down but very white. He was rough with everyone, only in a good temper when he was close to Picasso"[12]. A drawing which illustrates another letter despatched to Apollinaire, shows the inn in a very graphic manner, with the high mountains in the background (fig. 99). In this sketch Picasso introduces more the shape of the Pedraforca than the side where there is the Mitjaire, which is the mountain that you see beyond the inn, looking at it from the square. The Pedraforca would be more to the right of the viewer. Under the sketch is written "Gran Hotel, Gósol—it rains every day". In the text of the letter Fernande gives their impressions of the place, the people, the cooking, the customs and the religious and popular traditions... She also describes the inclemency of the weather, which afterwards, happily, changed. "(...) almost intolerable cold until yesterday, such cold that I kept my overcoat and scarf on throughout the day. Besides, it has been raining all the time and I would like you to know that the rain here is not ordinary rain, when it rains here the village is inundated ..." and on the landscape "(...) The countryside!! ... with mountains in front, mountains behind, mountains to the right and mountains to the left, and more mountains is between these points, a rugged kind of country (...)". Apollinaire answered this letter with another dated 27th June in which he gives his vision, idyllic, of the place, which clearly he had imagined from the descriptions sent to him by his good friends: "I see there that the Spanish friendship is a reality and I am very happy about it. You two portray a charming image, young and beautiful, in an atmosphere of paradise. That assures me of your happiness"[13].

From the balcony of the upper floor of the building, where they had their room, Picasso had a good view of the village with the Tossal beyond. He offers this panorama in the sketch *Landscape* (cat. no. 173) which shows in the foreground the Plaça Major, the Canemar, as it used to be called[14] which is projected to the right towards the road named Canal. To the left the district of Obac spreads out, filing towards the skirts of the Tossal, topped by the medieval remains and rocks.

This spectacular landscape, bare, with ochre and grey clay, unexpectedly surprised Picasso. The effect of this view, added to the new artistic experiences which he had undertaken in Paris[15] and the emotional stability which the company of Fernande brought him, provoked a substantial turnround in his work. Every day he went further with the driving desire to simplify, to make the volumes and forms more schematic, a desire which already is evident in this gouache, one of the few works in which he allows himself to be carried away by the magic of the place, and becomes possessed by the village and its surroundings. He observes it, he studies it and, later, he expresses it with a new lan-

guage, bringing us close to the prismatic vision with which Cézanne used to treat individual natural forms.

The work is impregnated with a monochrome ochre, lightly contrasted in some points by the green of the sparse vegetation and the blue of the sky. The variations in light which touch the buildings and the landscape make for a tremendous structural progress which the artist accentuates with the delicate outlining, done with black pencil, of the elements which make up the composition.

On the right of the work we see an narrow alleyway which as it goes on, becomes narrower, it is, as we have said, the road called Canal, and the artist offers us a second view of it in a drawing, done in lead pencil, which has a pure outline, and is free of details (cat. no. 173 bis)[16] - on the back is a watercolour of a woman walking, with a poem referring to her by her side, also of 1906. In both works the houses that can be seen from the square are faithfully described, the majority of them survive to this day. In the foreground, to the left, there is a small building which was the old chapel of Sant Roc, today disappeared and replaced by a house built in 1907. The church is attached to Can Triuet which is next to Ca la Julita, beside this is Cal Catí. The house which seems to barricade the street is Can Silvestre, and beside it, at the beginning of the descent, we see Cal Tinent[17] followed by Can Antonet and its roofs which join those of Cal Pujol, a house which remains outside the artistic frame[18].

The objectivity and serenity which Picasso projects in these two panoramas are also found in the two oil paintings which he devoted to landscape as the only motif of the composition: *View of Gósol* (fig. 101) and *Houses at Gósol* (fig. 102)[19].

In the first we are shown the village from the area of the Guàrdia. In front, on the right, is the parish church of Santa Maria, beside the uneven fields of the Clota where the road comes out which goes down towards Guardiola de Berga. Daix says that this road is the one which goes down towards Bellver de Cerdanya, when in fact it is the road which goes to Guardiola de Berga. The road which links Gósol with Bellver is the one which starts from the modern road to Cerdanya—the old track to Cerdanya—which

104. Photograph of the Plaça Major of Gósol. Showing Cal Ferrer and Cal Fuster and, on the other side, Cal Tempanada. Architectural Heritage Archives, Provincial Government of Barcelona.

104 b. View of Gósol, c. 1905 or 1906. On the right, in a corner of Plaça Canemar, beside Cal Triuet, is the little church with the broken-down roof, just as Picasso drew it. In the foreground, among the fields, is the parish church of Santa María, where the road passed by on the way down to Guardiola de Berga.

100. *Portrait of Fernande with a mantilla and the Pedraforca behind.* Gósol, 1906. Oil on wooden panel. 30×21 cm. Zervos 22, 345.

108. View of the massif of the Pedraforca.

starts from the square Agustí Pedro i Pons—which used to be the square Pedrell. This is the road the couple will take for their return journey to France. On the inside cover, on a right hand page of the Carnet Català, Picasso wrote, mixing Catalan and Spanish and with translations into French, the itinerary for the return to Paris: Gosol mules (mulet) / Vallvé / Puixcerda coach (diligence) / Ax coach / Paris train (train).

The crowded borders bring more into relief the enchantment of rusticity in the Gósol countryside. After the narrow lane, the houses of the Obac district file on towards the skirts of the towering hill topped by thick fog which also hides the medieval ruins.

The other oil, *Houses at Gósol*, according to Daix and Cooper, is a perspective of the house in front of the inn. Cooper speaks, more specifically, of the "court of the farm over which Picasso's windows looked"[20]. We have been able to verify that this is not a grange, in fact it is the house directly opposite Cal Tampanada, Cal Ferrer the blacksmith's. The house has been totally rebuilt and now has nothing to do with the previous construction which was identical with what Picasso painted. Giving on the street there was a grand portal which was the entrance to the square, at the side, on the right, was a smaller doorway leading into the smithy, above which the ancient doorway can be seen framed by an arch scarcely walled in. At the other side of the facade there is another, also walled up, which reveals the renovations that the house had already suffered before that time (fig. 104). The neighbouring house which is seen in the oil is Can Fuster, which has also changed its appearance completely.

Notwithstanding these landscapes, it is true as Palau asserts that Picasso did not approach Gósol as a landscape artist. Frequently he offers us a view of the environs tempered by the presence of the human figure. When we look at Picasso's Gósol works we find that, in fact, what interested him above all at that time, was the human body, especially the feminine body, that of Fernande. Palau says that the Gósol work is a "song to the body of Fernande"[21], and it is she who is the focus in the only landscapes with female figures that he did. The landscape is a compositional aid for portraits of Fernande. A restrained Fernande, with a white mantilla covering her head and gliding down to her shoulders. He paints her, half-length or full and always mounted on horse or mule (figs. 100 and 198)[22]. Beyond, the spectacular Pedraforca, with its escarpment, gives a pyramidal rhythm to the compositions, which in Palau's view were done on arrival at the village, after the long journey. The Carnet which we mentioned earlier includes, also, two drawings of female figures in surroundings of nature. These are Gósol women wearing the typical costume of the region and with scarves on their heads. One is going down to the valley with a light step, with the aid of a stick, loaded with a bundle of wood on her shoulder[23]. The other carries two loaves on her head on a padded ring, like the *Woman with the loaves*[24], and another under her arm. The woman is shown to us from the back, while she enjoys the mountain landscape of the background[25]. Both drawings combine the sharp outline of the figure with the calm brush work of watercolour.

Landscape also becomes a supporting element in a series of works on the subject of the countrymen, young men guarding the herds, like the *Shepherd*[26] who is looking

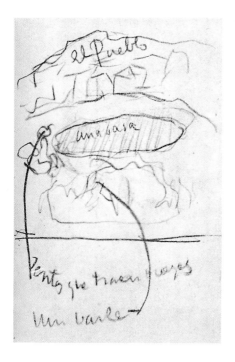

after a herd of pigs in some fields among the anodyne hills. This work reminds us of the shepherd who is looking after the sheep and the watercolours of Aragon mentioned by Daix, which the artist did in 1903[27]. The landscape, without any factual references, in combination with the placidness of the young fellow herding the pigs, brings us close, yet again, to Virgil's descriptions of nature.

In the *Shepherd with a basket* (fig. 105)[28], Picasso puts emphasis on the rhythms of the composition which is submitted to the proportions of the figures, inserted into a highly simplified landscape. The disproportion in the extremities of the young farmer create, as Daix says, movement and space[29]. This splendid drawing, together with the excellent composition *The countrymen* (fig. 106)[30], done when he returned to Paris, but for which he had done the preparatory studies at Gósol[31], and in a letter to his friend the American collector Gertrude Stein dated 17th April 1906, had announced the creation of this work: "(...) I am in the process of doing a man with a little girl. They carry flowers in a basket, with two oxen beside them and some wheat, something like that"[32], and a series of drawings for the Carnet Català[33], are all linked to a project of landscape compositions with figures, which he never actually carried out. One of these drawings (fig. 107)[34] seems to mark the guidelines upon which the composition was to be based. It is a perspective of the village, it seems, with the Tossal beyond. In the foreground there is a pond sketched in which, as far as we have been able to ascertain, could be in front of Cal Paraire. In fact it was not really a pond, but a large puddle which formed from the water which came out of the public washing place and which then drained away into the deposit which was near the parish church. Palau thinks that this large puddle was in the place where now there is the house that was built in 1907[35]. But at this point there had been the chapel of Sant Roc. The large puddle was situated in front of the chapel, on the other side of the road, opposite Cal Paraire, the house already mentioned,

105. *Shepherd with a basket*. Gósol, 1906. Tempera. 62×47 cm. The Columbus Gallery of Fine Arts, Ohio. Zervos 1, 338.

106. *Peasants*. Paris, 1906. Oil on canvas. 218.5×129.5 cm. Barnes Foundation, United States. Zervos 1, 384.

107. *Catalan sketchbook*, page 61.

in front of which there was the public deposit—still in use, according to people in the locality, in the 30s.

The deformations of the natural forms, executed with a lineal manner very different from what he had employed in the Blue Period, and with a growing angulation in the planes, as is shown in these two works, with strong references to El Greco[36] and to Cézanne, open the way towards the search for new means of expression which will be made clearer on his return to Paris and which will have a decisive role in works like The Reapers.

109. *Landscape.* Paris, 1907. Watercolour. 22×16.5 cm. Zervos 6, 950.

The Reapers

Picasso's stay at Gósol was decisive for the artistic development of his work. The isolation in an authentically rural world allowed him, as he had experienced at Horta at an earlier time, a direct contact with nature, and at the same time favoured his personal relationship with Fernande. All in all, it helped him to concentrate on his work and to assimilate all that he had seen in Paris during the autumn and winter of 1901[37]. This confluence of factors encouraged him in the search for new ways of plastic expression which meant the suppression of perceptual methods by expression through conceptual methods. This important turnround began at Gósol, continued in Paris[38] in the following autumn, materialized, months later, with *Les Demoiselles d'Avignon*[39] and culminated in cubism.

The last works which surprise us at Gósol denote a lineal mannerism never used up until then, with markedly angular and accentuated deformations which tighten in the use of an overriding lineal link which unifies the composition and sculptural forms of some of his figures, presaging the works which he was to produce in the spring and summer of 1907, among which is *The Reapers* (cat. no. 174).

According to Daix, Picasso himself told him that he painted this oil in the studio at Bateau-Lavoir at the same time as he was doing *Les Demoiselles d'Avignon*[40]. It seems, then, that the artist did not need to go out to any location to find the subject. The memory of Gósol was enough.

The synchrony between the two works alluded to by Daix is evident if we look at the albums of drawings done by the artist for the Demoiselles. Among the multiple studies of figures and of the elements which make up the great composition there are some sketches directly related to *The Reapers*[41]. Besides these studies which are directly related to the work, there are some others which we think it interesting to consider, studies done around the figure of the Gósol innkeeper, Josep Fondevila[42], and the studies of feet and hands[43] which with more or less intensity are to be used in the central figure of *The Reapers*, the monumental reaper who is the focus of the work.

The Reapers is an oil painting of excellent rhythms and contrarhythms and overflowing compositional dynamism. There is a preparatory drawing of well constructed

handwriting and modelled outlines, in which the artist shows the essentials of the bodies and of nature, while at the same time demonstrating that the initial idea prevails in the final oil painting (cat. no. 175), where the landscape is the frame which encloses the figures, the true protagonists of the work, whom Picasso groups into two blocks. On the left, occupying almost two thirds of the composition, are the persons, the reapers, men and women hard at work, in the middle of an sloping field in front of the looming mountains. On the right, there are the cattle, two oxen grazing tranquilly near the trees. The quiet scene of the grazing cattle contrasts strongly with the almost frenetic dynamism of the peasants, although peasants and cattle fit completely into the rural landscape, placed in different stages of the natural slope, recalling the terraces where the hamlet of Gósol is set. Figures and landscape are the result of the fusion of influences which have been showing in his works since the summer of 1906, influences mixed with the new works which the artist produced on his return to Paris[44]. The expressionism of the figures and the surroundings is accentuated by the chromatic eccentricity that the artist has used here. According to Daix, this bold chromaticism makes *The Reapers* the only truly "fauve" work by Picasso[45].

The scene formed by the trunks of the trees in the background, on the right, and the vault created by their branches, suggest to Green the opening of the curtains in the background of *Les Demoiselles d'Avignon* (fig. 9)[46]. This parallelism is well reflected in the spatial studies which Picasso did on the subject of the curtain in the albums already mentioned[47] and demonstrates the connections with this spectacular rhythm, culminating in the background of the composition, with which he imbues the cloth in the background of *Les Demoiselles*.

Green insists on the relationship between the two works, in spite of their thematic antagonism. Nothing connects the insalubrious haunt of low life with the idyllic rural landscape. Nevertheless, there is, from the point of view of compositional technique, a great proximity between the two oils, which also have a common denominator: the mixture of memory and invention used in them by the artist.

110. *Foliage.* Paris, 1907. Watercolour on paper. 31.5×24 cm. Heirs of Picasso Collection. Zervos 6, 943.

111. *Foliage.* Paris, 1907. Gouache on paper. 65×50 cm. Künstmuseum, Berne. Hermann & Margrit Rupf Stiftung Collection. Zervos 26, 172.

Around this oil there is brought together a series of works which are directly connected with its natural surroundings, above all the woodland. These are a group of watercolours and gouaches of great plastic beauty which show a strong tendency towards abstraction. *Landscape related to The Reapers* (cat. no. 177) is, according to Daix, the development of the study of the works *Landscape* (fig. 109)[48] and *Trees* (cat. no. 179). In the two first, together with *Landscape* (cat. no. 176), Picasso offers us a rich study of the spatial modulations in the landscape background of *The Reapers*, in which he allows himself to be carried by the orographic disequilibrium of the ground and the leafy foliage which springs from the trunks of the trees. In the final composition these trunks structure the frame through which we are projected towards another pictorial space. In *Trees*, the study of spatial rhythms is taken to its conclusion with an expressive language so concise that reaches the limits of abstraction. Only the trunks of the trees are left as a visual reference, above, the branches are suggested by means of a dynamic play of

112. *Landscape.* Paris, 1907. Gouache on paper. 65×50 cm. Unknown collection. Zervos 2**, 691.

114. *Five women.* Paris, 1908. Gouache and watercolour on paper. 47.5×58.5 cm. Philadelphia Museum of Art, Philadelphia. Zervos 2*, 105.

free and rapid lines that float in the nervous shades with which the vegetation is coloured. This reduction of the figurative reminds us of two studies which the artist did in one of the albums devoted to *Les Demoiselles*, carried out between the end of June and the beginning of July, in which he pours himself out in describing the surroundings with an extraordinary graphic purity which makes the works become almost illegible[49]. In spite of this immersion in abstraction, in its clear and logical dialectic, in the Platonian geometrical forms, beautiful by nature, Picasso never became an abstract artist.

The natural elements with which we have been dealing have a resonance in a series of compositions which Picasso produced on the same theme, *Landscape* (cat. no. 180) and *Foliage* (figs. 110, 111 and 112)[50] which become cadences, each more abstract than the last, culminating in *Landscape* (cat. no. 178), a gouache which Daix considers to be one of the first abstract landscapes in the whole of modern painting[51].

The study of "spatial rhythms of landscape", as the same commentator called it, continued during the course of the summer of 1907 and up to the spring of 1908, a period in which, in Green's opinion, Braque was following a cohesive pictorial plan by means of constructive brushwork and Cézanne's *passage*, while Picasso pursued a dynamic cohesion through the rhythms of lines and surfaces.

Nevertheless, it has to be said that Picasso's work shows, on several occasions, a taste for nature in the style of Cézanne. The recognition through simplified forms and planes divided into facets characteristic of Cézanne coincides with the discovery of negro art, according to which, in Clark's opinion, nature is truly reduced to cylinders and ovals and a reciprocal effect of concave and convex. Clark believes that there is a curious resemblance in the related manner in which Cézanne and a black sculptor feel the character of planes. In this way, "the *petite sensation* of Cézanne are transformed into the most cerebral and museological of all styles: cubism"[52].

The new landscapes done by the artist from then on serve as a framework for the development of the female nude, as we can observe in a set of works centred round the compositions *Three women* (fig. 113)[53], *Five women* (fig. 114)[54] and *The Dryad* (fig. 115)[55] or in drawings like *The dream*[56], in which, furthermore, the artist projects us through the trees into another perceived space, where he returns to the old theme of the fisherman and the boat. In this oil, *The Dryad*, the vault formed by the trees, according to Daix, is close to that formed in the imaginary landscapes which Picasso did in the spring-summer of 1908, in which the memory of his stay in Gósol is felt again in the projection, at the background of the compositions, of the svelte and charismatic summit of the Pedraforca[57].

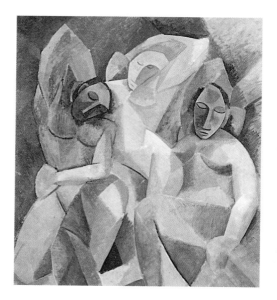

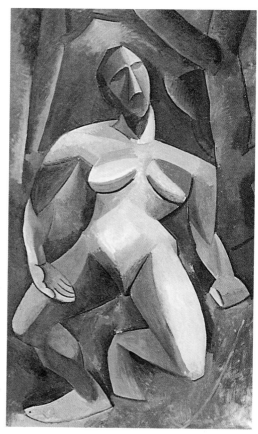

113. *Three women*. Paris, 1908. Oil on canvas. 200×178 cm. Hermitage Museum, St Petersburg. Zervos 2*, 108.

115. *Dryad*. 1908. Oil on canvas. 185×108 cm. Hermitage Museum, St Petersburg. Zervos 2*. 113.

NOTES

1. Salmon explains that he and Max Jacob "followed this spectacle. The hagiography of St Matorel takes me by the hand, without a word, without looking at me, content, his eyes full of tears like mariners" Séckel, 1994, p. 46.

2. Fernande Olivier was born in Paris on 6th June 1881. An illegitimate daughter of Clara Lang, she was given the name of Amélie Lang. She was brought up by relations, the Bellavé family, whose surname she adopted. On 8th August 1899 she married Paul Parcheron whom she left the following winter. In the spring of 1900 she met the sculptor Laurent Debienne and lived with him in a studio in Bateau-Lavoir between 1900 and 1905. It is probable that she adopted the name Fernande Olivier at that time. Fernande and Picasso met in August 1904. They lived together from Sunday, 3rd September 1905 until May 1912.

3. Before they left some companions met at Bateau-Lavoir to say goodbye. Guillaume Apollinaire, the art critic friend of the artist, made an amusing story out of it which he sent in a letter to the family home in Barcelona, at 3, Carrer Mercé. Caizernes/Séckel, 1992, p. 41-46.

4. Picasso's arrival and stay in Barcelona and his contacts with the cultural world of the time, as well as his reasons for spending the summer at Gósol have been dealt with fully by his biographers, especially Palau: Palau, 1963, p. 40; 1975, pp. 143-44; 1980, pp. 438-440; in the article of the Picasso catalogue 1905-1906, 1992, pp. 75-88 and by Richardson; 1992, pp. 434-436. Fernande has also left her own direct account. Olivier, 1964, pp. 81-83; 1990, pp. 170-171.

5. Sindreu, 1988, p. 30. The journey to Gósol, in those days, was long and complicated. They left the Plaça Espanya in Barcelona by Catalan Railways, which took them as far as Guardiola de Berga. From there they followed the narrow track which led to Gósol, passing through Maçaners, on muleback.

6. Olivier, 1990, p. 171.

7. MPP, 1857.

8. MPP, 1857, 59R.

9. MPP, 1857, 66R and 67R.

10. Olivier, 1990, pp. 171-172.

11. If Fernande is not mistaken in the date of the letter, it brings their stay forward several days if we take into account, as we have said, that the biographers usually date it around the middle of June. The letter was published and transcribed by Caizernes/Séckel, 1992, pp. 39-41.

12. Olivier, 1964, p. 83. During this time Picasso did several drawings of him: Z. 1, 346; Z. 6, 765, 769, 770 and 773; Z. 22, 453 and 454. Palau, 1980, no. 1,218, . A little later, in Paris, he made a bronze sculpture Z. 1, 380.

13. Caizernes/Séckel, 1992, p. 54.

14. The name of Canemar was because, in olden times, hemp was worked here.

15. In the Salon d'Automne of 1905 he could have seen the *Turkish Bath* by Ingres and a retrospective Manet, at the same time he could have visited the room devoted to the works of Matisse and Derain, of exuberant chromaticism—the "cage of deer" as their friends called them. His visits to the Louvre, where Salmon tells us he studied Egyptian art from 1903, would allow him to relax, also, with the ancient Greek pre-classical kyries, the monumentality of Cycladic statues and Etruscan art. In this same museum in the winter of 1905-1906 there was an exhibition of Iberian sculptures from the Osuna excavations—the

Dama de Elche was also exhibited. All these works were decisive in the later development of Picasso's art.

16. Z. 22, 369.

17. Picasso did a caricature of El Tinent, Z. 6, 1,469 (''El Tinen'' notes the artist) who was the owner of this house. It is a popular custom in Catalonia, deeply rooted, to give people the name of the house where they live or come from. According to Delors Fondevila, granddaughter of Josep Fondevila, Picasso and El Tinent were very good friends and every evening they used to play cards at Cal Tampanado. El Tinent had the habit of cheating a bit in the game which infuriated grandfather Fondevila and provoked fierce arguments which amused Picasso no end.

18. Today the names of these houses are still the same, except for Ca la Julita which has been changed to Cal Castellana and Cal Catí which is now Cal Carola. We are most grateful for this and other information about the people and places of Gósol to Father Ramon Maria Angarill and to other Gósol residents who have very kindly helped us.

19. Z. 6, 732 and Z. 1, 316, respectively.

20. Daix-Boudaille, 1967, p. 306 and Cooper, 1958, p. 7.

21. Palau, 1980, p. 440 and 454 respectively.

22. Z. 22, 344 and 345; Z. 6, 893.

23. MPP, 1857, 53R.

24. Z. 6, 735.

25. MPP, 1857, 54R.

26. Z. 6, 876.

27. Z. 1, 178, 186; Z. 6, 348, 588, 563, and Z. 22, 29; Daix, 1977, p. 79.

28. Z. 1, 338.

29. Daix, 1977, p. 79.

30. Z. 1, 384.

31. D-B. XV, 57-59; Z. 1, 311 and 312.

32. Gaya Nuño, 1975, p. 229.

33. Carnet Català, pp. 6, 59, 61, 64-68.

34. Carnet Català, p. 61.

35. Palau, 1980, p. 441.

36. Picasso's interest in El Greco arose at the time of his links with Catalan modernism, and was revived during his time in Barcelona as, shortly

before he arrived, his friend Miguel Utrillo had published a monograph in Spanish dedicated to the illustrious painter.

37. See note 15.

38. Before leaving for Gósol, in April 1906, Picasso had started to do a portrait of Gertrude Stein (Z. 1, 352). When he returned he took it up again to paint the face of the subject, but without her being there. The face became converted into a mask, which allowed him to legitimize the process of reduction that he had started doing not long before. Gertrude said later: ''All through the winter of 1906 I sat for Picasso; eighty sessions, and in the end he made a mess of the head. He said he couldn't see me any more and left for Spain (...) When he came back he painted the head without seeing me, and gave me the picture. I was, and still am, satisfied with my portrait. For me it is myself. It is the only image of me which is always myself''. Stein, 1959, pp. 17 and 18. Soon the artist would embark on the conception and development of *Les Demoiselles d'Avignon*, the most emblematic work of our century. For a study of the genesis and creation of this oil painting, we are referred to the catalogue of the exhibition *Les Demoiselles d'Avignon*, 1988.

39. Rubin stated: ''if there was a precise moment in the length of Picasso's career when the pictorial ideas which would culminate in *Les Demoiselles* really began to germinate, it was during his stay at Gósol ...''. Rubin, in the catalogue *Les Demoiselles d'Avignon*, 1988, p. 396.

40. Daix-Rosselet, 1980, p. 201.

41. For identification of the drawings in the albums which Picasso did on the theme of *Les Demoiselles d'Avignon*, we have followed the study prepared by Brigitte Léal for the catalogue *Les Demoiselles d'Avignon*, 1988, pp. 103-309. Album, 5: V, VI and VII. The first two are studies of the *Bearer of Offerings*, an Egyptian sculpture of the Middle Kingdom belonging to the collections in the Egyptian Antiquities Department of the Louvre Museum, the inspiration for the countrywoman who carries the basket on her head, near the centre of the composition. The third is related to the trees. Album, 15: 9R (Z. 26, 161). It is, also, a study of a tree.

42. Album 1: 47R (Z. 6, 772)
Album 8: 50R; 51R (Z. 2*, 669); 52R; 53R; 57V and 58R.

Album 12: 12R (Z. 6, 1,038)
Album 12; 8R (Z. 6, 966)

43. Album 1: 11R (Z. 6, 791); 34R (Z. 6, 793); 45R (Z: 6, 789); 28R (Z. 6, 792).
Album 2: 6V; 7V; 8V and 29V.
Album 8: 26V and 28V.
Album 13: 9R (Z. 6, 298); 9V (Z. 6, 934).

44. Two important factors had an impact on Picasso in the autumn of 1907: the death of Cézanne on 22nd October; and the retrospective Gauguin exhibition at the Salon d'Automne, that painter who had rejected the European orientation of art. A series of very important artistic events followed: the Salon des Indépendents showed the works *Blue nude* by Matisse and *Bathers* by Derain; and by March Picasso already had in his studio two Iberian heads from the excavations done at Cerro de los Santos, which he had bought from Géry Pieret, the controversial Belgian adventurer who was, for a time, secretary to his friend Apollinaire. Between 1906 and 1907 European artists began to be interested by primitive African art. Between the end of the year and the beginning of 1907, Picasso discovered negro art. At the beginning of the summer he visited the Trocadero Ethnographical Museum, of which years later he said to André Malraux: ''(...) The masks were not sculptures like the others. Not at all. They were magic things...'' Malraux, 1974, p. 18.

45. Daix-Rosselet, 1980, p. 201.

46. See the article by this author in this catalogue.

47. Album 12: 1R (Z. 6, 1065); 2R; 3R; 4R (Z.6, 1060); 5R (Z. 6, 1058); 6R (Z. 6, 1052); 7R (Z. 6, 1050); 8R (Z. 6, 1045); 9R (Z. 6, 1047); 10R (Z. 6, 1028) and 11R (Z. 6, 1035).

48. Z. 6, 950.

49. Album 13: 2R (Z. 6, 938) and 3R (Z. 6, 936).

50. Z. 6, 943; Z. 26, 172; Landscape Z. 2**, 691.

51. Daix-Rosselet, 1980, p. 202.

52. Clark, 1971, p. 191.

53. Z. 2, 108; Z. 26, 327, 332, 335, 331, 271 and Z. 2, 106, 107 and 104.

54. Z. 26, 331; Z. 26, 291; Z. 26, 288 and Z. 2*, 105.

55. Z. 2*, 112 and Z. 2*, 113.

56. See cat. no. 194.

57. Z. 2*, 72 and Z. 26, 174. See cat. no. 187.

173 b, fig. 103. Houses in Gósol
Gósol, 1906
Charcoal on paper, 36×47.5 cm
Private collection

173. LANDSCAPE
Gósol, 1906
Gouache and black pencil on paper, 47.5 61.5 cm
Musée Picasso, Paris

175. Study for the Reapers
Paris, June-July 1907
Charcoal on paper, 48.2×63 cm
Musée Picasso, Paris

174. The Reapers (Les Moissonneurs)
Paris, Spring 1907
Oil on canvas, 65×81.3 cm
Thyssen-Bornemisza Collection

176. LANDSCAPE RELATED TO THE REAPERS
Paris, Spring-Summer 1907
Watercolour on paper, 22.4×17.5 cm
Private collection

177. LANDSCAPE RELATED TO THE REAPERS
Paris, Spring-Summer 1907
Gouache and lead pencil on paper, 63×48.4 cm
Musée Picasso, Paris

180. LANDSCAPE
Paris, Spring-Summer 1907
Gouache on paper glued on cardboard, 64.8×49.8 cm
Virginia Museum of Fine Arts. The T. Catesby Jones Collection.

178. THE TREE
Paris, Summer 1907
Oil on canvas, 94×93.7 cm
Musée Picasso, Paris

179. Trees
Paris, 1907
Pencil and coloured pencils on paper, 63×48.5 cm
Marina Picasso Collection (0997)
Courtesy of the Jan Krugier Gallery, Geneva

CUBISM, 1908-1909

Malén Gual

The artistic season of autumn 1907 in Paris was dominated by the presence of Cézanne: in the Salon d'Automne a retrospective exhibition was held of his works, the Galeries Bernhaim Jeume showed his watercolours and sketches, and a considerable number of articles were published on him in the specialized magazines. For Picasso this meant a reappraisal, after the period of Iberian simplification and the stylization of negro art. These three influences now converged, reinforcing what they had in common; the intention of simplifying by the elimination of everything that was not indispensable in form and the expression of monumentality based on the force of the lines and the optical aspect of colour.

The figurative simplifications and the graphic rhythms, with their strong contrasts of colours and their stylizations, enabled Picasso to produce a series of monumental figures, generally set in imaginary woods and landscapes. Daix notes that the development of the series of bathers[1] could be exactly defined, starting as it did from the representation of a single figure, followed by the pairs, going on to the study of groups which led to *Three women (Z. 2*, 108)* and *Five women (Bathers in the wood)* (Z. 26, 291). In the studies for *Bathers in the wood* (cat. nos. 181-183) the artist combines the geometric conversions of Cézanne with a stylization clearly of negro influence, seen fundamentally in the faces/masks of the subjects. The volumes are constructed by chromatic contrasts and plastic rhythms. The imaginary landscape of the background serves to relate and situate the subjects. The series of *Five women* must be seen as a continuation or variant of the series *Three women*, both for its rhythm and colour and through the repetition of the attitudes of the bathers, in the same gesture and study of movement, as if to the group of three there had been added a pair from *The friendship* (Z. 2*, 60)[2]. All the elements in these works are treated in a homogenous form, from a basis of surfaces of equivalent rhythms, occupying the whole picture. The use of a limited chromatic range reinforces the sensation of unity of the whole.

From the first half of 1908 there are a small number of imagined landscapes painted in the studio at Bateau-Lavoir, which were aids to the researches of the series with figures. In *Trees* (cat. no. 184), *Landscape* (cat. no. 185) and *Landscape (two trees)* (cat. no. 186), the trunks and the scanty foliage compose a set of enlaced forms, frequently

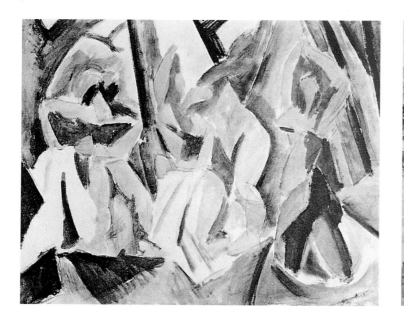

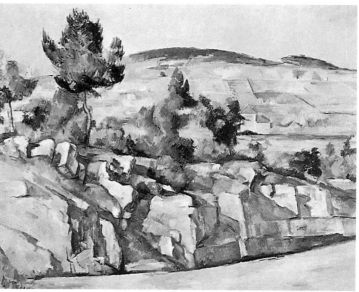

116. *Study for "Bathers in the wood".* 1908. Watercolour. 48×59.5 cm. Zervos 26, 291.

117. Cézanne: *Rocks and a hill in Provence.* 54×81 cm. Tate Gallery, London.

structured in striations and cut off at right-angles. These landscapes are still relatively naturalistic, respecting the perspective and maintaining the rich chromaticism of some works from the end of 1907. The dryness of the trees, devoid of leaves, gives them a wintry aspect but, in having been painted from memory, through their rhythm and colour they could have been studies for the backgrounds of the compositions of bathers.

In *Landscape* (cat. no. 187) the composition, also imagined, is more ambitious. It introduces new elements, as the mountain and the clouds in the background give it depth, differentiating it from those earlier, which were flatter. There is another version, narrower and vertical, painted in the same ochre and siena tones, where the stylization recalls the simplifications of Customs Officer Rousseau—Picasso professed a great admiration for his exceptional realism, free from visual conventions[3] - and also the very simplified landscapes by André Derain of 1906[4].

In August 1908 Picasso and Fernande moved to Rue-des-Bois, a little village some 60 km. north of Paris, close to the Halatte woods. Braque, in the meantime, moved into l'Estaque and painted the first collection of truly cubist works, which were exhibited in the autumn in the Galeries Kahnweiler and provoked the first appearance of the term "cubist"[5].

In Rue-des-Bois, landscape again became the subject of interest for itself, not merely as a background for figures. Golding saw the influence of Cézanne in the landscapes from this time, "still related in many ways with Picasso's primitive work. Some of them recall the naïf interpretation of houses and trees of Customs Officer Rousseau"[6]. The influence of Cézanne is seen in the structure of the paintings and in the technique of small flat brushstrokes. As did Braque in l'Estaque, Picasso reinterpreted Cézanne in a conceptual sense, taking some liberties with the conventional perspective, rejecting the single point of view and obtaining the relief effect through the arbitrary juxtaposition of light and shade.

Production during this stage was relatively sparse and, except for some still-lifes and the solid portrait of the farmer's wife (Z. 2*, 91), was centred on landscape research. The landscapes of this time were characterized by a dark green with a touch of yellow, where the schematic trunks, the branches and foliage constitute the principal subjects.

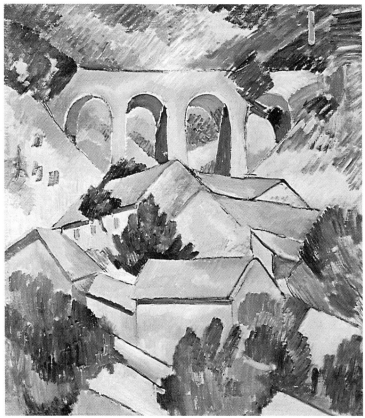

119. *Bathers in a landscape.* 1908. Indian ink and tempera. 27×22.5 cm. Zervos 26, 380.

118. Braque: *L'Estaque viaduct.* 1908. Oil on canvas. 72×59 cm. Private collection.

The three paintings *Leafy landscape* (cat. no. 188), *Landscape* (cat. no. 189) and *Landscape* (cat. no. 190) were acquired by Leo and Gertrude Stein in the autumn of that same year. In them, Picasso attempted his first *passages* in the manner of Cézanne, opening the forms of the trees in order to make them communicate with the space surrounding them and blur them into it. The spatial articulations formed by the vertical thrust of the trees and the space of the open sky, already implied in the imaginary landscapes in Paris, become confirmed in the direct observation of nature, freely reinterpreted. In these landscapes everything is reduced to the essential, details are suppressed and the foreground is integrated into the background. Again, the influence of Customs Officer Rousseau shows in the elimination of detail, leaving only the trunks, rocky masses and the large plain leaves. In *Leafy landscape* (cat. no. 188) the very abundant vegetation occupies completely the whole plane surface of the painting and the artist has practically suppressed the sky, thus removing the sensation of depth.

Although the simplifications of the houses and trees in these works and their green tonalities may be due to the influence of Customs Officer Rousseau, Rubin[7] makes us note that Picasso's instinct for conceptualization and his continued interest in Cézanne's work were determinant at this time, as was the use of one of the characteristic traits of Cézanne at the end of his career, the *passages*, through which the viewer is invited to observe freely the pictorial space offered in a subtle conjunction of outlines and planes.

In *Landscape* (cat. no. 189) the Cézanne-style conjunctions are seen around the right-hand branch of the central tree which is integrated into the earth near the line of the horizon and in the upper left-hand part, where another branch marks the point where the different planes of the house and the tiled roof converge. With respect to this work,

doubts exist as to the precise date of its painting. Zervos dated it in the autumn of 1908, but Picasso told Jardot that he had painted it in Rue-des-Bois. Rubin was inclined to date it in August or September 1908, as it could have been begun in Rue-des-Bois and finished in Paris.

In the two landscapes *Cottage in a garden* (cat. no. 191) and *Cottage and trees* (cat. no. 192) there is a reinterpretation of landscape, starting from reality and a redistribution of volumes. The monumentality comes from the elimination of everything that is not fundamental and, assuming Cézanne's elevated point of view, Picasso prolonged the outline of the walls from deliberately different angles, accentuating the visual communication between the closed volume of the object and the spatial exterior which contains this volume.

The articulation of the figure and the landscape are the subject of *Landscape with two figures* (cat. no. 193). Picasso said that this imaginary landscape was painted in Paris before the summer, but Daix notes its similarity to the landscapes unquestionably painted in Rue-des-Bois, and in the event of its having been painted in Paris, it must have been on his return in September[8]. The bodies are integrated into the landscape, prolonging the line in such a way that they are blurred with it. The vertical framing of the trees and the ground, accentuated by the arrangement of the figures, encloses the central part composed by a set of strongly modelled geometric volumes in the characteristic tones of ochre and dark green which predominated in this period.

The dream (cat. no. 194) also displays the same framing and arrangement of the figures, more defined, without blurring them into the landscape. The composition in the foreground, very precisely drawn, encloses a small rectangle of paper glued on with a drawing of a figure in a boat. Picasso glued to the surface of the drawing a fragment which he perhaps cut from an advertisement from the Grands Magasins de la Louvre or from the Louvre Museum, and drew on it a different scene to the rest of the composition. Probably the fragment was used to cover a hole in the paper, and although it was perhaps involuntary, from a technical point of view we are dealing with the first *"papier-collé"*, as Kahnweiler and Picasso noted on the back of the work.

On returning to Paris Picasso and Braque reviewed their work, and realized that they had both attempted to solve the same problems of destroying the pictorial illusion, on the basis of a reflection of the methods of Cézanne. In spite of small differences between them, both were using a distancing of the subject, which no longer structured the painting and passed the reasoning of the pictorial development to its composition and rhythms. It was at this time that the period of friendship and cooperation began between the two artists.

Picasso, at the end of 1908, transformed his pictorial handwriting, introducing a new element influenced by Cézanne: the multiplicity of "steps" accompanied by the rotation of planes under the variations of lighting. This transformation enabled him to abandon the use of exclusively angular forms. Picasso's formal research was centred on the human figure, treated in a monumental form, still with a face displaying a negroid cast.

120. Photograph of Horta and reproduction of "Houses on a hill", similar to *Transition*, no. 11, 1928.

He returned to the subject of the bathers in the wood at the beginning of 1909, with a series of sketches. In two of these, entitled *Nudes in a landscape* (cat. no. 195 and Z. 26, 380) the group of figures appears in the same arrangement as that of 1908, but the forms are here more rounded and smooth, less angular, and the faces, although still masks, have lost some of the primitive traits. The landscape in the background, more diaphanous, is less geometrical and the small planes and a light striping enable him to depict the details of the volumes with greater precision.

In the watercolour *St Anthony and Harlequin* (cat. no. 196) the rounded figures contrast with the geometric forms of the houses and the church in the background. The subject, which is of a monk and a harlequin before a nude woman, was probably inspired by the *Temptation of St Anthony* by Cézanne[9]. Picasso sketched a variation for a woodcut, which was never made, in which the monk was replaced by a second woman. Palau i Fabre thought that this was a reminiscence of Horta, probably evoked by the decision to return to his friend Pallarès's village in the summer of 1909. The same landscape of rocks and trees also appears in *People with a boat in a landscape* (cat. no. 197) and *Bathers in a landscape* (cat. no. 198) new versions of the group of bathers on which he had worked in 1909, but which he never finished.

In *Landscape with bridge* (cat. no. 199), the genre of landscape, somewhat neglected since his return from Rue-des-Bois, returned in all its splendour as a premonition of the importance which it would acquire in Horta. Some authorities have situated this work in Horta, but both Daix and Palau i Fabre believe that it was painted in Paris a little before he left for Spain. Its similarity to the architecture of *St Anthony and Harlequin* leads us to think also that it could be an imaginary landscape painted in his studio. The sharpness of this landscape was obtained through forms like blocks to represent the houses and it creates the spatial articulation through lines of direction. Thus, the cubic forms, of defined volumes, obtained by the use of small flat brushstrokes, are arranged on the plane surface from several points of view, without a central point of escape. The absence of the sky takes away the sensation of depth and it seems that the mountains of the background are on top of the bridge and not in the distance. The use of the *passages* is now more advanced and the artist leaves the planes of the houses open and they are integrated into the bridge and the background and among themselves. The egalitarian treatment of the architectural elements and nature accentuates the importance given to volume and the construction of the composition.

In May 1909 Picasso and Fernande travelled to Barcelona, where they stayed until the beginning of June[10], and then spent the summer in Horta where: "Picasso consolidated his achievements of the previous years and produced the most important group of paintings of his early cubist period"[11].

The stay in Barcelona allowed him to meet his family again, whom he had not seen since 1906, and also his friends Vidal Ventosa and Pallarès, of whom he painted a portrait (Z. 26, 425). In a series of sketches (cat. nos. 200-203) made from his hotel in Barcelona, according to what he himself told Pierre Daix[12], the progressive abandon-

ment of reality and abstraction of form can already be perceived and the interest is in a new concentration on composition, obtained by the rupture of the structure and the proliferation of the lines of flight.

At the beginning of June, Picasso and Fernande left for Horta de Sant Joan, following the same route as eleven years before, when Picasso had travelled by train to Tortosa. They arrived at their destinaton on the 5th June, according to Fernande's correspondence with Alice B. Toklas. Manuel Pallarès told Palau i Fabre that Picasso and his companion stayed some days in Tobias Membrado's house and later in the "Posada Antonio Altés"[13].

During this stay in Horta, from June to September, Picasso consolidated and crystallized the stylistic changes he had begun in Paris. If it is with the human figure that his progress is most daring, in landscape he achieved the development and perfectioning of the system of shaded facets for obtaining volume. The sober landscape and the individual geometric structures of the buildings at Horta conformed to the method of analysis and cubist construction. Picasso in Horta "eliminated the natural forms almost completely and concentrated on the relationships between blocks of cubic buildings and on harmonizing their obvious solidity with the bi-dimensionality of painting"[14]. He breaks down the volume through facets and accentuates the simultaneity of the points of view; he reduces the colour to greys, ochres and pale green and utilizes this colour to accentuate the compactness of form. The lights and shades, employed in an arbitrary manner, are counterposed to make the outlines stand out in relief.

Picasso took several photographs of corners of the village and, comparing them with his works, they show that at that moment he was working from a real model, which he reinterpreted according to the coordinates of simplification, seeking the way to mould three-dimensional forces on a flat surface.

One of the photographs refers to the subject of *Houses on the hill* (cat. no. 204) which belonged to Gertrude Stein, who enjoyed displaying the landscape together with the photograph to show how Picasso had approximated to the reality and considered that: "the treatment of the buildings was especially Spanish and in consequence essentially a Picasso treatment. In these paintings the artist made clear above all the special manner of construction of houses in the Spanish villages, in which the rows of houses do not follow the landscape, adapting themselves to it, but are blurred into it"[15]. Gertrude herself sent photographs of the painting and the landscape to the magazine "Transition" in 1928, in order to illustrate a study about cubism.

In *Houses on the hill* Picasso used a divergent perspective and displayed some of the houses from a frontal perspective and others from an aerial perspective. In widening the forms of the tiled roofs and making the doors slide down below the level to which they belonged, he produced the effect of breaking the traditional perspective and accentuated the sensation of the flat surface. The application of colour was idealized, making it far from reality, and the luminous yellows for the houses and metallic grey for the shadows give the solid forms the sensation of translucent crystals of rock. The forms of the hill and sky in the background tend to fuse together, constructed on the basis

NOTES

1. Daix, *Le cubisme de Picasso*, 1979, p. 209.

2. Ibid. p. 214.

3. In November 1908 he organized a dinner in his studio in Bateau-Lavoir in homage to Customs Officer Rousseau.

4. Daix, 1977, p. 99.

5. Louis Vauxcelles, ''Gil Blas'', 14-XI-1980

6. Golding, 1988, p. 77.

7. Masterpieces from the David and Peggy Rockefeller Collection. Manet to Picasso. P. 91.

8. Daix, 1979, p. 255.

9. Ibid. p. 238.

10. See the chronology by Judith Cousins in *Picasso et Braque. L'invention du cubisme.*

11. Golding, 1988, p. 80.

12. Daix, 1979, p. 66.

13. Palau, 1990. p. 136.

14. Golding, 1988, p. 83.

15. Stein, *Autobiography of Alice B. Toklas*, p. 116.

16. Baldassari, *Picasso photographe*, p. 174.

17. Palau, 1990, p. 501.

of a series of planes cut into facets with short brushstrokes, Cézanne style. For this work he did some preparatory studies (cat. nos. 205, 206) in a vertical format in which, as in the *Reservoir*, he grouped the houses in a pyramidal and compact arrangement, much more accentuated than in *Houses on the hill*, which indicates that he worked on the subject until the last moment before making it definite in the final painting.

Gertrude Stein also acquired *The Reservoir* (Z. 2*, 157), two preparatory drawings for which are in the exhibition (cat. nos. 207, 208). Two of the photographs taken by Picasso in Horta correspond to different angles of the village water reservoir; one of these (fig. 28) has been taken from close by and from an elevated position and shows the curve of the cistern in the foreground while the architecture of the houses melts into the arid ground of the valley. In the other photograph (fig. 29) the cistern appears tangentially and the tiled roofs dominate the composition. In the painting, constructed with a strict harmony and severe architectural lines in yellow, ochre and green, subordinated to the domination of the form, Picasso gave the general view from the village from a point of view from below: ''in contradiction with the treatment of each one of the volumes, figured as though they were seen from above. Two treatments of perspective, incompatible in principle, have been put together: a space seen from below where the painted elements are placed in immersion''[16]. Thus, the buildings further away give the impression of being superimposed on and not behind those of the foreground. In order to reinforce the divergent perspective, the artist gave to some houses a contradictory or divergent shadow, like the house in the centre which projects two shadows in front and one at the back, all at the same time.

In the third landscape acquired by the Steins, *The Horta Factory* (Z. 2*, 158), Picasso drew three palm trees which did not exist in Horta. As the artist explained to Palau i Fabre, he introduced them because they interested him for the composition[17], and they could be a memory of palm trees seen in Barcelona, shown in the drawings (cat. nos. 200-203). The palm tree, very hazy and less perceptible than those in the previous work, centres the composition of *The Mill at Horta* (cat. no. 208 b). In this watercolour, simpler than the other works from Horta, the diversity of viewpoints is very much accentuated in the house on the right, where we see the facades and the two roof-slopes at the same time, and the enclosed garden in juxtaposition to the house, as seen from the air. With a soft chromaticism, he uses ochre tones for the houses and the surrounding countryside, a light hazy grey for the shadows and pale green in the centre to evoke the palm tree and concentrate the composition in the centre of the paper, leaving the edges clean, which accentuates the sensation of fragility. This same group of houses shown in *The Mill at Horta* appears in *The Oil Mill* (Zervos 2*, 160), which Daix dates at the beginning of his stay in Horta, while Palau, Zervos and Kahnweiler consider it to be a memory of Horta done in Paris shortly after his return. The introduction of the palm trees and the freedom and imagination in the application of colour in the landscapes of this period make them a sublimation of the village and not a simple interpretation of reality.

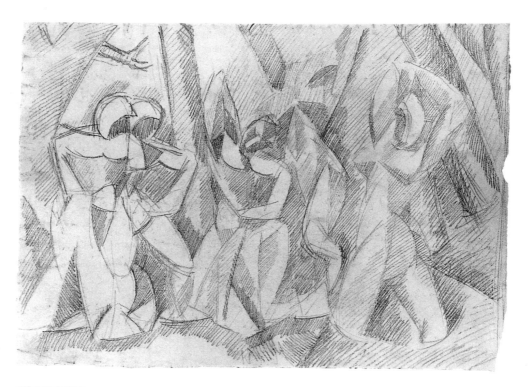

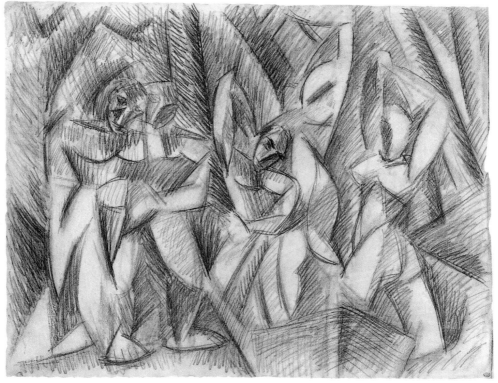

181. STUDY FOR "BATHERS IN THE WOOD"
Paris, Spring 1908
Lead pencil on paper, 32×43.5 cm
Musée Picasso, Paris

182. STUDY FOR "BATHERS IN THE WOOD"
Paris, Spring 1908
Charcoal on paper, 47.7×60.2 cm
Musée Picasso, Paris

183. Study for "Bathers in the Wood"
Paris, Spring 1908
Gouache and lead pencil on paper, 48.4×62.7 cm
Musée Picasso, Paris

184. Trees
Spring 1908
Watercolour on paper, 22.3×17.5 cm
Private collection, Paris

185. LANDSCAPE
Spring-Summer, 1908
Watercolour on paper, 22.4×17.5 cm
Christine Ruiz-Picasso

186. LANDSCAPE
Spring 1908
Gouache on paper, 48.8×63.3 cm
Philadelphia Museum of Art: The Louise and Walther Arensberg Collection

187. LANDSCAPE
Paris, Spring-Summer 1908
Gouache and watercolour on paper, 64×49.5 cm
Künstmuseum, Berne. Hermann and Margrit Rupf-Stiftung

188. LANDSCAPE
Rue-des-Bois, August 1908
Oil on canvas, 72.5×59.5 cm
Civico Museo d'Arte Contemporanea - Jucker Collection - Milan

189. LANDSCAPE
August-September 1908
Oil on canvas, 100.8×81.3 cm
The Museum of Modern Art, New York
Gift of David Rockefeller, 1974

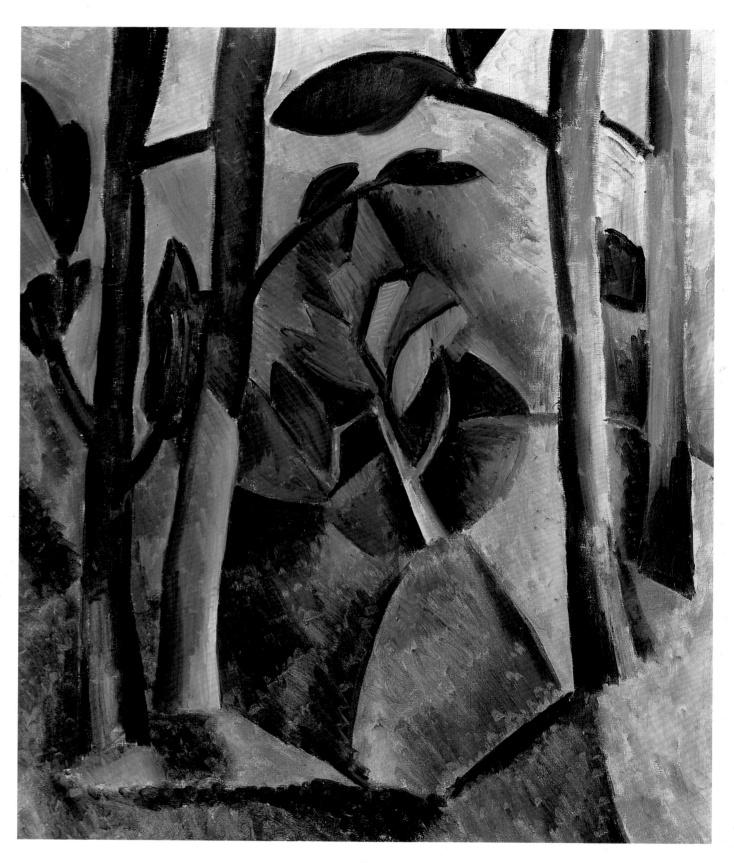

190. Landscape
Rue-des-Bois, August 1908
Oil on canvas, 73×60 cm
Private collection

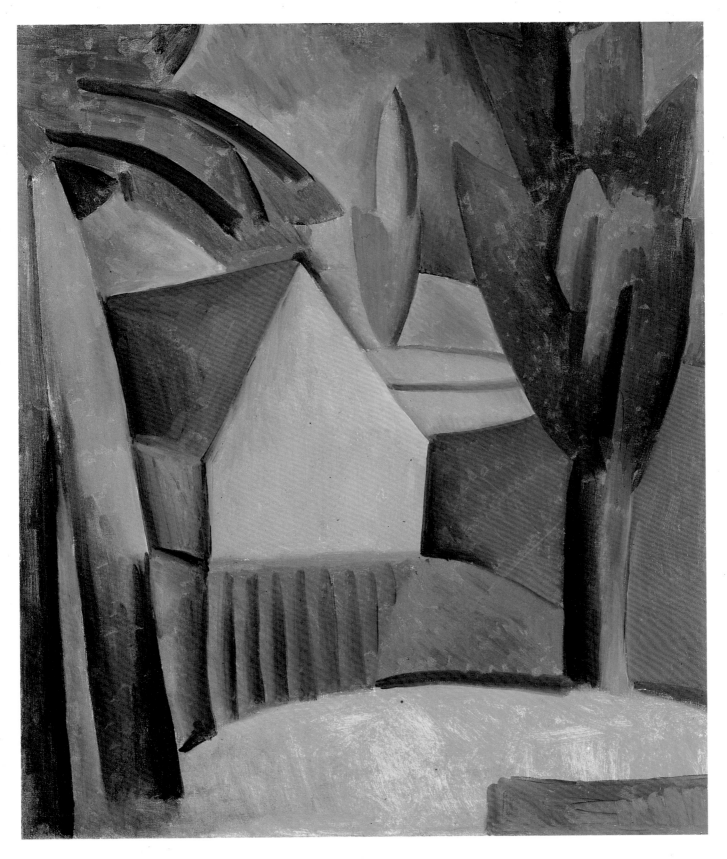

191. Cottage in a Garden
Rue-des-Bois, August 1908
Oil on canvas, 73×61 cm
The Hermitage Museum, St. Petersburg

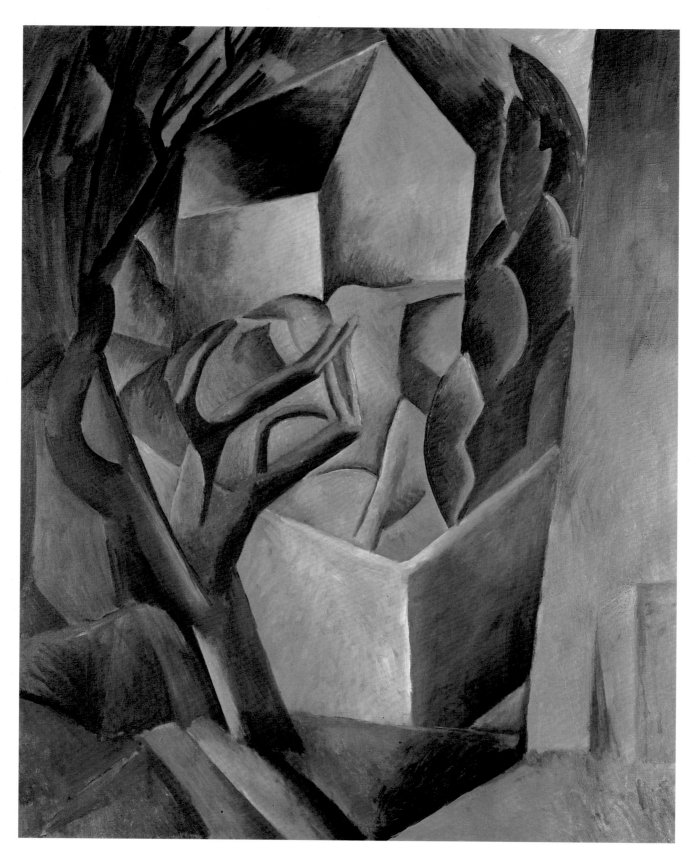

192. Cottage and Trees
Rue-des-Bois, August 1908
Oil on canvas, 92×73 cm
Pushkin Fine Arts Museum, Moscow

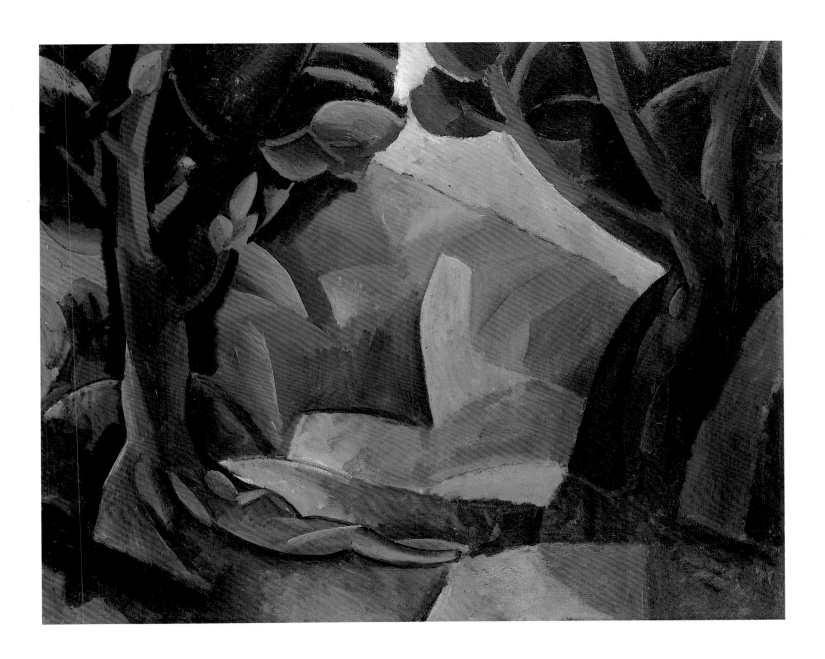

193. LANDSCAPE WITH TWO FIGURES
Summer, 1908
Oil on canvas, 60×71 cm
Musée Picasso, Paris

194. THE DREAM
Paris, Summer 1908
Pen, ink, gouache and collage on cardboard, 41.5×26 cm
Hilde Thannhauser Succession, Berne
Silva-Casa Foundation

195. NUDES IN A LANDSCAPE
Paris, 1909
Pen, brown ink, coloured pencil and gouache on paper, 13.2×17.4 cm
Musée Picasso, Paris

196. St Anthony and Harlequin
Paris, Spring 1909
Watercolour on paper, 62×48 cm
Moderna Museet, Stockholm

197. PEOPLE WITH A BOAT IN A LANDSCAPE
Paris, Spring 1909
Lead pencil on paper, 31×48 cm
Musée Picasso, Paris

198. BATHERS IN A LANDSCAPE
Paris, Spring 1909
Gouache and Indian ink on paper, 27×22.5 cm
Musée Picasso, Paris

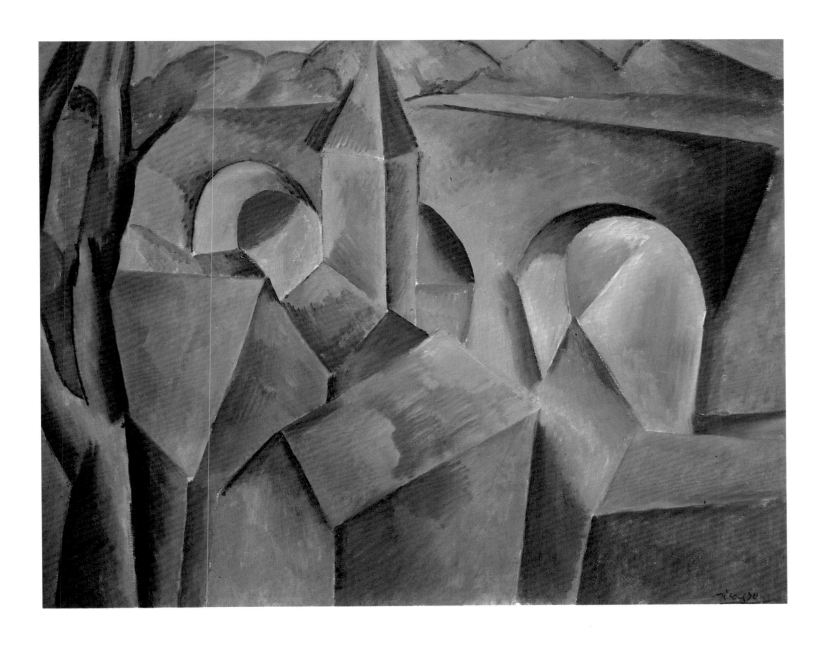

199. LANDSCAPE WITH A BRIDGE
Paris, Spring 1909
Oil on canvas, 81×100 cm
Národny Gallery, Prague

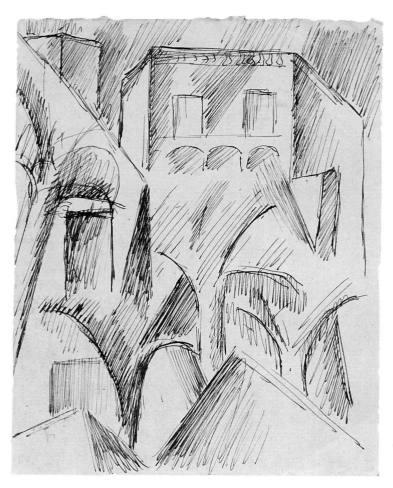

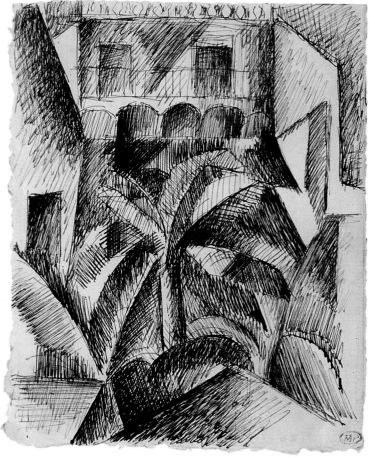

200. HOUSES
Barcelona, May 1909
Pen on paper, 17×13.2 cm
Private collection, Paris

201. HOUSES AND PALM TREES
Barcelona, May 1909
Pen and black ink on paper, 17.3×13.5 cm
Musée Picasso, Paris

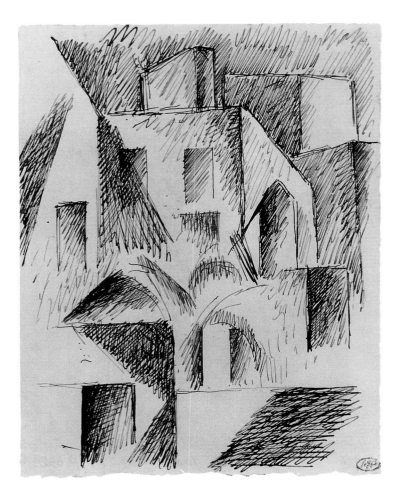

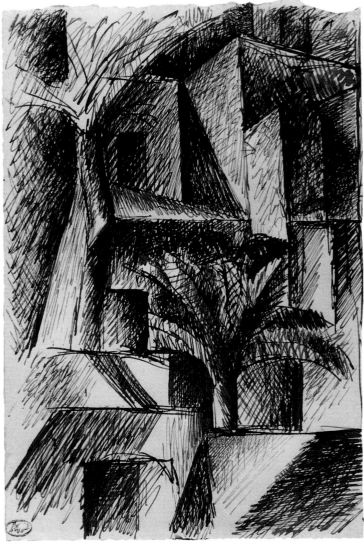

202. HOUSES
Barcelona, May 1909
Pen and black ink on paper, 17×13 cm
Musée Picasso, Paris

203. HOUSES AND PALM TREES
Barcelona, May 1909
Pen and black ink on paper, 17×11 cm
Musée Picasso, Paris

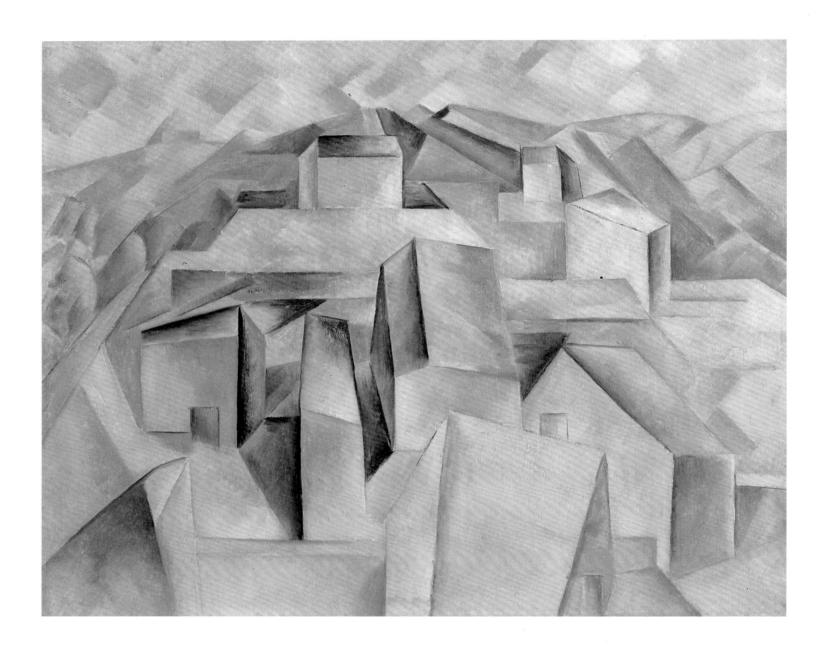

204. HOUSES ON THE HILL
Horta, Summer 1909
Oil on canvas, 65×81 cm
The Museum of Modern Art, New York. Nelson A. Rockefeller Bequest

205. HOUSES ON THE HILL
Horta, Summer 1909
Lead pencil on striped paper, 20.3×13.3 cm
Musée Picasso, Paris

206. Houses
Horta, Summer 1909
Pen and brown ink on striped paper, 20.2×13.2 cm
Musée Picasso, Paris

207. SKETCH FOR THE RESERVOIR AT HORTA
Horta, Summer 1909
Pen and ink on a new envelope, 11.2×14.4 cm
Musée Picasso, Paris

208. SKETCH FOR THE RESERVOIR AT HORTA
Horta, Summer 1909
Pen on paper, 11.2×14.5 cm
Private collection, Paris

208 b. THE MILL AT HORTA
Horta, Summer 1909
Watercolour on paper, 24.8×38.2 cm
The Museum of Modern Art, New York.
The Joan and Lester Avnet Collection

Towards Abstraction

M. Teresa Ocaña

After his return from Horta, landscape almost disappeared as a subject in Pacasso's work. The human figure and still-life became the exclusive subjects of his cubist experiments.

There are, however, some paintings and sketches in which the artist transposed to his immediate environment the progressive nuances and innovations that the evolution of cubist semantics imposed upon him.

On his return from Horta and during the whole of the winter of 1909 and 1910 he only painted one oil representing a landscape, *The Sacré Coeur* (cat. no. 209). This perspective of the Montmartre church, the emblem of this district of Paris, is the view from his new home in 11, Boulevard Clichy. In this work, which appears unfinished, he was still continuing with the progress made in Horta d'Ebre, in which the transparency of superimposed planes evidences still the constant references to Cézanne. This transparency of planes brings it close to the conception of two contemporary works *Portrait of Ambroise Vollard*[1] and *Portrait of Wilhelm Uhde*[2]. Of a similar structure, *The Sacré Coeur* has a greater transparency than these, which no doubt contributes to the sensation of an unfinished work. There is a drawing of the same year[3] which shows the same view. The superimposition of planes still at this time gives no difficulty in reading the townscape represented.

Sounding abstraction. Cadaqués, summer 1910

His trip to Cadaqués at the end of June 1910 marked an inclination in Picasso's work towards abstraction. He arrived in Cadaqués under the tension which he had experienced in the previous months in Paris, produced by his efforts to advance his research into the reduction of bodies and objects to geometric planes, and to find a greater homogeneity in the forms. Although his interest in the human figure was prevalent, there are a few seascapes in which the composition is determined by the monotony of colour and the interlacing of a conjunction of interactive planes. This happens in *The port of Cadaqués* (fig. 121), where the severity and sharpness of the line to which the planes have been reduced make it difficult to read. Only the discontinuity of some of these

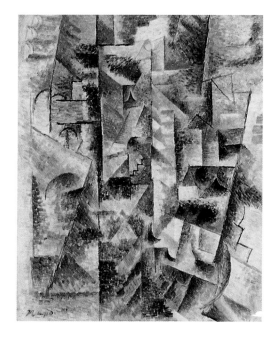

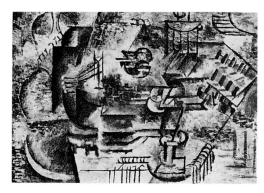

planes in their intersections with the others breaks the homogeneity of the composition and permits a certain clarity.

 Palau[4], notes the set of washes in which *Seascape* (cat. no. 210) is outstanding, a work in which the homogeneity of the composition is no obstacle to an excellent description of the marine world, and it is certainly true that, as Golding[5] makes clear, the engravings and sketches are less abstract than the oil paintings which at times cannot be deciphered without the help of these preliminary sketches. This is applicable to *Seascape*, its aesthetic effects and the brushstrokes done in a mosaic manner to form the smooth swell are characteristics of a later cubism, in which certain ornamental elements already appear, but which in this case marks the rhythm of the composition.

 During the month of August of his stay in Cadaqués, Picasso's work was concentrated on the preparation of illustrations for the text of *Saint Matorel* by Max Jacob[6], written in Quimper in 1910. The illustrations were begun in Cadaqués and finished in Paris in the autumn. One of the etchings which serves as an illustration is a view of a convent of Santa Teresa in Barcelona[7]. The artist made two plates for this view of the Santa Teresa convent[8]. The second was the one used for the printing, so the other (begun in Cadaqués and finished in Paris in the autumn) was scrapped.

 As opposed to the hidden meaning of the other three illustrations, especially of *Mme. Léonie* and of *Mademoiselle Léonie on a chaise-longue*, *The Convent* (cat. no. 211) presents a structure much closer to the compositions done in the summer of 1909 in Horta, in which the transparency of the planes, larger and with clearer intersections, allows us to read it more easily. There is a sketch for the same building (cat. no. 212)[9], made in Cadaqués in this same summer, of extraordinary conciseness and beauty, closely related with the works *Houses* (cat. no. 200) and *Houses and palm trees* (cat. no. 201),

122. *Céret landscape.* Céret, 1911. Oil on canvas. 65×50 cm. The Solomon R. Guggenheim Museum, New York. Zervos 2*, 281.

123. *Mandolin and glass of Pernod.* Paris, 1911. Oil on canvas. 33×46 cm. Private collection, Prague. Zervos 2*, 259.

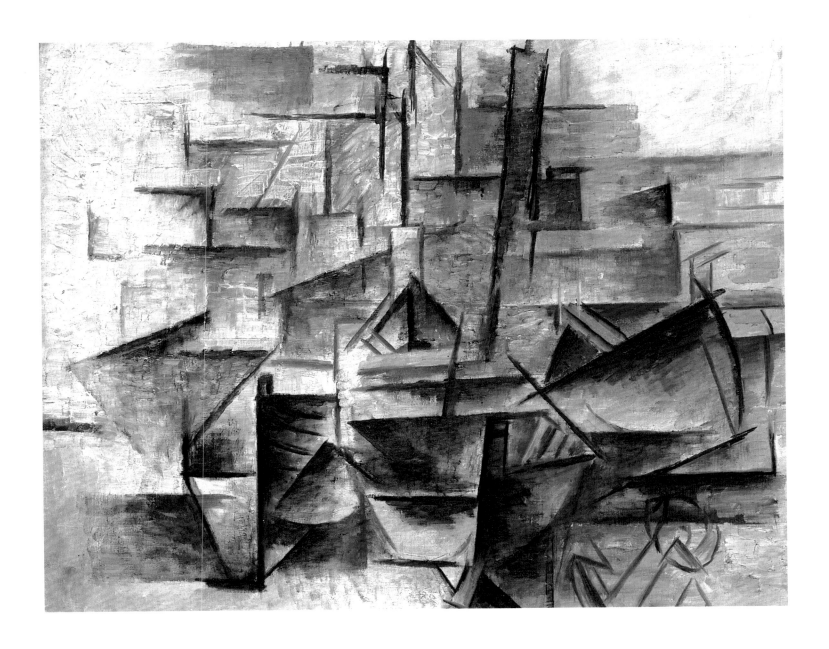

121. *Port of Cadaqués.* Cadaqués, 1910.
Oil on canvas. 38×45.5 cm. Národny Gallery, Prague.
Zervos 2*, 230.

done in the spring of 1909 in Barcelona and which probably were the references used by the artist in the illustrations for Saint Matorel and which could constitute a series with them.

The presence of the human figure and of still-life are the exclusive subjects in 1911, up to the point that only two landscapes were painted in the spring of 1911: *La Pointe de la Cité* (cat. no. 213) and *Le Pont Neuf* (cat. no. 214). *La Pointe de la Cité* is already a prelude to *Céret landscape* (fig. 122) done in this southern French town during the summer of that year. The architectural structure of the painting is divided into a series of little planes, reduced on various occasions to simple lines, made by the same type of brushstrokes disposed in a mosaic manner, softening the reserve and secretiveness of the composition and giving it a definite luminosity, which allows a touch of abstraction but without falling into it. Picasso himself said to Zervos in 1935: "There is no abstract art. You must always start with something. Afterwards you can remove all traces of reality. There's no danger then, anyway, because the idea of the object will have left an indelible mark. It is what started the artist off, excited his ideas, and stirred up his emotions. Ideas and emotions will in the end be prisoners in his work. Whatever they do they can't escape from the picture. They form an integral part of it, even when their presence is no longer discernible"[10].

Cooper says that between the summer of 1910 and the spring of 1912 Picasso is, during this period and particularly in *La Pointe de la Cité*, at the point at which he bordered on the frontier of non-figuration in a more intense manner, in the same way as Braque had done, but in a manner not so profound. Before this frame of mind both of them drew back and reconsidered how to save the situation. The incorporation of some

124. *Woman with a guitar beside a piano.* Paris, 1911. Oil on canvas. 57×41 cm. Národny Gallery, Prague. Zervos 2*, 337.

126. *Avenue Frochot seen from the studio.* Paris, 1911. Oil on canvas. 24×19 cm. Unknown collection. Zervos 2*, 268.

125. *La rue d'Orchamp*. Paris, 1912. Oil on an oval canvas. 24×41 cm. Zervos 2*, 330.

NOTES

1. Daix, 1979, no. 337.

2. Daix, 1979, no. 338.

3. Z. 6, 997.

4. Palau, 1990.

5. Golding, 1988, p. 90.

6. Any reference to this subject is splendidly dealt with in the recent and exhaustive catalogue *Max Jacob et Picasso* by Hélène Séckel.

7. The convent of Santa Teresa was founded by the Descalced Carmelites in 1674 and was demolished in 1936.

8. Baer, 1955, pp. 63 and 65.

9. The Picasso Museum of Paris places one between April and May 1909 in Barcelona under the title of *Houses and palm trees* (cat. no. 201, MP 636) and the other in Cadaqués in the summer of 1910 under the title of *Houses and palm tree* (cat. no. 212). Palau in *Picasso cubisme (1907-1917)* had already placed it in Cadaqués in 1910.

10. Mentioned by Cooper and Tinterow, *The essential cubism*, p. 266.

11. Douglas Cooper: *The cubist epoch.*

12. *Picasso cubisme*, p. 206.

legible elements to facilitate the reading of the composition, really, did no more than obscure the spatial structure still further, so that the final result was a reading even more complex.

This concern for clarifying the reading gave way in the summer of 1911 in Céret to a new turn in the arrangement and structuring of the forms, which comes out in a greater concentration of compositional elements but pursues a greater legibility, *Céret landscape* (fig. 122) is a clear example[11].

In *Le Pont Neuf* the planes are not so schematic as in the painting mentioned above and there are certain curvilinear elements which allow identification of some of the elements of the this landscape, which combines the current of the Seine passing beneath the Pont Neuf, a series of buildings which define the surroundings and a steam boat blowing out smoke which is placed in the centre of the composition. The treatment of this composition is very similar to that employed in the still-lifes at this time, such as the *Mandoline and glass of Pernod* (fig. 123) and *Woman with guitar beside a piano* (fig. 124). Palau[12] speaks to us of a markedly Baroque-style trend in the work done in the spring of 1911. In *Le Pont Neuf* the great amalgam of identifying and decorative elements contributes to this Baroque tendency, while in a certain sense doing no more than create a complex structure. In the face of this he drew back during the summer in Céret in 1911, as we can appreciate in *Céret landscape*, a canvas of a more homogeneous and ordered structure, and for that reason much clearer.

The schematic nature of the planes is accentuated in the oval canvas of *La rue D'Orchamp*, done in the winter of 1912, which has as its subject the view from a studio in the Bateau-Lavoir where he had returned to work at that time. The structure, of an absolute homogeneity, goes very well with the uniformity of colour. Composed with the strictness and austerity of *La rue d'Orchamp*, a landscape currently of unknown whereabouts, *L'Avenue Frochot* (fig. 126) shows the view from Picasso's studio at 11 Boulevard Clichy, with a reappearance of the figurative and a certain decorativeness which presage later experiments.

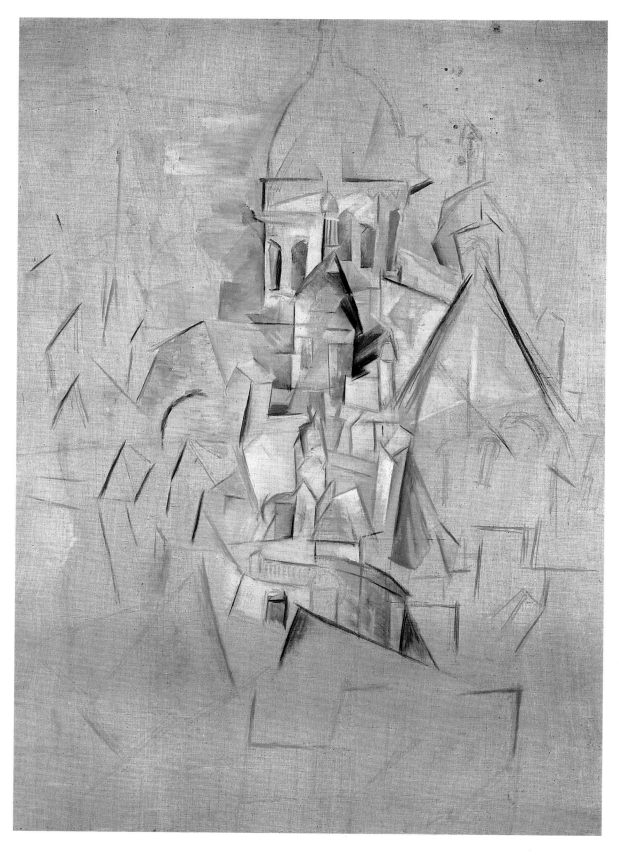

209. THE SACRÉ-COEUR
Paris, Winter 1909-1910
Oil on canvas, 92×65 cm
Musée Picasso, Paris

210. SEASCAPE
Cadaqués, Summer 1910
Indian ink wash on paper, 24.2×31.7 cm
Musée Picasso, Paris

211. THE CONVENT
Cadaqués, Summer 1910
Etching for the book by Max Jacob: *Saint Matorel*, 26.7×22.3 cm
Museu Picasso, Barcelona

212. HOUSES AND PALM TREE
Cadaqués, Summer 1910
Pen and brown ink on paper, 22.7×17.4 cm
Musée Picasso, Paris

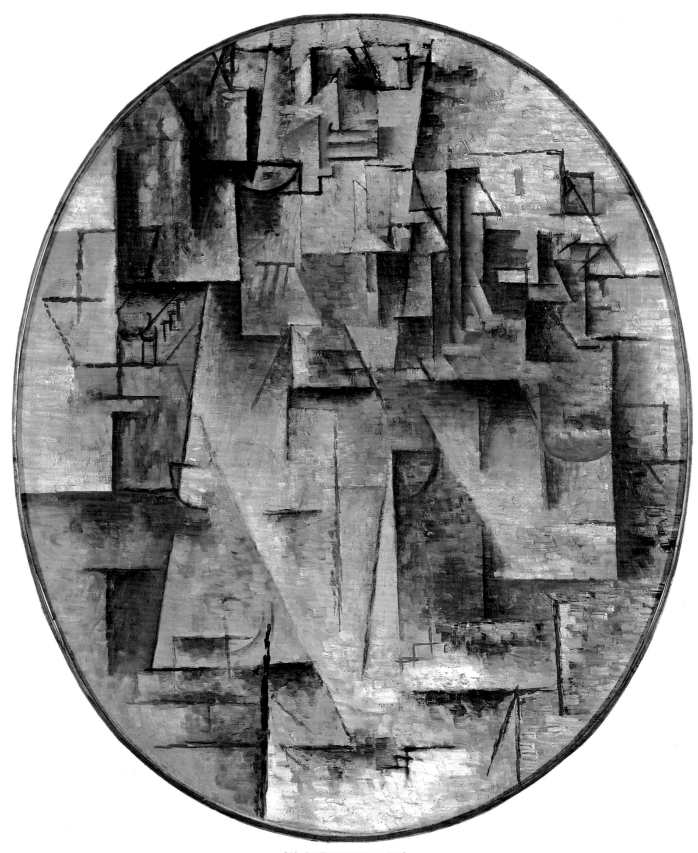

213. La Pointe de la Cité
Paris, Spring 1911
Oil on canvas, oval, 90×71 cm
Private collection

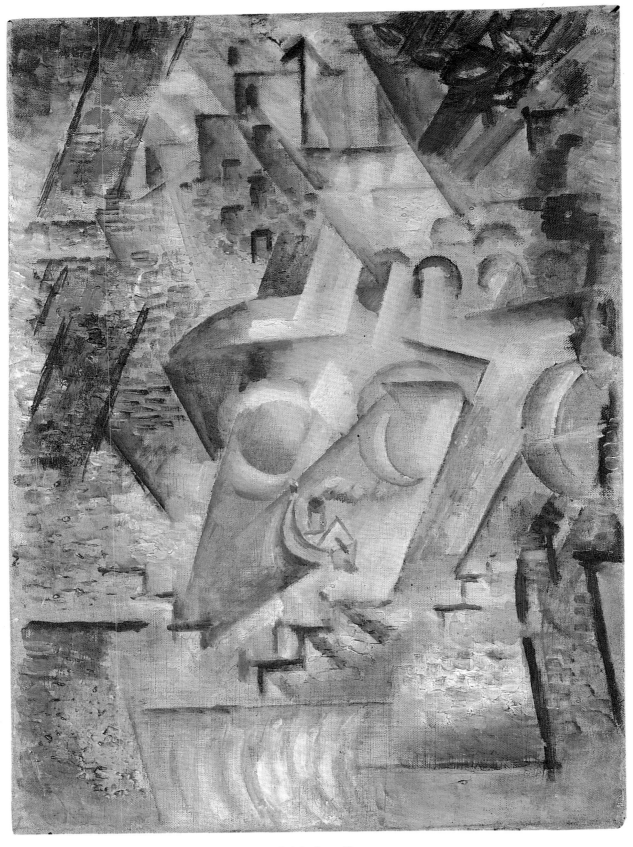

214. LE PONT NEUF
Paris, Spring 1911
Oil on canvas, 33×24 cm
Private collection, Switzerland

215. STUDY FOR LE PONT NEUF
Paris, Spring 1911
Pen and brown ink on squared paper, 27.2×20.7 cm
Musée Picasso, Paris

216. CÉRET LANDSCAPE
Summer, 1911
Pen and brown ink on paper, 19.4×30.7 cm
Musée Picasso, Paris

217. LANDSCAPE
1911
Indian ink on paper, 21.5×13.5 cm
Private collection, Paris

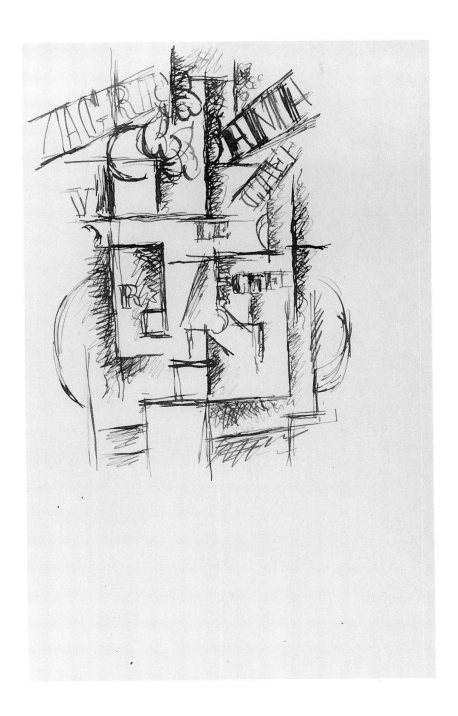

218. THE CAFE
1911-1912
Indian ink on paper, 31×19.5 cm
Private collection, Paris

72. BARCELONETA BEACH
Barcelona, 1896
Oil on canvas, 24.4×34 cm
Museu Picasso, Barcelona
MPB 110.073

73. THE PORT
Barcelona, 1896
Oil on panel, 18×12.7 cm
Museu Picasso, Barcelona
MPB 110.201

74. BARCELONETA
Barcelona, January 1897
Oil on panel, 13.8×22.4 cm
Museu Picasso, Barcelona
MPB 110.220
On the reverse: The words «Barcelona January 97»,
 in pen

75. ANGLE OF THE CLOISTER OF SANT PAU DEL CAMP
Barcelona, December 1896
Oil on panel, 15.5×10.1 cm
Museu Picasso, Barcelona
MPB 110.195
On the reverse: Dated «Barcelona December 96»
The words «Cloisters of Sant Pau/48»

76. MAN LEANING IN A GOTHIC DOORWAY
Barcelona, 1896
Oil on panel, 20.2×12.8 cm
Museu Picasso, Barcelona
MPB 110.203
On the reverse: Dated «Barcelona»
Stamp «Faustino Nicolás/ Engrever/ Stationery/
 Writing Materials/ and Paints/ Start»

77. DETAIL OF THE CLOISTER OF BARCELONA CATHEDRAL
Barcelona, 1896
Oil on panel, 22.1×13.8 cm
Museu Picasso, Barcelona
MPB 110.219

78. TWO ROADS IN A PARK
Barcelona, December 1896
Oil on panel, 13.8×22.5 cm
Museu Picasso, Barcelona
MPB 110.226

79. CUPOLA OF THE CHURCH OF LA MERCÈ
Barcelona, January 1897
Pastel and conté pencil on paper, 18×25.2 cm
Museu Picasso, Barcelona
MPB 110.949

80. URBAN LANDSCAPE
Barcelona, 1896
Oil on panel, 13.7×22.2 cm
Museu Picasso, Barcelona
MPB 110.206
On the reverse: Dated «Barcelona/96», in pen
The words «To my very dear Sir/ with all
 my respect and love/ now and always

81. MAN BY A LAKE
Madrid, 1897
Oil on canvas, 28.3×20.2 cm
Museu Picasso, Barcelona
MPB 110.088

81 b, fig. 41. THE COUPLE
Madrid, 1898
Oil on canvas, 52×44 cm
Private collection

82. PARK
Madrid, 1897
Oil on canvas, 18.5×26.5 cm
Museu Picasso, Barcelona
MPB 110.097

83. ROAD AMONG TREES
Madrid, 1897-1898
Oil on canvas, 28.1×39.6 cm
Museu Picasso, Barcelona
MPB 110.068

84. POND AT EL RETIRO
Madrid, 1897-1898
Oil on canvas, 19.6×26.7 cm
Museu Picasso, Barcelona
MPB 110.094

85. POND AT EL RETIRO
Madrid, 1897-1898
Oil on canvas, 16×25.2 cm
Museu Picasso, Barcelona
MPB 110.227

86. WOODLAND
Madrid, 1897-1898
Oil on canvas, 28.1×37.5 cm
Museu Picasso, Barcelona
MPB 110.071

87. SALÓN DEL PRADO
Madrid, 1897
Oil on panel, 10×15.5 cm
Museu Picasso, Barcelona
MPB 110.160

88. URBAN LANDSCAPE WITH CUPOLA
Madrid, 1897
Oil on canvas, 31×46.5 cm
Museu Picasso, Barcelona
MPB 110.064

89. LANDSCAPE
Madrid, 1897
Conté pencil on paper, 10.5×17.5 cm
Museu Picasso, Barcelona
MPB 111.350 R (leaf of album MPB 110.917)
On the observe: Seated cat

90. BALCONY
Madrid, 1898
Conté pencil on paper, 10.5×17.5 cm
Museu Picasso, Barcelona
MPB 111.353 (leaf of album MPB 110.917)
On the reverse: Sketch

91. TREES AND THICKETS
Madrid, 1898
Conté pencil, sanguine and watercolour on paper,
 10.5×17.5 cm
Museu Picasso, Barcelona
MPB 111.354 (leaf of album MPB 110.917)
On the reverse: Various additions and subtractions,
 in pen

92. DR. BENJAMIN TAMAYO ENTERING THE ATHENEUM
 IN MADRID
Madrid, 1898
Brown pencil and sanguine on paper, 17.5×10.5 cm
Museu Picasso, Barcelona
MPB 111.356 (leaf of album MPB 110.917)
On the reverse: Man with a beret, seated

93. SKETCH
Madrid, 1898
Brown pencil and sanguine on paper, 17.5×10.5 cm
Museu Picasso, Barcelona
MPB 111.358 (leaf of album MPB 110.917)
On the reverse: Various sketches

94. NOTE OF EL RETIRO
Madrid, 1898
Siena pencil on paper, 19.5×12 cm
Museu Picasso, Barcelona
MPB 111.426 (leaf of album MPB 110.920)

95. EL RETIRO PARK
Madrid, 1898
Siena pencil on paper, 12×19.5 cm
Museu Picasso, Barcelona
MPB 111.427 (leaf of album MPB 110.920)

96. POND AT EL RETIRO
Madrid, 1898
Siena pencil and watercolour on paper, 12×19.5 cm
Museu Picasso, Barcelona
MPB 111.428 (leaf of album MPB 110.920)

97. TREES
Madrid, 1898
Siena pencil and watercolour on paper, 19.5×12 cm
Museu Picasso, Barcelona
MPB 111.432 (leaf of album MPB 110.920)

98. TREES
Madrid, 1898
Siena pencil on paper, 12×19.5 cm
Museu Picasso, Barcelona
MPB 111.435 (leaf of album MPB 110.920)

99. EL RETIRO CANTEEN
Madrid, 1898
Siena pencil on paper, 12×19.5 cm
Museu Picasso, Barcelona
MPB 111.436 (leaf of album MPB 110.920)

100. SKETCH
Madrid, 1898
Siena pencil on paper, 19.5×12 cm
Museu Picasso, Barcelona
MPB 111.445 (leaf of album MPB 110.920)

101. SKETCH
Madrid, 1898
Colour pencil on paper, 12×19.5 cm
Museu Picasso, Barcelona
MPB 112.575 (leaf of album MPB 110.920)

102. EL RETIRO
Madrid, 1897-1898
Lead pencil on paper, 12×20 cm
Museu Picasso, Barcelona
MPB 111.513 (leaf of album MPB 110.924)
On the reverse: Sketch

103. VIEW OF EL RETIRO
Madrid, 1897-1898
Sanguine on paper, 12×20 cm
Museu Picasso, Barcelona
MPB 111.515 (leaf of album MPB 110.924)

104. STEPS AND RAMP IN THE EL RETIRO PARK
Madrid, 1897-1898
Sanguine on paper, 12×20 cm
Museu Picasso, Barcelona
MPB 111.516 (leaf of album MPB 110.924)

105. VIEW OF EL RETIRO
Madrid, 1897-1898
Sanguine on paper, 12×20 cm
Museu Picasso, Barcelona
MPB 111.518 (leaf of album MPB 110.924)
On the reverse: Various sketches

106. NOTE OF SALÓN DEL PRADO
Madrid, 1897-1898
Sanguine on paper, 12×20 cm
Museu Picasso, Barcelona
MPB 111.520 (leaf of album MPB 110.924)

107. STREET SKETCH
Madrid or Barcelona, 1898
Conté pencil on paper, 13.5×9 cm
Museu Picasso, Barcelona
MPB 111.326 (leaf of album MPB 110.916)

108. VARIOUS SKETCHES
Madrid or Barcelona, 1898
Conté pencil on paper, 13.5×9 cm
Museu Picasso, Barcelona
MPB 111.327 (leaf of album MPB 110.916)

109. CHIMNEYS
Madrid or Barcelona, 1898
Conté pencil on paper, 13.5×9 cm
Museu Picasso, Barcelona
MPB 111.328 (leaf of album MPB 110.916)

110. HORTA LANDSCAPE. SAN SALVADOR CONVENT
Horta, 1898-1899
Conté pencil on paper, 16×24 cm
Museu Picasso, Barcelona
MPB 110.926 (first leaf of album, of the same number)

111. HORTA LANDSCAPE
Horta, 1898-1899
Conté pencil on paper, 16×24 cm
Museu Picasso, Barcelona
MPB 111.563 (leaf of album 110.926)

112. SKETCH OF A TREE
Horta, 1898-1899
Conté pencil on paper, 24×16 cm
Museu Picasso, Barcelona
MPB 111.564 (leaf of album 110.926)

113. HERMITAGE OF SANT ANTONI DEL TOSSAL
Horta, 1898-1899
Conté pencil on paper, 16×24 cm
Museu Picasso, Barcelona
MPB 111.566 (leaf of album 110.926)

114. SKETCH OF TREES
Horta, 1898-1899
Conté pencil on paper, 16×24 cm
Museu Picasso, Barcelona
MPB 111.568 (leaf of album 110.926)

115. NOTE OF A TREE
Horta, 1898-1899
Conté pencil on paper, 24×16 cm
Museu Picasso, Barcelona
MPB 111.569 (leaf of album 110.926)

116. NOTE OF AN OLIVE ORCHARD
Horta, 1898-1899
Conté pencil on paper, 16×24 cm
Museu Picasso, Barcelona
MPB 111.570 (leaf of album 110.926)

117. WINTER LANDSCAPE
Horta, 1898-1899
Conté pencil on paper, 16×24 cm
Museu Picasso, Barcelona
MPB 111.578 (leaf of album 110.926)

118. TREE
Horta, 1898
Charcoal on paper, 25×16.5 cm
»Marina Picasso Collection (Inv. 0069)
Courtesy of Jan Krugier Gallery«
Zervos 6, 66
On the reverse: Spanish types

119. TREES
Horta, 1898
Conté pencil on paper, 15.6×21.5 cm
Museu Picasso, Barcelona
MPB 110.718
On the reverse: Woman with bonnet and muff, and
other sketches

120. LANDSCAPE
Horta, 1898
Conté pencil on paper, 24.5×32.1 cm
Museu Picasso, Barcelona
MPB 110.775
On the reverse: Various sketches

121. PEASANT IN AN APPLE ORCHARD
Horta, 1898-1899
Conté pencil on paper, 16.2×24.3 cm
Museu Picasso, Barcelona
MPB 110.743

122. PEASANT IN A FIELD
Horta, 1898
Conté pencil on paper, 24.2×31.8 cm
Museu Picasso, Barcelona
MPB 110.774
On the reverse: Sketch

123. MOUNTAIN LANDSCAPE
Horta, 1898-1899
Conté pencil on paper, 16×24.5 cm
Museu Picasso, Barcelona
MPB 110.744
On the reverse: Banderillero, bull, group of men and dogs

124. LANDSCAPE
Horta or Barcelona, 1898-1899
Conté pencil on paper, 23.8×31.8 cm
Museu Picasso, Barcelona
MPB 110.773
On the reverse: Various figures

125. THREE WASHERWOMEN
Horta, 1898-1899
Conté pencil on paper, 16.2×24.3 cm
Museu Picasso, Barcelona
MPB 110.747
On the reverse: Various types from Aragon

126. THREE WASHERWOMEN
Horta, 1898-1899
Oil on panel, 10×15.6 cm
Museu Picasso, Barcelona
MPB 110.168

127. MOUNTAIN LANDSCAPE. NOTE OF ELS PORTS
Horta, 1898
Oil on canvas, 16.5×22.2 cm
Museu Picasso, Barcelona
MPB 110.105

128. VALLEY BETWEEN MOUNTAINS
Horta, 1898
Conté pencil on paper, 11×13.3 cm
Museu Picasso, Barcelona
MPB 110.703 R
On the reverse: Couple celebrating

129. MOUNTAIN LANDSCAPE
Horta, 1898-1899
Oil on canvas, 28.2×39.5 cm
Museu Picasso, Barcelona
MPB 110.065

130. SNOWY MOUNTAIN RANGE
Horta, 1898-1899
Oil on canvas, 19.1×27.1 cm
Museu Picasso, Barcelona
MPB 110.092

131. MOUNTAIN LANDSCAPE
Horta, 1898
Oil on canvas, 28.5×39.5 cm
Museu Picasso, Barcelona
MPB 110.067

132. MAS DE TAFETANS. RURAL LANDSCAPE
Horta, 1898
Oil on canvas, 33×44 cm
Museu Picasso, Barcelona
MPB 110.936

133. MAS DE QUIQUET
Horta, 1898
Oil on canvas, 27×40 cm
Museu Picasso, Barcelona
MPB 110.066

134. HORTA HOUSES
Horta, 1898-1899
Oil on canvas, 10.7×19.5 cm
Museu Picasso, Barcelona
MPB 110.107

135. VIEW OF A STREET IN HORTA
Horta, 1898-1899
Oil on canvas, 9.4×14.1 cm
Museu Picasso, Barcelona
MPB 110.120

136. PARTIAL VIEW OF HORTA
Horta, 1898-1899
Oil on panel, 10×15.5 cm
Museu Picasso, Barcelona
MPB 110.173
On the reverse: The words »Hall/ Alla/ arriba/ en el/ ar
y/ oll.../ Ruiz/ Ru/ Pablo/ Ruiz/ Ruiz/ El Que Quería«

137. HOUSES IN HORTA
Horta, 1898-1899
Conté pencil on paper, 16×24 cm
Museu Picasso, Barcelona
MPB 111.580 (leaf of album MPB 110.926)

138. HOUSES IN HORTA
Horta, Summer 1898
Oil on canvas, 27×39 cm
Private collection
Zervos 21, 54

139. PARODY OF A VOTIVE OFFERING
Barcelona, 1899-1900
Oil on canvas, 55.6×40.8 cm
Museu Picasso, Barcelona
MPB 110.055 R
On the obverse: Landscape with tree

140. WOODS ON A MOUNTAIN SLOPE
Barcelona, January 1899
Oil on canvas glued to panel, 22.4×27.3 cm
Museu Picasso, Barcelona
MPB 110.079

141. INNER HARBOUR
Barcelona, 1899
Conté pencil on paper, 23.5×33.5 cm
Museu Picasso, Barcelona
MPB 110.578
On the reverse: Sketch

142. CLOSED BALCONY
Barcelona, 1899
Oil on canvas, 38.5×28 cm
Museu Picasso, Barcelona
MPB 110.069
On the reverse: Male torso

143. BALCONY WITH NET CURTAIN SEEN FROM INSIDE
Barcelona, 1899
Oil on canvas, 21.8×13.7 cm
Museu Picasso, Barcelona
MPB 110.218
On the reverse: The number »35«

144. VIEW OF SNOWY LANDSCAPE FROM AN INTERIOR
Barcelona, 1900
Oil on canvas, 50×32.6 cm
Museu Picasso, Barcelona
MPB 110.062

145. LOLA, THE ARTIST'S SISTER, IN THE STUDIO IN RIERA
SANT JOAN
Barcelona, 1900
Oil on canvas, 55.7×46.2 cm
Museu Picasso, Barcelona
MPB 110.054

146. ROOFTOPS AND SANTA MARTA CHURCH
Barcelona, 1900
Oil on canvas, 21.1×22.5 cm
Museu Picasso, Barcelona
MPB 110.102

147. THE STREET OF RIERA SANT JOAN FROM THE ARTIST'S
STUDIO WINDOW
Barcelona, 1900
Oil on panel, 22.3×13.8 cm
Museu Picasso, Barcelona
MPB 110.898

148. THE STREET OF RIERA SANT JOAN FROM THE ARTIST'S
STUDIO WINDOW
Barcelona, 1900
Charcoal and conté pencil on paper, 34.8×26.1 cm
Museu Picasso, Barcelona
MPB 110.213

149. A COUNTRY FUNERAL
Barcelona, 1900
Pastel on paper, 24×30.6 cm
Museu Picasso, Barcelona
MPB 110.233
On the reverse: Note of crossed legs

150. FIGURES IN A SQUARE WITH TREES
Barcelona, 1900
Charcoal and conté pencil on paper, 16.2×23 cm
Museu Picasso, Barcelona
MPB 110.628
On the reverse: Fragment of a drawing

151. TO BE OR NOT TO BE
Barcelona, 1900
Charcoal on laid paper, 29.5×40 cm
Museu Picasso, Barcelona
Zervos 6, 317

152. »LA MUSCLERA«
Barcelona, 1900
Oil on canvas, 48.1×48.3 cm
Private collection, Paris
Zervos 21, 157

153. WOMAN SEATED ON A WHARF
Barcelona, 1900
Pen on paper, 21.8×31.8 cm
Museu Picasso, Barcelona
MPB 110.771
On the reverse: Heads of various characters

154. SPANISH COUPLE IN FRONT OF AN INN
Barcelona, 1900
Pastel on paper, 40×50 cm
Kawamura Memorial Museum of Art, Sakura
Daix 1990, p. 27, no. 4

155. SNACK-BAR IN THE OPEN AIR
Barcelona, 1900
Wash, pastel and charcoal on card, 24.6×30.6 cm
Museo de Bellas Artes, Bilbao

156. THE EMBRACE
Paris, 1900
Pastel on paper, 59×35 cm
Museu Picasso, Barcelona
Zervos 1, 24

157. OLD MAN FROM TOLEDO (LE CHEMINEAU)
Toledo, 1901
Pencil and wash on paper, 20.4×12.4 cm
Musée des Beaux-arts, Reims
Zervos 21, 240

158. THE MEDITERRANEAN
Barcelona, Spring 1901
Oil on cardboard, 27.5 36.5 cm
Private collection, Paris
Palau, no. 565

159. BLUE ROOFS
Paris, 1901
Oil on cardboard, 40×60 cm
The Visitors of the Ashmolean Museum, Oxford
Zervos 1, 82

160. THE FLOWER SELLER
Paris, 1901
Oil on cardboard, 33.7×52.1 cm
Glasgow Museums: Art Gallery and Museum,
Kelvingrove, Glasgow
Zervos 21, 207

161. MOTHER AND CHILD BY THE SEA
Barcelona, 1902
Oil on panel, 26.8×13.4 cm
Museu Picasso, Barcelona
MPB 110.037
On the reverse: The words »high/left«

162. MOTHERHOOD ON THE WHARF
Barcelona, 1902
Pen on paper, 15.1×23 cm
Museu Picasso, Barcelona
MPB 110.492

163. THE GOLDEN AGE
Paris, December 1902
Pen and aquatint on paper, 26.1×40 cm
Museu Picasso, Barcelona
MPB 110.546
On the reverse: Dated »D02«

164. PORTRAIT OF JULIO GONZÁLEZ
Barcelona, 1902
Watercolour and ink on paper, 29×24 cm
Private collection, Paris
Zervos 21, 189

165. BARCELONA ROOFS
Barcelona, 1902
Oil on canvas, 57.8×60.3 cm
Museu Picasso, Barcelona
MPB 110.020
On the reverse: Rural landscape with mountains beyond

166. BARCELONA ROOFS
Barcelona, 1902
Oil on canvas, 69.5×109.6 cm
Museu Picasso, Barcelona
Zervos 1, 207

167. THE CHRIST OF MONTMARTRE (LE SUICIDÉ)
Paris, 1904
Pen and watercolour on paper, 36×26 cm
Bollag Collection, Zurich
Zervos 6, 617

168. PICASSO AND JUNYER DEPART ON THEIR JOURNEY
Paris, 1904
Ink and coloured pencils on paper, 22×16 cm
Museu Picasso, Barcelona
Zervos 6, 485

169. PICASSO AND JUNYER ARRIVE AT THE FRONTIER
Paris, 1904
Ink and coloured pencils on paper, 22×16 cm
Museu Picasso, Barcelona
Zervos 6, 486

170. PICASSO AND JUNYER ARRIVE AT MONTAUBAN
Paris, 1904
Ink and coloured pencils on paper, 22×16 cm
Museu Picasso, Barcelona
Zervos 6, 487

171. PICASSO AND JUNYER ARRIVE AT PARIS
Paris, 1904
Ink and coloured pencils on paper, 22×16 cm
Museu Picasso, Barcelona
Zervos 6, 488

172. JUNYER VISITS DURAND-RUEL
Paris, 1904
Ink and coloured pencils on paper, 22×16 cm
Museu Picasso, Barcelona
Zervos 6, 489

173. LANDSCAPE
Gósol, 1906
Gouache and black pencil on paper, 47.5 61.5 cm
Musée Picasso, Paris
MP 489

173 b, fig. 103. HOUSES IN GÓSOL
Gósol, 1906
Charcoal on paper, 36×47.5 cm
Private collection
Zervos 22, 369
On the reverse: Woman walking. Zervos 22, 369

174. THE REAPERS (LES MOISSONNEURS)
Paris, Spring 1907
Oil on canvas, 65×81.3 cm
Thyssen-Bornemisza Collection
Zervos 2*, 2

175. STUDY FOR THE REAPERS
Paris, June-July 1907
Charcoal on paper, 48.2×63 cm
Musée Picasso, Paris
Zervos 26, 169

176. LANDSCAPE RELATED TO THE REAPERS
Paris, Spring-Summer 1907
Watercolour on paper, 22.4×17.5 cm
Private collection
Zervos 6, 955

177. LANDSCAPE RELATED TO THE REAPERS
Paris, Spring-Summer 1907
Gouache and lead pencil on paper, 63×48.4 cm
Musée Picasso, Paris
Zervos 26, 173

178. THE TREE
Paris, Summer 1907
Oil on canvas, 94×93.7 cm
Musée Picasso, Paris
Zervos 2**, 681

179. TREES
Paris, 1907
Pencil and coloured pencils on paper, 63×48.5 cm
Marina Picasso Collection (0997)
Courtesy of the Jan Krugier Gallery, Geneva
Zervos 26, 166

180. LANDSCAPE
Paris, Spring-Summer 1907
Gouache on paper glued on cardboard, 64.8×49.8 cm
Virginia Museum of Fine Arts. The T. Catesby Jones
Collection.
Zervos 2*, 41

181. STUDY FOR »BATHERS IN THE WOOD«
Paris, Spring 1908
Lead pencil on paper, 32×43.5 cm
Musée Picasso, Paris
Zervos 26, 292

182. STUDY FOR »BATHERS IN THE WOOD«
Paris, Spring 1908
Charcoal on paper, 47.7×60.2 cm
Musée Picasso, Paris
MP 604

183. STUDY FOR »BATHERS IN THE WOOD«
Paris, Spring 1908
Gouache and lead pencil on paper, 48.4×62.7 cm
Musée Picasso, Paris
Zervos 26, 331

184. TREES
Spring 1908
Watercolour on paper, 22.3×17.5 cm
Private collection, Paris
Zervos 6, 1020

185. LANDSCAPE
Spring-Summer, 1908
Watercolour on paper, 22.4×17.5 cm
Christine Ruiz-Picasso
Zervos 6, 1023

186. LANDSCAPE
Spring 1908
Gouache on paper, 48.8×63.3 cm
Philadelphia Museum of Art: The Louise and Walther
 Arensberg Collection
Zervos 2*, 54

187. LANDSCAPE
Paris, Spring-Summer 1908
Gouache and watercolour on paper, 64×49.5 cm
Künstmuseum, Berne. Hermann and Margrit Rupf-
 Stiftung
Zervos 26, 174

188. LANDSCAPE
Rue-des-Bois, August 1908
Oil on canvas, 72.5×59.5 cm
Civico Museo d'Arte Contemporanea - Jucker
 Collection - Milan
Zervos 2*, 86

189. LANDSCAPE
August-September 1908
Oil on canvas, 100.8×81.3 cm
The Museum of Modern Art, New York
Gift of David Rockefeller, 1974
Zervos 2*, 83

190. LANDSCAPE
Rue-des-Bois, August 1908
Oil on canvas, 73×60 cm
Private collection
Zervos 2*, 82

191. COTTAGE IN A GARDEN
Rue-des-Bois, August 1908
Oil on canvas, 73×61 cm
The Hermitage Museum, St. Petersburg
Zervos 2*, 80

192. COTTAGE AND TREES
Rue-des-Bois, August 1908
Oil on canvas, 92×73 cm
Pushkin Fine Arts Museum, Moscow
Zervos 2*, 81

193. LANDSCAPE WITH TWO FIGURES
Summer, 1908
Oil on canvas, 60×71 cm
Musée Picasso, Paris
Zervos 2*, 79

194. THE DREAM
Paris, Summer 1908
Pen, ink, gouache and collage on cardboard,
 41.5×26 cm
Hilde Thannhauser Succession, Berne
Silva-Casa Foundation
Zervos 2*, 66

195. NUDES IN A LANDSCAPE
Paris, 1909
Pen, brown ink, coloured pencil and gouache on
 paper, 13.2×17.4 cm
Musée Picasso, Paris
MP 607

196. ST ANTHONY AND HARLEQUIN
Paris, Spring 1909

Watercolour on paper, 62×48 cm
Moderna Museet, Stockholm
Zervos 26, 376

197. PEOPLE WITH A BOAT IN A LANDSCAPE
Paris, Spring 1909
Lead pencil on paper, 31×48 cm
Musée Picasso, Paris
Zervos 26, 374

198. BATHERS IN A LANDSCAPE
Paris, Spring 1909
Gouache and Indian ink on paper, 27×22.5 cm
Musée Picasso, Paris
Zervos 26, 381

199. LANDSCAPE WITH A BRIDGE
Paris, Spring 1909
Oil on canvas, 81×100 cm
Národny Gallery, Prague
Zervos 26, 426

200. HOUSES
Barcelona, May 1909
Pen on paper, 17×13.2 cm
Private collection, Paris
Zervos 6, 1091

201. HOUSES AND PALM TREES
Barcelona, May 1909
Pen and black ink on paper, 17.3×13.5 cm
Musée Picasso, Paris
Zervos 6, 1093

202. HOUSES
Barcelona, May 1909
Pen and black ink on paper, 17×13 cm
Musée Picasso, Paris
Zervos 6, 1085

203. HOUSES AND PALM TREES
Barcelona, May 1909
Pen and black ink on paper, 17×11 cm
Musée Picasso, Paris
Zervos 6, 1092

204. HOUSES ON THE HILL
Horta, Summer 1909
Oil on canvas, 65×81 cm
The Museum of Modern Art, New York. Nelson A.
 Rockefeller Bequest
Zervos 2*, 161

205. HOUSES ON THE HILL
Horta, Summer 1909
Lead pencil on striped paper, 20.3×13.3 cm
Musée Picasso, Paris
Zervos 6, 1078

206. HOUSES
Horta, Summer 1909
Pen and brown ink on striped paper, 20.2×13.2 cm
Musée Picasso, Paris
Zervos 6, 1088

207. SKETCH FOR THE RESERVOIR AT HORTA
Horta, Summer 1909
Pen and ink on a new envelope, 11.2×14.4 cm
Musée Picasso, Paris
Zervos 6, 1081

208. SKETCH FOR THE RESERVOIR AT HORTA
Horta, Summer 1909
Pen on paper, 11.2×14.5 cm
Private collection, Paris
Zervos 6, 1082

208 b. THE MILL AT HORTA
Horta, Summer 1909
Watercolour on paper, 24.8×38.2 cm
The Museum of Modern Art, New York.

The Joan and Lester Avnet Collection
Zervos 2*, 159

209. THE SACRÉ-COEUR
Paris, Winter 1909-1910
Oil on canvas, 92×65 cm
Musée Picasso, Paris
Zervos 2*, 196

210. SEASCAPE
Cadaqués, Summer 1910
Indian ink wash on paper, 24.2×31.7 cm
Musée Picasso, Paris
Zervos 6, 1143

211. THE CONVENT
Cadaqués, Summer 1910
Etching for the book by Max Jacob: *Saint Matorel*,
 26.7×22.3 cm
Museu Picasso, Barcelona
Geiser 1, 26. Copy no. 78, MPB 113.002

212. HOUSES AND PALM TREE
Cadaqués, Summer 1910
Pen and brown ink on paper, 22.7×17.4 cm
Musée Picasso, Paris
MP 639

213. LA POINTE DE LA CITÉ
Paris, Spring 1911
Oil on canvas, oval, 90×71 cm
Private collection
Zervos 2*, 309

214. LE PONT NEUF
Paris, Spring 1911
Oil on canvas, 33×24 cm
Private collection, Switzerland
Zervos 2*, 248

215. STUDY FOR LE PONT NEUF
Paris, Spring 1911
Pen and brown ink on squared paper, 27.2×20.7 cm
Musée Picasso, Paris
Zervos 6, 423

216. CÉRET LANDSCAPE
Summer, 1911
Pen and brown ink on paper, 19.4×30.7 cm
Musée Picasso, Paris
Zervos 28, 26

217. LANDSCAPE
1911
Indian ink on paper, 21.5×13.5 cm
Private collection, Paris
Daix 297

218. THE CAFE
1911-1912
Indian ink on paper, 31×19.5 cm
Private collection, Paris
Daix 304

CHRONOLOGY

1881 25th October, Pablo Ruiz Picasso was born in Málaga.

1890 Painted his first landscape *The Port of Málaga* (fig. 31).

1893-1895 In Corunna where the Ruiz Picasso family had lived since 1891, he began a series of small paintings on panel, in which the principal subject was landscape. In these and in the sketches collected in the album MPB 110.919 (cat. no. 2-9), are reflected the interests of Picasso, the boy, for a landscape very different from that of his birthplace, Málaga.

1895 After spending the summer in Málaga, the family undertook the sea voyage to Barcelona in September. A series of small panels done during the journey show the itinerary, following the Mediterranean coast; Cartagena (cat. no. 14), Alicante (cat. no. 15) and Valencia (cat. no. 16).
In Barcelona the Ruiz Picasso family went to live in 3 carrer Cristina on the corner of carrer Llauder. From the rooftop of the building Picasso made a series of urban views. He visited the Ciutadella park near to his home and made several sketches in oil, pencil or ink.

1896 He painted a series of small landscapes of bold composition and colour, such as *Stall in the park* (cat. no. 33). At the end of June the family went to Málaga and stayed in the farm belonging to his relatives, the Blasco Alarcón family, in Llanes. He painted various landscapes of the Montes of Málaga and their surroundings, the most ambitious being *Mountain Landscape* (cat. no. 35).
At the end of July they returned to Barcelona and went to live at 3 carrer Mercé. Picasso's father rented the young artist's first studio at 4 carrer Plata. Pablo continued the series of urban views from the roof of his home and from his studio. He painted various seascapes and paintings in the proximity of the port and the seamen's districts of Barcelona.

1897 In the summer, again in Málaga, he painted the two versions of *Montes of Málaga* (cat. nos. 41 and 42).

In October he went to Madrid to further his studies. In the San Fernando School of Fine Arts, he was enrolled for the subject of "Landscape" . He made notes and sketches on small panels and canvases and in sketchbooks, far from any academicism, of the Paseo del Prado, the Retiro Park and other corners of Madrid.

1898 In June he returned to Barcelona suffering from scarlet fever.

At the end of the month he went with Manuel Pallarés to Horta in the Terra Alta, in the province of Tarragona. The two friends spent about two months on the mountains in the region of Els Ports. During his stay in Horta and in the mountains he carried out an exhaustive analysis of landscape and the rural world, from which there remain a series of partial or global views of the village, sketches of the agricultural fields and some canvases of mountainous landscapes.

1899 In January he returned to Barcelona. He set up his studio at 2 carrer Escudillers Blancs. He abandoned the study of nature, dedicating himself to urban landscape. The subjects of windows and balconies appear in his work (cat. nos. 142-145).

1900 In January he changed the studio of Escudillers Blancs for another at 17 Riera de Sant Joan. He continued to paint urban landscapes from the window. He mixed pastel and oil in order to create paintings of intense colours.

In October he went for the first time to Paris. There he painted the two versions of *Embrace in the street* (cat. no. 156 and fig. 61) and *In the street* (Z. 6, 302).

1901 In the middle of January he went to Madrid after a short stay in Barcelona and Málaga in 1900. He published the magazine "Arte Joven". The fruits of his train journey to Toledo are preserved, *Toledo* (Z. 6, 363) and *The Vagrant* (cat. no. 157).

In June he returned to Paris and set up in a studio in Boulevard Clichy. From his window he painted *Boulevard Clichy* (fig. 65) and the *Blue Tiles* (cat. no. 159). Attracted by the bustle of the city life he caught its diversity in different works such as *The strolling florist* (cat. no. 160), *Longchamps* (Z. 6, 301) and *Public gardens* (Daix 5, 19).

1902 At the end of January he was again in Barcelona, living at 6 Conde del Asalto. Although principally interested in the human figure, he painted two important urban landscapes, *The blue house* (fig. 72) and *Barcelona rooftops* (cat. no. 165). In October he travelled to Paris. Landscape only appears in his work as a secondary element, in support of the human figure.

1903 In January he returned to Barcelona, to the studio in Riera de Sant Joan. He painted three urban views, *Barcelona street and The Palau de Belles Artes* (fig. 77), *Barcelona rooftops* (cat. no. 166) and *Barcelona by night* (fig. 76).

1904 In April he made his fourth visit to Paris. The few landscapes which he painted were always as a background to human figures.

1905 From the middle of June to the middle of July, he was in Holland. He visited Schoorl, Alkmar and Hoorn. The watercolours of a sketchbook reflect the smoothness of the Dutch landscape (figs. 88-91).

1906 Between 22nd and 29th May, after some days in Barcelona, he went with Fernande for some days to Gósol. He painted *Gósol landscape* (fig. 101) and *Gósol houses* (fig. 102). Other landscapes appear as a background for portraits of Fernande and village people. In the middle of August they returned to Paris.

1907 In his studio at Bateau-Lavoir, at the same time as *Les Demoiselles d'Avignon* (fig. 9), he painted *The Reapers* (cat. no. 174), an evocation of the previous summer spent in Gósol. He did a series of trees and landscapes with a clear tendency towards abstraction.

1908 In his studio he painted imaginary landscapes which on many occasions were studies for the backgounds for his compositions of bathers and women in the wood.
In August he moved to Rue-des-Bois where he remained until September. He came back to nature and produced various landscapes using Cézanne's "passage" technique.
In Paris he did *The dream* (cat. no. 194), the first *papier-collé*.

1909 He painted *Landscape with bridge* (cat. no. 199).
At the beginning of May he went with Fernande to Barcelona. He made some sketches of urban views from the hotel where they stayed. From 5th June to the beginning of September he stayed in Horta, where his important work was the development of cubism, among it six landscapes, such as *Houses on the hill* (cat. no. 205) *The reservoir* (fig. 27) and *Horta factory* (fig. 7).
At the end of September, in Paris, he changed his home to 11 Boulevard Clichy. Landscape is continually less frequent in his work.
In the winter of 1909-1910 he painted the *Sacré Coeur* (cat. no. 209) as viewed from his studio.

1910 He stayed in Cadaqués from 26th June to 26th August, and made two very abstract seascapes. He engraved four etchings to illustrate Max Jacob's *Saint Matorel*; one of these being a view of a Barcelona convent (cat. no. 211).

1911 In the spring he painted only two landscapes, *La Pointe de la Cité* (cat. no. 213) and *Le Pont Neuf* (cat. no. 214) in very obscure cubism. On 5th July he went to Céret where he remained until 5th September. His production was limited to still-lifes and a few figures. He painted only one landscape *Céret landscape* (fig. 122).

1912 In the winter he painted two landscapes, *La rue d'Orchamp* (fig. 125) from Bateau-Lavoir where he had temporarily returned to work and *L'Avenue Frochot* (fig. 126) from his studio in Boulevard Clichy.
In April he went with Braque to Le Havre. On his return he painted *Memory of Le Havre* (Z. 2*, 367).

1913 Céret. He used the *papier-collé* for two landscapes (Z.2*. 343 and Z. 28, 60).

BIBLIOGRAPHY

BIBLIOGRAPHY OF REFERENCES USED

BESNARD-BERNADAC, Marie-Laure; Michèle RICHET; Hélène SÉCKEL. *Musée Picasso París: catálogo de las colecciones*. Barcelona: Polígrafa, 1985-1988, 2 vol.

DAIX, Pierre; Georges BOUDAILLE. *Picasso 1900-1906: catalogue raisonné de l'œuvre peint* [2nd edition]. Neuchâtel: Ides et Calendes, 1988.

DAIX, Pierre; Joan ROSSELET. *El cubismo de Picasso*. Barcelona: Blume, 1979.

GEISER, Bernhard; Brigitte BAER. *Picasso peintre-graveur*, vol. I. Berna: Kornfeld, 1990.

Museu Picasso: catàleg de pintura i dibuix. Barcelona: Ajuntament de Barcelona, 1984.

PALAU I FABRE, Josep. *Picasso vivent (1881-1907)*. Barcelona: Polígrafa, 1980.
— *Picasso cubisme (1907-1917)*. Barcelona: Polígrafa, 1990.

ZERVOS, Christian. *Catalogue de l'œuvre de Picasso*. Paris: *Cahiers d'Art, 1932-1978*, 34 vol.

GENERAL BIBLIOGRAPHY

APOLLINAIRE, Guillaume. *Les peintres cubistes: méditations esthétiques*. Paris: Hermann, 1965.

BALAGUER, Víctor. *Las calles de Barcelona*. Barcelona: Salvador Manero, 1865-1866, 2 vol.

BALDASSARI, Anne. *Picasso photographe 1901-1916*. Paris: Réunion des Musées Nationaux, 1994.

BLUNT, Anthony; POOL Phoebe. *Picasso: the formative years*. London: Studio Books, 1962.

BOECK, Wilhelm. *Picasso* [with a preliminary study by Jaume Sabartés]. Barcelona, etc.: Labor, 1958.

BRASSAÏ. *Conversaciones con Picasso*. Madrid: Aguilar, 1966.

CABANNE, Pierre. *El siglo de Picasso*. Madrid: Ministerio de Cultura, 1982.

CAIZERGUES, Pierre; Hélène SÉCKEL [ed.]. *Picasso/Apollinaire: correspondance*. Paris: Gallimard: Réunion des Musées Nationaux, 1992.

CARRERAS CANDI, Francesc. *La Via Layetana substituint als carrers de la Barcelona mitgeval: catálech de la colecció gráfica de dita vía*. Barcelona: Albert Martín, 1913.

CIRICI PELLICER, Alexandre. *Picasso antes de Picasso*. Barcelona: Iberia, 1946.

CIRLOT, Juan-Eduardo. *Picasso: el nacimiento de un genio*. Barcelona: Gustavo Gili, 1972.

CLARK, Kenneth. *El arte del paisaje*. Barcelona: Seix Barral, 1971.

CLAVIJO GARCÍA, Agustín. *Picasso y lo picassiano en las colecciones particulares malagueñas*. Màlaga: Universidad de Málaga, 1981.

COMBALIA DEXEUS, Victoria [ed.]. *Estudios sobre Picasso*. Barcelona: Gustavo Gili, 1981.

COOPER, Douglas. *La época cubista*. Madrid: Alianza, 1984.

COOPER, Douglas; Gary TINTEROW. *The essential Cubism: Braque, Picasso & their friends 1907-1920*. London: Tate Gallery, 1983.

COWLING, Elizabeth; GOLDING John. *Picasso: sculptor/painter*. London: Tate Gallery, 1994.

DAIX, Pierre. *Picasso*. Paris: Chêne, 1990, Profils de l'Art.
— *Picaso: life and art*. London: Thames and Hudson, 1994. [Modern translation of the French original *Picasso créateur* (1987).]
— *La vie de peintre de Pablo Picasso*. Paris: Seuil, 1977.
— *Les Demoiselles d'Avignon*. Paris: Réunion des Musées Nationaux, 1988, 2 vol.

FONTBONA, Francesc. *El paisatgisme a Catalunya*. Barcelona: Destino, 1979.

FRANCÍN, Francesc. *Picasso y Horta de Ebro*. Tarragona: the author, 1981.

GAYA NUÑO, Juan Antonio. *Picasso*. Madrid: Aguilar, 1975.

GEELHAAR, Christian. *Picasso: Wegbereiter und Förderer seines Aufstiegs 1899-1939*. Zurich: Palladion/ABC, 1993.

GLIMCHER, Arnold; Marc GLIMCHER [ed.]. *Los cuadernos de Picasso*. Madrid: Mondibérica, 1986.

GOLDING, John. *El cubismo: una historia y un análisis. 1907-1914*. Madrid: Alianza, 1993. [Original in English, 1988.]

GONZÁLEZ GARCÉS, Miguel. «Isidoro Brocos y Pablo Picasso». *Isidoro Brocos: dibujo, pintura, escultura*. Corunna: Diputación Provincial, 1985, p. 17-20.

GUTIÉRREZ BURÓN, Jesús. «Picasso y las exposiciones nacionales: tradición y ruptura». *5.º Congreso español de historia del arte: actas*. Barcelona: Ediciones Marzo 80, 1986, vol. 2, p. 53-62.

JUNOY, Josep. *Arte y artistas (1.ª serie)*. Barcelona: L'Avenç, 1912.

KACHUR, Lewis C. *Themes in Picasso's Cubism, 1907-1918*. Columbia University, 1988. [Doctoral thesis.]

KAHNWEILLER, Daniel-Henry. *Mes galeries et mes peintres*. Paris: Gallimard, 1961.

KAPLAN, Temma. *Red city, blue period: social movements in Picasso's Barcelona*. Berkeley: University of California Press, 1992.

LECALDANO, Paolo. *La obra completa de Picasso azul y rosa*. Barcelona; Madrid: Noguer, 1976.

LEIGHTEN, Patricia. *Re-ordering the universe: Picasso and anarchism 1897-1914*. Princeton (New Jersey): Princeton University Press, 1989.

LEYMARIE, Jean. *Picasso: métamorphoses et unité*. Geneva: Skira, 1971.

Màlaga. Centenario Picasso. Madrid: Ministerio de Cultura, 1981, 3 vol.

MALRAUX, André. *La cabeza de obsidiana*. Buenos Aires: Sur, 1974.

Masterpieces from the David and Peggy Rockefeller Collection. New York: The Museum of Modern Art, 1994.

MAYER, Susan. *Ancient Mediterranean sources in the works of Picasso, 1892-1937*. New York University, 1980. [Doctoral thesis.]

MENDOZA GARRIGA, Cristina [dir.]. *Catàleg de pintura segles XIX i XX: fons del Museu d'Art Modern*. Barcelona: Ajuntament de Barcelona, 1987, 2 vol.

MINERVINO, Fiorella. *La obra pictórica completa de Picasso cubista*. Barcelona; Madrid: Noguer, 1972.

OCAÑA, Maria Teresa. *Picasso: viatge a París*. Barcelona: Gustavo Gili, 1979.

OLANO, Antonio D. *Picasso íntimo*. Madrid: Dagur, 1971.

OLIVIER, Fernande. *Picasso y sus amigos.* Madrid: Taurus, 1964.
— *Recuerdos íntimos: escritos para Picasso.* Barcelona: Parsifal, 1990.

PADÍN, Ángel. *Los cinco años coruñeses de Pablo Ruiz Picasso (1891-1895).* Corunna: Diputación Provincial, 1991.

PALAU I FABRE, Josep. *Picasso a Catalunya.* Barcelona: Polígrafa, 1975.
— *Picasso i els seus amics catalans.* Barcelona: Aedos, 1971.
— *Picasso per Picasso.* Barcelona: Joventut, 1970.

PARMELIN, Hélène. *Habla Picasso.* Barcelona: Gustavo Gili, 1968.

PENROSE, Roland. *Picasso: su vida y su obra.* Barcelona: Argos Vergara, 1981.

PEÑA HINOJOSA, Baltasar. *Los pintores malagueños en el siglo XIX.* Málaga: Diputación Provincial de Málaga, 1964.

PERUCHO, Joan. *Picasso, el cubisme i Horta de Sant Joan.* Barcelona: Columna, 1993. [Text in Catalan, Spanish, French and English.]

PICASSO, Pablo. *Carnet catalan* [preface and notes by Douglas Cooper]. Paris: Berggruen, 1958. [Facsimile edition.]

PICASSO, Pablo. *Carnet Picasso. La Coruña, 1894-1895* [with introduction by Juan Ainaud de Lasarte]. Barcelona: Gustavo Gili, 1971.

PICASSO, Pablo. *Carnet Picasso. Madrid 1898* [with introduction by Xavier de Salas]. Barcelona: Gustavo Gili, 1976.

PICASSO, Pablo. *Écrits:* established texts, presented and annotated by Marie-Laure Bernadac and Christine Piot. Paris: Réunion des Musées Nationaux: Gallimard, 1989.

Picasso i Barcelona 1881-1981. Barcelona: Ajuntament de Barcelona, 1981. [Also published in Spanish.]

Picasso i Horta. Horta de Sant Joan: Centre Picasso d'Horta, 1992.

Picasso, jeunesse et genèse: dessins 1893-1905. Paris: Réunion des Musées Nationaux, 1991.

Picasso 1881-1973 [anthological exhibition]. Madrid: Ministerio de Cultura; Barcelona: Ajuntament de Barcelona, 1981. [Also published in Spanish.]

Picasso 1905-1906. Barcelona: Ajuntament de Barcelona: Electa, 1992. [Catalogue of the exhibition held at the Museu Picasso, Barcelona, and at the Künstmuseum, Berne.]

PODOSIK, Anatoli. *Picasso: la interrogante eterna: obras del pintor en los museos de la Unión Soviética.* Leningrad: Aurora, 1989.

RICHARDSON, John. *A life of Picasso. Vol. 1: 1881-1906.* New York: Random House, 1991.

RIVERO MATAS, Nuria. *Un Picasso en el Museo de Bellas Artes de Bilbao: Merendero. Museo de Bellas Artes de Bilbao. Anuario 1993.* Bilbao: el Museo, 1994, p. 57-62.

RUBIN, William. *Picasso y Braque: la invención del cubismo.* Barcelona: Polígrafa, 1991.

RUBIN, William [ed.]. *Pablo Picasso: retrospectiva. Museum of Modern Art, New York.* Barcelona: Polígrafa, 1980.

SABARTÉS, Jaume. *Picasso: retratos y recuerdos.* Madrid: Afrodisio Aguado, 1953.
— *Picasso: documents iconographiques.* Genève: Pierre Cailler, 1954.

SALMON, André. *Souvenirs sans fin: première époque (1903-1908).* Paris: Gallimard, 1955.

SÉCKEL, Hélène. *Max Jacob et Picasso.* Paris: Réunion des Musées Nationaux, 1994.

SINDREU, Josep. *Gósol.* Lleida: Diputació de Lleida, 1988.

SPIES, Werner. *La escultura de Picasso.* Barcelona: Polígrafa, 1989.

STEIN, Gertrude. *Autobiografía de Alice B. Toklas.* Barcelona: Bruguera, 1978.
— *Picasso.* Buenos Aires: Schapire, 1954.

SUBIRANA, Rosa M. *Museo Picasso.* Madrid: Orgaz, 1979.

TOKLAS, Alice B. *Recuerdos.* Barcelona: Noguer, 1991.

UHDE, W. *Picasso et la tradition française: notes sur la peinture actuelle.* Paris: Quatre-chemins, 1928.

VALLENTIN, Antonia. *Vida de Picasso.* Buenos Aires: Hachette, 1957.

VOLLARD, Ambroise. *Memorias de un vendedor de cuadros.* Barcelona: Destino, 1983.

WARNCKE, Carsten-Peter. *Pablo Picasso 1881-1973.* Cologne: Benedikt Taschen, 1992, 2 vol.

WARNOD, Jeanine. *Le Bateau-Lavoir 1892-1914.* Paris: Les Presses de la Connaissance, 1975.

WATTENMAKER, Richard J. *Puvis de Chavannes and the Modern Tradition.* Toronto: Art Gallery of Ontario, 1975.

WORMS DE ROMILLY, Nicole; Jean LAUDE. *Braque: le cubisme fin 1907-1914.* Paris: Maeght, 1982.

PHOTOGRAPHIC CREDITS

AHC/PHOTOGRAPHIC ARCHIVES
Cat. nos.: 2, 3, 4, 5, 6, 7, 8, 9, 20, 21, 22, 23, 24, 25, 43, 50, 61, 64, 74, 81,
82, 88, 88, 89, 90, 102, 107, 108, 109, 110, 111, 112, 113, 114, 115, 116, 117 119,
120, 121, 122, 123, 124, 125, 126, 128, 137, 141, 143, 145, 147, 148, 150, 151,
153, 161, 162, 163. Figs.: 35, 37, 45, 51, 57, 74

AHC/PHOTOGRAPHIC ARCHIVES/J. Calafell & R. Feliu
Cat. nos.: 1, 10, 12, 13, 30, 31, 32, 46, 52, 56, 57, 62, 62R, 63, 66, 67, 68, 75,
76, 77, 79, 84, 85, 87, 127, 129, 130, 131, 132, 133, 134, 135, 136, 149, 156,
165, 165R, 166, 211

ANDRÉ CHENUE & FILS, Paris
Cat. no.: 173 b.

ARCHIVES OF THE ARCHITECTURAL HERITAGE DEPARTMENT
OF THE PROVINCIAL GOVERNMENT OF BARCELONA
Fig.: 104

ASHMOLEAN MUSEUM, Oxford
Cat. no.: 159

BÉATRICE HATALA
Figs.: 85, 86, 87, 88, 89, 90, 91, 92, 93, 94, 95, 96, 97, 98

BOLLAG GALLERY, Zurich
Cat. no.: 167

CENTRE EXCURSIONISTA DE CATALUNYA, PHOTOGRAPHIC
ARCHIVES
Fig.: 104 b.

CESTMIR SILA
Cat. no.: 199

CHRISTINE RUIZ PICASSO
Cat. no.: 185

CULTURAL CENTRE OF CONTEMPORARY ART, A.C. México
Cat. no.: 213

ERIC POLLITZER, New York
Fig.: 10

FRANCIS BRIEST
Cat. no.: 164

GLASGOW MUSEUMS: ART GALLERY AND KELVINGROVE MUSEUM
Cat. no.: 160

HERMITAGE MUSEUM
Cat. no.: 191

JAN KRUGIER GALLERY
Cat. nos.: 118, 179. Fig.: 48

KEN COHEN, PHOTOGRAPHY
Cat. no.: 174

LUNWERG EDITORES, Paco Rojas
Cat. nos.: 11, 14, 15, 16, 17, 18, 19, 26, 27, 28, 29, 33, 36, 37, 38, 39, 40, 44,
45, 47, 48, 49, 51, 53, 54, 55, 58, 59, 60, 65, 69, 70, 71, 72, 73, 78, 80, 83,
86, 91, 92, 93, 94, 95, 96, 97, 98, 99, 100, 101, 103, 104, 105, 106, 139, 140,
142, 146. Fig.: 62

LLUÍS PRAT
Fig.: 14, 108

MALCOLM VARON
Cat. no.: 190